Quarry Quest

The History of Stearns County
Quarry Park and Nature Preserve

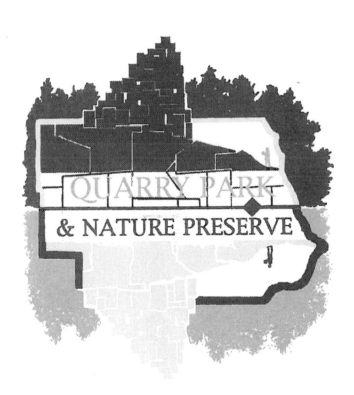

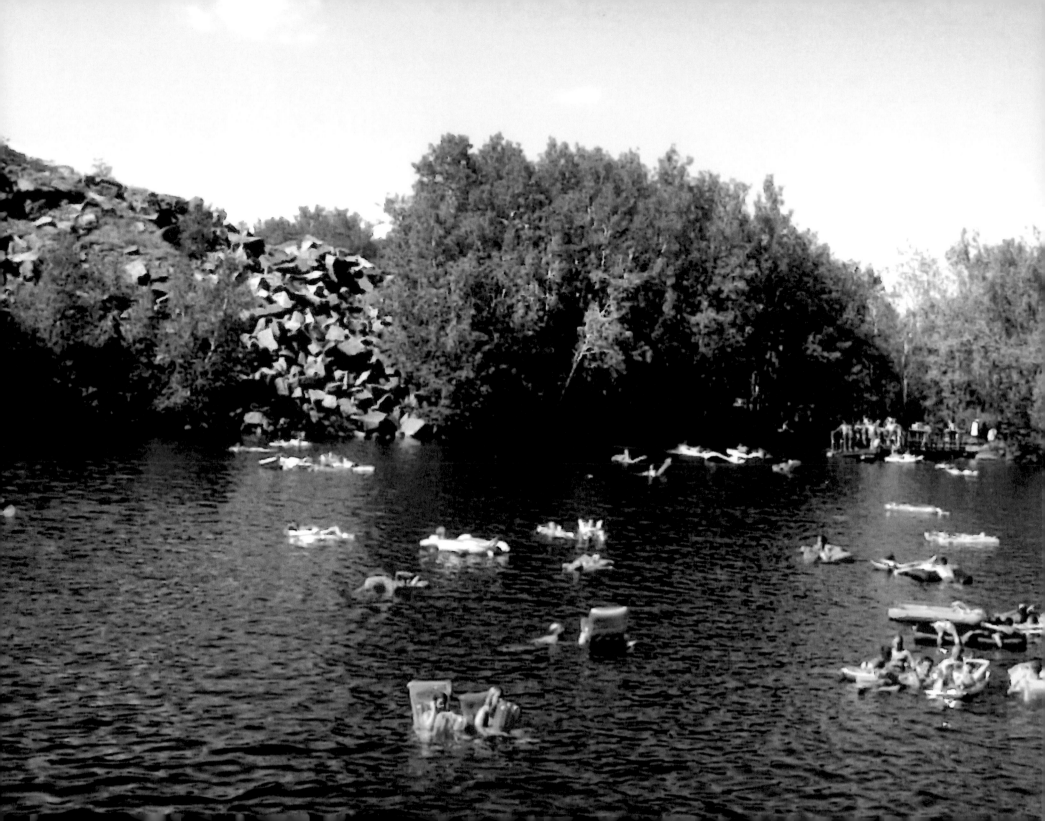

Quarry Quest

The History of Stearns County Quarry Park and Nature Preserve

By Retired Stearns County Commissioner Mark Sakry

North Star Press of St. Cloud, Inc.
St. Cloud, Minnesota

ISBN: 978-0-87839-753-2

First Edition: July 2016

Printed in the United States of America
by Sentinel Printing

Published by:
North Star Press of St. Cloud, Inc.
P.O. Box 451
St. Cloud, Minnesota 56302

www.northstarpress.com

Table of Contents

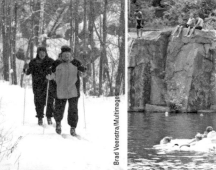

Quarry Park

In Granite Country USA

Truly a local treasure, Quarry Park and Nature Preserve (formerly known as "Hundred Acres Quarry") is the largest park in the Stearns County Parks System. The 643-acre park is a fascinating look at the early granite industry in the Central Lakes area, and it is a haven for those who love the outdoors. Natural features include scenic woodlands, open prairie, wetlands, and unquarried bedrock areas, with many trails winding throughout the park. Plant life includes everything from oaks and aspens to yellow ladyslippers, Indian paintbrush and prickly pear cactus. Man-made features include sizeable hills composed of quarried rock remnants (grout piles) and 30 granite quarries, most of which are now filled with water and form picturesque rock-fringed ponds — which are surprisingly clear and deep. Hills afford spectacular views of the landscape and a new observation deck provides a unique perspective. Vehicle parking permits can be purchased at the contact station or from the Stearns County Parks Department (320-255-6172). Picnic, swim, hike, fish, bike or cross-country ski — Quarry Park will provide you hours of enjoyment any time of year!

Granite, Granite Everywhere!

Once known as the "Nitty Gritty Granite City", St. Cloud used the above headline for a 1921 advertising campaign. When granite deposits were found along area rivers and in land nearby, the granite industry began to develop. Granite was everywhere and even today, as you drive through St. Cloud and Central Minnesota, you'll find buildings, houses, churches, monuments and public artwork made of granite of all kinds. One of the largest granite companies in the world is in nearby Cold Spring, and the Minnesota Correctional Facility was built on the site of the first granite quarry in St. Cloud. At one time the area claimed 19 granite companies, and the granite industry provided thousands of jobs throughout the mid-1800s to present day. Most recently, a plan to expand tourism related to this fascinating industry was created, so be sure to watch for details in the future!

Contact the St. Cloud Area Convention and Visitors Bureau for more information at 1-800-264-2940 or www.granitecountry.com, or call the Stearns History Museum at 320-253-8424.

St. Cloud, Minnesota: The Granite City of the World
BIDS YOU WELCOME!

Granite Country Attractions:

Stearns History Museum • 235 33rd Ave. S, St. Cloud • 5-g
Quarry Park (Stearns County Parks) • County Rd 137, Waite Park • 1-i
Stearns County Courthouse • 725 Courthouse Square, St. Cloud • 9-e
St. Mary's Cathedral • 25 8th Ave. N, St. Cloud • 9-e
North Star Cemetery • 1901 Cooper Ave. N, St. Cloud • 8-h
Minnesota Correctional Facility
2305 Minnesota Blvd. SE, St. Cloud • west of 12-g

St. John's Abbey, St. John's University • Collegeville • ♥MN map pg. 2
Assumption Chapel (Grasshopper Chapel)
Hwy. 23, Cold Spring • ♥MN map pg. 2
St. Boniface Catholic Church & Cemetery
418 Main St., Cold Spring • ♥MN map pg. 2
First National Bank of Rockville
205 Broadway St. E, Rockville • ♥MN map pg. 6
Rockville City Hall • 209 E Broadway St., Rockville • ♥MN map pg. 6

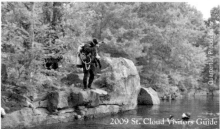

Dedication

To my loving family . . .
Left to right: Brent, Diane and Mark Sakry, Dionne (Sakry) Allan with
daughter Summer, and Curtis Allan with son Noah

Photo Credits

Introduction

SWIMMING, FISHING, GEOCACHING, jogging, hiking, wildlife observing, snowshoeing, cross country skiing, rock climbing, scuba diving, mountain biking, family picnicking, studying the history of the granite industry . . . all this and more is waiting for visitors at Stearns County Quarry Park and Nature Preserve. Once a beautiful park like Quarry Park is "up and operating," the public might assume this regional treasure has always generated the same love and support it enjoys today. That would be a erroneous assumption. Often for something major to be accomplished, like the founding of a unique, regional park, the right people with a shared vision need to be in the right place at the right time. Such was the case in the founding of Stearns County Quarry Park and Nature Preserve. As chair of the Stearns County Board of Commissioners in 1992, I happened to be one of the people in the right place to make something happen. But *why* I wanted so badly to see Quarry Park become a reality warrants a brief look back to my childhood. Also, a look back to my early adult years, when living on a granite quarry of my own fueled my love for these unique rock-and-water wonderlands.

My father, Maynard Sakry, worked on the Great Northern (later Burlington Northern) Railroad for over forty years, supporting his family—my mother, Evelyn, and their seven children. My five older brothers and one younger sister and I were fortunate to have a dad who not only loved to swim, but who especially loved swimming in abandoned granite quarries! Enjoying the crisp, clean, spring-fed waters of these deep granite pools was, and still is, a rite of passage for many young people in Central Minnesota. We all sensed that growing up in "granite country" was something very special, but like most young people, we probably took too much for granted. It was easy to assume that the treasures of childhood, such as the charm of a quiet, safe neighborhood, or a summertime "dip in the quarries," would be there forever for everyone to enjoy. One should not assume. These precious landscapes must be protected. The establishment of Stearns County Quarry Park and Nature Preserve was not a sure thing, nor was it an easy sell to the county's insurance trust, the City of Waite Park, and a host of others. In fact, the park almost didn't happen. But more on that later.

Dad taught us all to swim. Actually it was easy. He made sure when we were young that we wore a lifejacket or "lifebelt." Oh, I remember the day well when I was first given permission to take off the red lifebelt and paddle around a bit in the deep waters just beyond the safety of a submerged granite ledge that we would stand on to enter the water. We knew we better keep kicking and "dog paddling" because it was a long, long way to the bottom of that granite pool.

In those years most abandoned quarries, though company owned, were regarded by most folks as quasi-public parks! "No trespassing" didn't seem to apply to abandoned granite quarries. Everyone went for a refreshing dip with family and friends, and nobody seemed to care.

Back in the 1950s and 1960s swimmers might bring an old tractor tire inner tube to float on in luxury while soaking up the sun. Few people had "air mattresses" as we know them today. Any old log or telephone pole floating in the quarry (and it seemed every quarry had one or two) made for a whole

afternoon of fun, bobbing up and down like a seesaw, or log fights trying to knock the other team off their floating fortress, or simply riding the log past the abundance of wild raspberry patches that graced the quarry wall. These are the delicious memories of childhood . . . the joy of sampling fresh, wild raspberries that cling to a granite wall at the water's edge!

My sister, Joan, and I enjoyed these quarry outings so much that when we got home we refused to let the fun end. We would "play quarry" by spreading a large, black quilt across the living room floor, pretending it was the cool quarry water. We would jump off a couch or living room chair onto the quilt, imagining spectacular granite ledges and Olympic-quality dives.

In the case of the Melrose Granite Company quarry

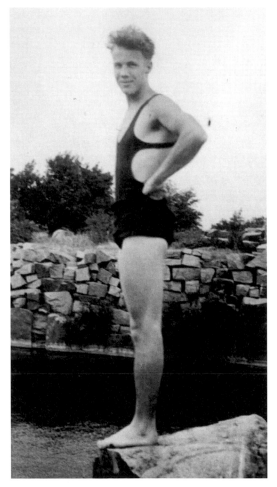

Maynard Sakry, circa 1935, enjoyed quarry swimming in his youth and taught his seven kids to swim at local quarries in the 1950s and 1960s. (Author's Collection)

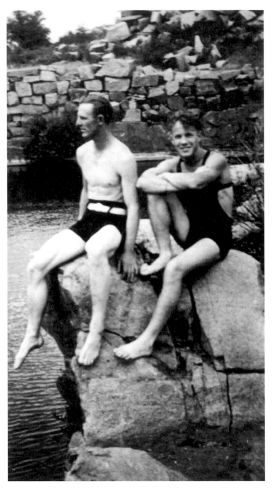

Maynard Sakry (right) with friend at the quarries, circa 1935. (Author's Collection)

swimming quarry of my youth. Someone dumped oil on the surface of the pristine waters to discourage swimming. The motivation for such a senseless act was no doubt due to some exaggerated fear of liability. Finally, in the ultimate insult, Cold Spring Granite Company simply moved in with heavy equipment and pushed the slag piles into the water and brought in truckload upon truckload of fill to finish the job. This was a foreshadowing of what was yet to come. As we'll discuss later, liability issues or at least the exaggerated perceptions of unmanageable liability, almost prevented Stearns County Quarry Park and Nature Preserve from becoming a reality. True, not every abandoned quarry in Central Minnesota could remain forever as a local swimming hole, but, nevertheless, it was sad to see such beautiful places destroyed.

that we claimed for Sakry family "field trips," there would be no protection or preservation of this unique landscape. Cold Spring Granite Company purchased the property in 1959. It is ironic that a company that would ultimately do so much to make Quarry Park possible destroyed the favorite

I suppose I would be remiss if I failed to mention the "dark side" of abandoned granite quarries in those early years. Teenagers did indeed

Nothing like quarry swimming on a hot summer day! (Author's Collection)

throw wild parties, beer busts that led to loud singing, midnight skinny dipping, and reckless behavior. For the most part, this particular rite of passage, partying at quarries in Central Minnesota, was rather harmless . . . but not always. Many a parent feared what could happen when teens and alcohol mixed with massive granite blocks and deep water.

The years passed, and we Sakry kids became teenagers, then college students. We still visited the quarries on a regular basis, but now the partying was with high school, then college friends. The quarry of choice during this period was known as "Cemetery 2," located just north of the Waite Park Cemetery. This was the quarry with the infamous graffiti which read, "Swim bare ass, we did!" However, because of the way the graffiti was positioned on the rock, the "artist" might have intended it to read "Swim we did, bare ass." Although that seemed a more "classy," somewhat French way

Kim Sakry shows great form on her fifteen-foot quarry jump. (Author's Collection)

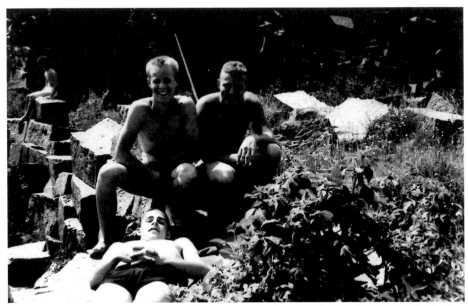

Denny and Dick Sakry, second-generation quarry enthusiasts, circa 1957. (Author's Collection)

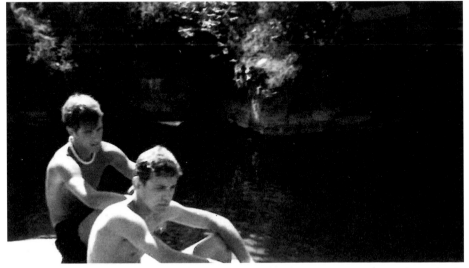

Mark Stockinger and Mark Sakry take in sunshine at what was to become the Sakry family quarry in Waite Park, circa 1970. (Author's Collection)

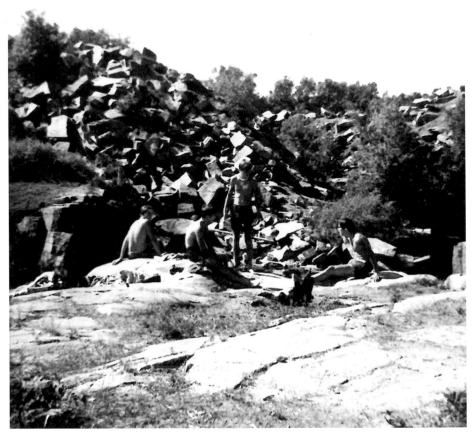

Cemetery 2 Quarry was a favorite swimming hole for decades for Waite Park and St. Cloud area youth. (Author's Collection)

to interpret the graffiti, most visitors to the quarry chose to read it simply as, "Swim bare ass, we did." And so we did. Many late night swims and long philosophical discussions around the glow of the campfire filled our teenage summer nights.

At age twenty-one, I had a brainstorm. *Somebody* must own this "Cemetery 2" party spot. I wondered if whoever owned it would consider selling it. I stopped by the Stearns County Courthouse and found out that

The Sakry family at their quarry in the 1980s. (Author's collection)

the approximately ten acres of quarry property was owned by Alfred C. Petters, a retired crushed-rock executive, and his wife, Violet A. Petters. As luck would have it, Mr. Al Petters was getting on in years and was thinking about selling some of his land holdings. When I called him and explained that I might be interested in purchasing the quarry next to the Waite Park Cemetery, he asked me if I was the fellow who had called him about a year earlier. I said, "No, this is my first time calling you."

Al said, "Well, I told that other guy I wasn't interested in selling it. But I've been thinking maybe I should. Then if I pass on, my wife won't have to mess with putting it up for sale. Let me think about it. Call me in a couple weeks."

I was ecstatic when I hung up the phone. It appeared that timing and youthful exuberance was on my side!

When I called Mr. Petters back and asked if he would consider a contract-for-deed purchase, he said, "Yes, I guess I'd be willing to sell it on a contract-for-deed. Let's say $1,000 down and $4,500 at eighty percent interest. At monthly payments of $70.00 per month, you should have it paid off in six or seven years." I couldn't believe my ears. I got tears in my eyes when I hung up the phone. I was actually going to own my own quarry! My favorite party spot from high school days was soon going to be my home!

I remember stopping by the quarry a night or two later to join my old gang of friends for a few beers around the campfire. "Well, boys," I said, "I'm going to own these granite ledges we're sitting on."

"Oh, yeah, right," was the quick response. "Sakry, you better have another beer."

"No, seriously," I said, "I'm going to buy this quarry, all ten acres for $5,500!"

Someone asked, "How do you know this is where you'll want to settle down and live the rest of your life? Some of us are thinking about heading out to California."

"I just know this is meant to be," I said with youthful confidence and a smile.

Now, $5,500 might seem like nothing in today's dollars, but back in 1974, that was still a lot of money for a college kid to come up with, even if Alfred C. Petters was willing to be "the banker." I asked my brother Denny if he could loan me $1,000 for the down payment. He agreed, with the understanding that he would have the option to "buy in" to one half ownership of the property at a later date if we both decided to build on the property someday.

And so it began. The papers with Al and Violet Petters were signed on October 12, 1974. I became the proud owner of 9.5 acres of beautiful quarry property in what was then St. Cloud Township, just west of the Waite Park city line. Al Petters died just a little over one year later, on

Quarry water is a little brisk for much of the summer, so Joan (Sakry) McLaughlin decides to acclimate by getting just her feet wet. (Author's Collection)

Mary Jo Sakry and son Scott float along on a comfortable air mattress in the summer of 1976. (Author's Collection)

December 27, 1975, and I made my monthly payments to Violet Petters. A few years later, when making plans to build a home, I asked to be annexed into the City of Waite Park in order to take advantage of city water service. (Although it could have been done, it would have been very expensive to drill through solid granite to find a source of drinking water.) Land values climbed significantly in the 1970s. With the increased value of my quarry property as collateral, I was able to secure a construction loan and build my dream home on the quarry in 1978. Imagine, a natural one-acre "swimming pool" with no chemicals or maintenance and beautiful rainbow trout to catch and fry for dinner!

I renamed "Cemetery 2" *LaMancha*, in honor of Don Quixote, another man with a dream. I thought about turning *LaMancha* over to the City of Waite Park someday to serve as a city park when I was eventually

Sakry family members and friends at Cemetery 2 in 1976. (Author's Collection)

dead and gone. But then along came the wonderful possibility of establishing a park of regional significance, a park with potentially 700 acres or more as opposed to just 9.5 acres. Yes, Stearns County Quarry Park and Nature Preserve would be a project worth fighting for, a dream worth dreaming, and a legacy worth bequeathing to all future generations!

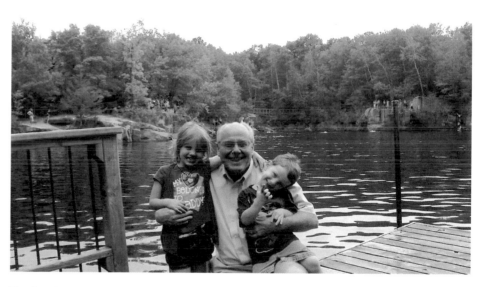

The fourth generation of quarry enthusiasts, Summer and Noah Allan (Mark and Diane Sakry's grandchildren) with Mark Sakry enjoying their 2013 visit to Quarry Park. (Author's Collection)

Tom, Jean, and Sandy Sakry introduce a few third-generation Sakrys (baby Alison and Penny) to the joys of quarry swimming. (Author's Collection)

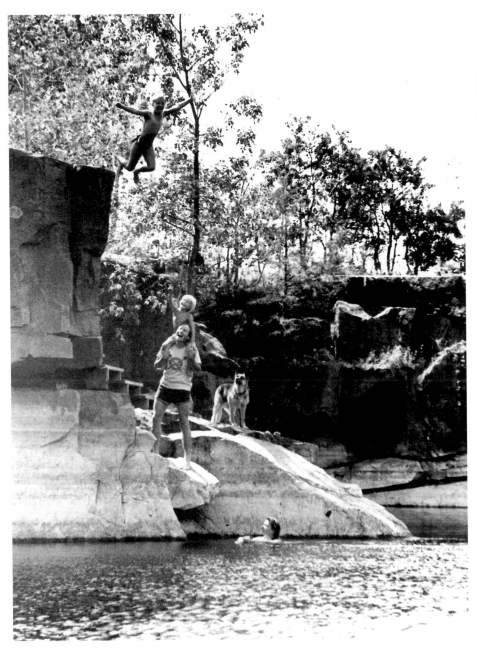

In early spring, Peter Drinkwine and the gang would push the last of the floating ice chunks out of the way to be the first to dive into the new swim season. (Courtesy of George Reisdorf)

The 1988 Board of Commissioners campaign photo of the Sakry family (Mark, Diane, Dionne, and Brent) enjoying a sunny day at their quarry home in Waite Park half a mile north of Quarry Park. Mark won the election and went on to serve the next twenty-two years on the Stearns County Board of Commissioners. (Author's Collection)

Chapter 1

Granite Industry History in Central Minnesota

ASK ANYONE WHO GREW UP in Central Minnesota, "As a young person, what did you enjoy most about the St. Cloud area?" and chances are they'll include "swimming in the quarries" near the top of their list! In fact, swimming in abandoned granite quarries has refreshed several generations of young people. As noted in the introduction, abandoned quarries, though privately owned, were regarded by most folks as quasi-public parks! "No trespassing" didn't seem to apply to these sparkling, recreational jewels. As Governor Arne Carlson noted on his 1995 visit to Quarry Park, "This is like Mark Twain all over again!" Of course, it wasn't just St. Cloud's young Tom Sawyers or Huckleberry Finns who enjoyed a refreshing dip over the years. Central Minnesotans of *all ages* have enjoyed swimming in these picturesque, transformed landscapes. The establishment of Quarry Park and Nature Preserve ensures that this wonderful Central Minnesotan tradition, along with a host of other recreational opportunities, will continue for all future generations.

More on the park's many attractions in later chapters. Let's take a brief look at the history of the granite industry that transformed the Central Minnesota landscape and made Quarry Park possible. The quarries which now comprise Quarry Park, known for many years as "Hundred Acres Quarry," were quarried from the 1880s to the 1960s. Stearns County Park staff examined abstracts from these properties and discovered several small companies that, at the very least, owned property in the area. Several properties were family owned and were actively quarried for commercial sale.

Holes Brothers Granite Works, for example, supplied the red granite for the James J. Hill mansion on Summit Avenue in St. Paul. There were quarries named after the Benzie, Theilman, and Oberg families. The Trebtoske family quarry was operated by several brothers. One was the president, at least one was a stone cutter, and another was the marketing guy, according to Richard Trebtoske, a descendent. Richard Trebtoske believes the family named the operation the Universal Granite Company. The map to the park, available at the main entry kiosk, shows the traditional name for Quarry 8 as "Trebtoske Quarry." This particular quarry is 100 feet deep and appeared in a 1932 *Monumental Stone* publication from the University of Minnesota. A photo in that publication shows the quarry dry, with no water in it. The geologists who completed a geological inventory on Quarry Park at the time Stearns County purchased the property recognized that quarry by the description and the seams, faults, and fractures pictured in that publication from 1932.

The largest and deepest quarry in the park (116 feet deep), "Melrose Deep 7," was owned and operated by the Melrose Granite Company. Melrose Granite Company was founded by two brothers, Anton and John Luckemeyer, in 1896. Quarrymen gave individual quarries their names and those names (or nicknames) tended to last for decades. In the case of the quarry I own in Waite Park, the name "Cemetery 2" no doubt came about due to the quarry's close proximity to St. Joseph's Catholic Cemetery. Cemetery 2 was purchased by Alfred and Violet Petters. I purchased Cemetery 2 from them in 1974.

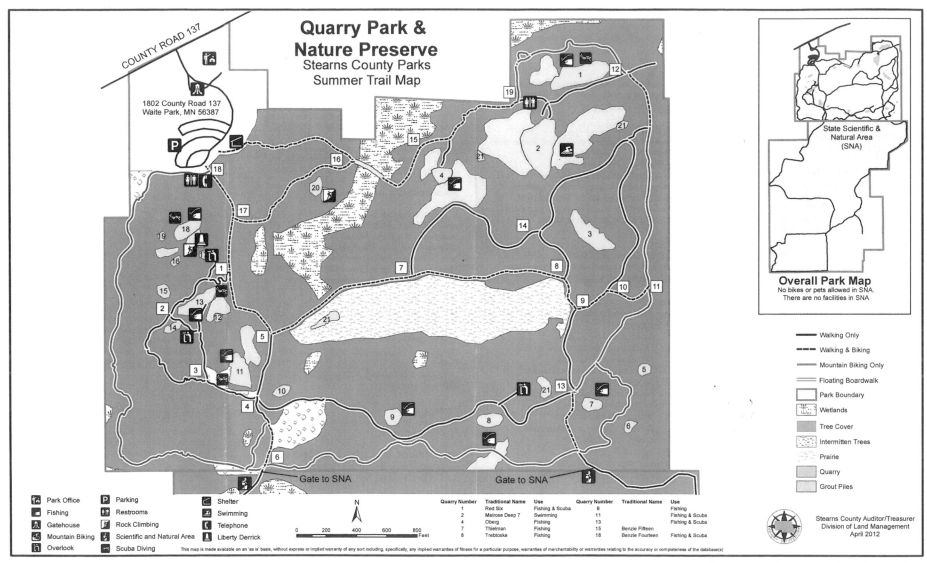

Quarry Park & Nature Preserve

Stearns County Parks
Summer Trail Map

1802 County Road 137
Waite Park, MN 56387

COUNTY ROAD 137

Gate to SNA

Gate to SNA

N

0 200 400 600 800
Feet

State Scientific & Natural Area (SNA)

Overall Park Map
No bikes or pets allowed in SNA.
There are no facilities in SNA

——	Walking Only
– – –	Walking & Biking
——	Mountain Biking Only
≡≡≡	Floating Boardwalk
☐	Park Boundary
	Wetlands
	Tree Cover
	Intermitten Trees
	Prairie
	Quarry
	Grout Piles

Stearns County Auditor/Treasurer
Division of Land Management
April 2012

Park Office Parking Shelter

Fishing Restrooms Swimming

Gatehouse Rock Climbing Telephone

Mountain Biking Scientific and Natural Area Liberty Derrick

Overlook Scuba Diving

Quarry Number	Traditional Name	Use	Quarry Number	Traditional Name	Use
1	Red Six	Fishing & Scuba	9		Fishing
2	Melrose Deep 7	Swimming	11		Fishing & Scuba
4	Oberg	Fishing	13	Benzie Fifteen	Fishing & Scuba
7	Thielman	Fishing	15	Benzie Fifteen	
8	Trebtoske	Fishing	18	Benzie Fourteen	Fishing & Scuba

This map is made available on an 'as is' basis, without express or implied warranty of any sort including, specifically, any implied warranties of fitness for a particular purpose, warranties of merchantability or warranties relating to the accuracy or completeness of the database(s)

Courtesy of Stearns County Park Department

One of several Holes Brothers' quarries mentioned in Oliver Bowles 1918 publication *Structural and Ornamental Stones of Minnesota* is located on the west side of Quarry Park in the Scientific and Natural Area (SNA), on the former Trisko parcel. Bowles writes in 1918 about a quarry north of what is now Quarry Park:

Holes Bros. are pioneers in the quarrying industry of St. Cloud. They first quarried at Sauk Rapids in 1875. In 1885 they began excavating in the west central part of sec. 20, St. Cloud Township, and continued until 1912. The rock is medium grained and attractive in appearance, becoming a deeper red in the bottom of the quarry. Unfortunately several large trap dikes pass through the quarry, and associated with them are numerous hairlines, or small trap dikes, together with certain bands of bleached or faded rock, known among the quarrymen as "jasper bands," which greatly mar the polished rock. In consequence of the dikes the expense of removing waste rock became so great that the quarry was abandoned. The old quarry pit is very large. The derrick was the tallest in the St. Cloud region and was a prominent landmark for many miles.

Bowles goes on to describe a new Holes Brothers' quarry that ultimately became part of Quarry Park:

In 1912 a new quarry was opened in the NE. ¼ NE. ¼ sec. 30, St. Cloud Township. The rock is a medium-grained red granite of attractive appearance.

Of course, Holes Brothers Granite Works was not the only company attracted to "St. Cloud Red" granite. Documents available at the Stearns County History Museum confirm that St. Cloud Red was marketed by many companies, under a variety of different trade names, such as "Indian red," "Rose Red," "Melrose Red," "North Star Red," "Ruby Red," "Mahogany Red," and "Standard Red," among others. According to one publication, "Most of the rock is used for monumental purposes, but some architectural stone is also fabricated."

The number of granite companies that sprang up in the St. Cloud area over many decades is quite impressive and led to St. Cloud being nicknamed the "Nitty Gritty Granite City." Here is a sampling of granite companies that operated in Central Minnesota:

Empire Quarrying Co., Melrose Granite Co., Hilder Granite Co., Sauk Rapids Granite Co., Frick & Borwick Granite Co., Rockville Granite Co. (later to become Cold Spring Granite), North Star Granite Co., Royal Granite Co., Holes Brothers Granite Works (later incorporated as simply Holes Brothers Co.), Bruce & Campbell, Simmers & Campbell, Black Diamond Granite Co., Liberty Granite (quarried the land just east of the north entry to Quarry Park), Northwestern Granite Co., Pioneer Granite Co., Granite City Granite Co., Agate Granite Co., St. Cloud Granite Works, St. Cloud Granite Quarrying & Manufacturing Co. (the first company organized to operate in granite on the west side of the Mississippi in Stearns County), Drake & Co., Breen & Young, Northern Granite Co. (successor to Coates & Freeman), St. Cloud Granite Co., Anderson & Co.

Quarry Park quarries were not the first opened in Central Minnesota. The earliest quarry in Central Minnesota dates back to 1868.

The Stearns County History Museum's September 2011 issue of *Crossings* magazine documents the very first successful *commercial* granite quarry not only in Central Minnesota, but in the entire state. The quarry is located in what is now known as East St. Cloud Quarries Historic District:

Located between the eastern end of University Drive and Highway 10 is approximately 102 acres filled with former granite quarries that were active between 1868 and 1941. The site of some of the Midwest's most valuable commercial granite deposits, Minnesota's granite industry began within and immediately south of the area when the first successful commercial granite quarry was launched by an Irish immigrant, Mathias Breen (1833 to 1890), and his Scottish partner, John T. Young, in the spring of 1868. Granite from the Breen and Young quarries was initially used for building foundations, bridge piers, and architectural trim. Breen and Young granite can be found in the first building at the St. Cloud State Teachers College and the Rock Island Arsenal in Illinois. Granite for the Arsenal was the first from Minnesota to be shipped out of the state. A large Breen and Young quarry was located within the walls of the Minnesota State Reformatory for Men and a number of smaller ones were outside and to the north. According to Oliver Bowles in *The Structural and Ornamental Stones of Minnesota* (1918), inmates excavated rock at several large pits both inside and outside the walls after the Reformatory first opened in 1889. Bowles identified a pit outside the walls as the site where Breen and Young began work in 1868. Part of the success of companies in the area, such as Breen and Young, resulted from easy access to the railroad, which bordered the district on the east.

Construction of the St. Cloud Reformatory began in late 1887, eighteen years before the granite wall itself was started. The institution officially opened on October 15, 1889. Construction of the 1.5-mile granite wall surrounding the St. Cloud Reformatory took over ten years to complete—1905 to 1916. According to the Minnesota Department of Corrections, "In 1916 construction of the longest granite wall in the world built using prison labor was completed at the State Reformatory. The wall is over one mile long, twenty-two feet high, four and one-half feet thick and constructed from granite quarried within the prison grounds." Actually, that

statement is not totally accurate. At the time of completion, the massive wall ranked as the second-longest wall in the world (second only to the Great Wall of China, which also involved penal labor in its construction). However, even today, the St. Cloud Reformatory wall is considered one of the longest walls in the world.

According to Sister Owen Lindblad, a local history author, "Granite from Central Minnesota was harder than that quarried in other parts of the country. It also shone, when polished, in distinct shades of color. For these reasons, the granite of the St. Cloud area became especially prized as monumental stone."

Mike Moran, *Times* columnist, commented on the uniqueness of St. Cloud area granite in his July 24, 2004, *St. Cloud Times* editorial. He also listed several significant national monuments, churches, government buildings, and other edifices and locations where St. Cloud granite can be found and viewed today.

Given the value of the stone, why were quarries abandoned? According to George Schnepf, chief financial officer at Cold Spring Granite Company, once the best rock had been extracted from a particular site, the search for stone would move to another location where a particular color characteristic might be found. Whatever color was popular was quarried. In fact, only a small percentage of rock from each quarry actually wound up being used for tombstones or building material. As much as eighty percent of the rock wound up as scrap on the waste or "grout" piles surrounding the quarry holes. Quarrymen were looking for a particular color of stone and would often follow a "vein" of bedrock that promised to yield that color. That explains why some quarries appear very small. That area of granite just didn't measure up to the color being sought, so the quarrymen moved on to try their luck at another site. In the quarries that comprise what is now Quarry Park, the two most popular colors were "St. Cloud Red" and "St. Cloud Gray" (now more commonly known as "Charcoal Black"). Over the decades, "St. Cloud Gray" has been the most commonly

quarried rock in Central Minnesota, and that's because there is a lot of it throughout Central Minnesota. (A walk through an area cemetery will confirm this abundance!)

Other factors that contributed to an active quarrying operation being abandoned had to do with cracks or fractures in the granite, resulting from the quarrying process itself. Derrick technology resulted in pressure build up deep in the hole, leading to pressure cracks and potentially dangerous conditions for the quarrymen. In today's technology huge trucks drive into the quarry, creating hauling roads as they go, thus avoiding the pressure issue. Color also played a role in quarries being abandoned. Sometimes color balls or "knots" existed that made the finished product look less uniform and, therefore, less attractive to some people's eyes. So, consistency in the granite's color tonality mattered a great deal to the customers, and that drove and still drives many of the decisions about what rock to keep and what rock ends up on the grout pile. As a percentage of the rock quarried,

The second-longest wall in the world. Only the Great Wall of China is longer. (With the permission of the *St. Cloud Times* and Bill Morgan)

Reformatory boasts one of world's longest walls

Only Great Wall of China beats it as longest wall built by penal labor

BILL MORGAN
♦
TIMES COLUMNIST

You have passed by it hundreds of times — the huge gray wall that surrounds the Minnesota Correctional Facility. A thought runs through your head. What is it that's so special about the wall? Is it the longest wall in the United States? The longest granite wall? Perhaps the longest enclosed granite wall? Or is it the longest wall built by penal labor?

The key to the answer to this question begins with an important Central Minnesota product — granite.

If you could see behind the wall that forms a point at the junction on Minnesota Highway 10 and Minnesota Boulevard, you would find three water-filled holes, the site of the first granite quarry in the state. Opened in 1868, the quarry has been dormant for several decades.

When the 1885 Minnesota Legislature called for establishing a reformatory, members sought a site "at or upon one of [Minnesota's] stone quarries." Two years later, after visiting 22 towns, legislators voted unanimously to locate the reformatory in East St. Cloud.

Constituting 240 acres of land including 40 acres of granite, the Sherburne County site was chosen for its quality and abundance of granite, availability of land and water, and its proximity to transportation. An early account noted that the quarry contained "a ledge deep enough to keep convicts busy for hundreds of years."

The granite was sold for commercial use until 1891 when the Legislature stopped production under pressure from private quarriers. This short-term venture also suffered because private companies could offer buyers brighter-colored stone. Crushed stone for highway surfacing was worked by inmates until about 1930.

In 1891, reformatory officials began teaching prisoners how to cut, dress and lay stone. It quick-ly became apparent that the ready supply of granite and the skills learned could be put to use for building an enclosing wall.

The original wall was made of 16-foot-high oak planks supported by oak posts. By 1905, it had become apparent that wood was a poor substitute for stone and erection of the present granite wall commenced.

The St. Cloud Journal-Press noted in 1905 that the proposed reformatory wall "is to be the largest about any prison in the United States." Quarried, dressed, and laid entirely by inmates, the wall that stands today is 4 feet wide at the base, 3 feet thick at the top, and 22 feet high. An amazing mile-and-a-half enclosure resulted when the wall was completed in 1922.

So, what is the wall's true claim to fame?

When the wall was finished in 1922, The Daily Times called it the "largest granite wall in the United States." In 1948, the Times said the reformatory project "comprises one of the most extensive outlays of granite in the United States." A 1981 article calls the wall "the second longest connected wall in the world," next to a wall in Chicago that surrounds a shopping mall.

Not entirely satisfied with any of these popular statistics, I called former warden Bill McRae, an expert on the history of the reformatory. McRae emphatically stated: "It is the longest wall in the world built by penal labor, except for the Great Wall of China." (That wall, by the way, is 2,150 miles long with another 2,195 miles of branches and spurs).

I'll go with Warden McRae on this one.

Bill Morgan is a community studies professor at St. Cloud State University. He can be reached at 255-2140 or by e-mail at Bill Morgan <Oasis@STCLOUDSTATE.EDU>

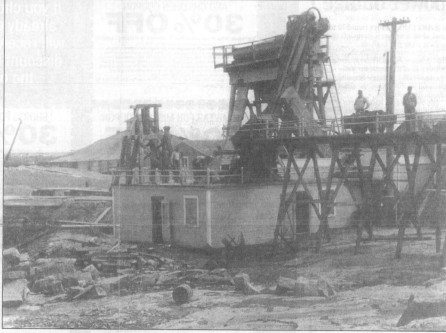

PHOTO COURTESY OF THE MINNESOTA CORRECTIONAL FACILITY-ST. CLOUD

A photograph of the quarry at the St. Cloud reformatory at the turn of the century.

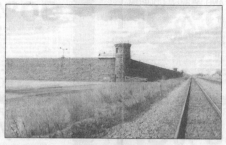

PHOTO COURTESY OF BILL MORGAN

The granite wall around the Minnesota Correctional Facility-St. Cloud is the second longest wall built by prison labor. The longest is the Great Wall of China.

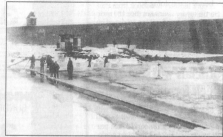

PHOTO COURTESY OF THE MINNESOTA CORRECTIONAL FACILITY-ST. CLOUD

Workers cut ice blocks near the St. Cloud reformatory quarry at the turn of the century.

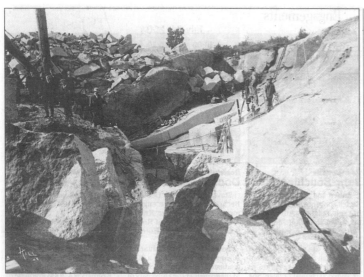

Men work in the John Clark Granite Quarry in 1908 near Rockville. Granite from area quarries is known internationally for its strength, even texture and special colors.

Unique granite brought national attention to area

The first successful granite quarry into this area's bedrock of coal black, red, pink and almost clear-colored granites — in fact, Minnesota's first granite quarry — was opened by Breen and Young in 1868 on St. Cloud's East Side.

The next year, this site was chosen for the state's second reformatory, in part because of the granite that would "keep the prisoners busy for years."

Indeed, stone by stone, the prisoners slowly erected the longest granite wall in the world around themselves and that first small quarry.

The first quarry west of St. Cloud opened in 1875.

National attention

Area granite received national attention in 1887 when 37 local granite columns became part of the capitol in Lincoln, Neb. Monument work became popular in the 1890s.

By then more than 1,000 men were employed here in the granite industry.

In 1889, Henry Alexander and other former Breen and Young employees opened the Rockville Granite Company in Rockville. Alexander soon bought out the others.

His company became the Cold Spring Granite Company in 1920, and it would become one of the largest granite companies in the world.

In 1920, there were 50 granite-related companies in this area.

By 1947, the St. Cloud area was said to rival Barre, Vt., as the leading granite-producing area in the country.

Modernization

Blasting powder was used to remove stone, and hammers, chisels and crowbars were the tools of the trade.

The 1920s brought the machine age to the quarries.

Channeling, in which several closely drilled holes near an edge allowed a smaller amount of powder or just a crowbar to remove stone, decreased waste.

The use of sandblasting allowed

Mike Moran
Times columnist

finer engraving, and newer polishing techniques brought out the special colors of the area's granite.

Quarry workers often drifted between quarries seeking work. New machinery allowed more steady work.

Workers faced the danger of falling from ledges or being hit by falling stone. Shop workers were subject to silicosis because of the granite dust. Better machinery improved safety and ventilation.

Granite now

Interestingly, granite is finding more favor with artists. Then again, our own "Granite Trio" sculptures have been on display downtown since 1973.

St. Cloud chose a city slogan, "St. Cloud, the Busy Gritty Granite City," in 1913.

In 1931, a slogan for the granite itself was most aptly chosen, "St. Cloud Granite, the Material of Masterpieces."

Visit Quarry Park to touch old quarries from which came some of the finest buildings in the state. Stay tuned for a granite expo, "Granite Country U.S.A.," Aug. 19-20, sponsored by the Northwest Granite Manufacturers Association.

Where to find St. Cloud granite

A few places you will find St. Cloud granite:
- Stearns County Courthouse.
- Buildings in Singapore.
- The St. Paul Cathedral.
- In Chicago, on a granite copy of the Ten Commandments.
- On an American Indian battlefield in Nebraska and the Shiloh battleground in Tennessee.
- In the walls of Fort Knox.
- In a 1904 World's Fair display of seven granite columns, now at the Smithsonian Institute
- In Mount Rushmore.
- In the FDR, Korean War, and World War II memorials in Washington.

This column is the opinion of Mike Moran. Write to him at the St. Cloud Times, P.O. Box 768, St. Cloud, MN 56302.

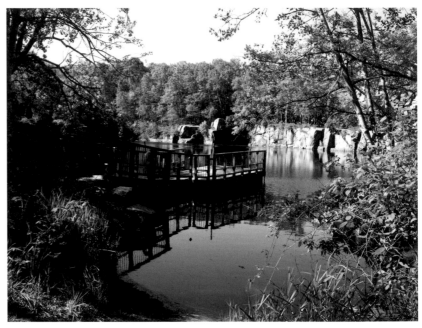

Summer in Quarry Park. (Courtesy of Don Kempf)

even more granite "goes to waste" today. Currently less than twenty percent of quarried rock is sent on to be polished. High standards for the perfect-looking stone are even more prevalent now than in decades past. Clearly, the wants and needs of the customer drive the quarrying process today, just as it did over 130 years ago.

As defined in Wikipedia:

Dimension stone is natural stone or rock that has been selected and fabricated (i.e., trimmed, cut, drilled, ground, or other) to specific sizes or shapes. Color, texture and pattern, and

The uniqueness of Central Minnesota granite. (Used with permission of the *St. Cloud Times*)

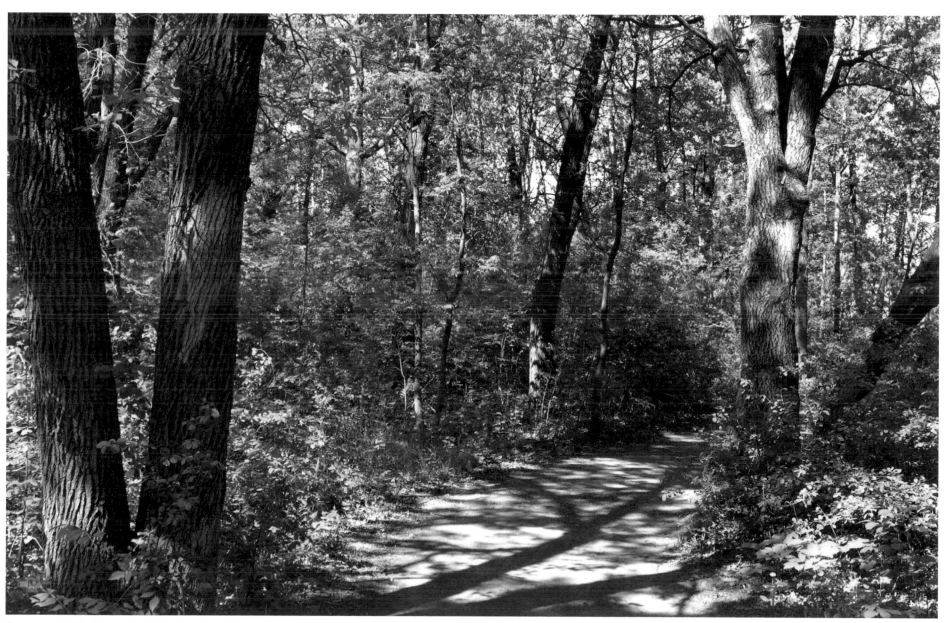

A summer trail in Quarry Park. (Courtesy of Don Kempf)

surface finish of the stone are also normal requirements. Another important selection criterion is durability; the time measure of the ability of dimension stone to endure and to maintain its essential and distinctive characteristics of sktrength, resistance to decay, and appearance.

Quarries that produce dimension stone or crushed stone (used as construction aggregate) are interconvertible. Since most quarries can produce either one, a crushed stone quarry can be converted to dimension stone production. However, first the stone shattered by heavy and indiscriminate blasting must be removed. Dimension stone is separated by more precise and delicate techniques, such as diamond wire saws, diamond belt saws, burners (jet-piercers), or light and selective blasting with Primacord, a weak explosive.

Some might ask, why not crush all the "waste" rock on the grout piles to create construction aggregate? According to George Schnepf, the industry is working on this issue. Currently, it is more economical to create crushing plants specifically for that purpose than to haul large granite grout, from dimension stone grout piles, to a crushing facility. Martin Marietta Aggregates (prior to 2001, Meridian Aggregates Company), located half a mile north of Quarry Park in the city of Waite Park, is just such an operation. The company's Rainbow Quarry operation is located just north and across County Road 137 from Quarry Park. To make crushing rock into aggregate an economical endeavor, it helps to have access to a rail line, and one needs to crush a *lot* of rock! Trains with fifty to fifty-five air dump (ballast) cars are a common sight coming out of the Martin Marietta plant in Waite Park. Keep in mind, every train ballast car carries the equivalent of five semi-trailer truckloads of rock! In the aggregate business, volume and the ability to move that volume is the key to success. Mike Reinert, from Martin Marietta Aggregates, pointed out that some of their plants with access to river barges are able to move product even more economically than product that's moved by train. It all depends on where the various quarries are located, where the product is headed, and what means are available to move large quantities of crushed rock.

Back to Quarry Park . . . Once the quarrying of granite had ceased and ground water was no longer being pumped from the "quarry hole," water would seep into the hole and fill it to whatever the water table (level) happened to be in that area. Voila! Unique and pristine swimming holes with crystal clean groundwater were ready for swimmers to enjoy on hot summer days. Once a pit was abandoned, it didn't take long for that hole to fill with water. Martin Marietta's Mike Reinert gave an example. In the fall of 2008, they quit pumping water out of one of their quarry operations that was ready to be abandoned. Less than two years later, water had completely filled a 250-foot-deep quarry hole! The water table and amount of groundwater in a particular area, as well as annual rainfall, all play a part in how quickly a quarry will fill and how deep the quarry will be from one year to the next.

How clean are these waters? Having tested the water from my own quarry property, I know the water was described by the testing agency as "almost drinkable" and certainly safe for swimming. Clarity tests, known as secchi disk readings, in the first years of Quarry Park, indicated that the water quality was high and similar in clarity to Lake Superior!

Since the 1860s, quarrying granite has played a significant role in Central Minnesota's economy. Cold Spring Granite Company alone currently employs over 700 people in Central Minnesota and an additional 200 across North America. Cold Spring Granite purchased Melrose Manufacturing Company (formerly known as Melrose Granite Company), including the property known as "Hundred Acres Quarry," in 1959. In 1961, they established "Royal Melrose" as their branded monument division. Cold Spring has been a national and international leader in the granite industry for decades. They did very little quarrying at the "Hundred Acres" site, but by purchasing it and other quarry properties in Central Minnesota, Cold Spring Granite set the stage for what ultimately would become Quarry Park and Nature Preserve. Quarry Park, through its educational displays and future interpretive center, plays a unique role in preserving the history of the Central Minnesota granite industry for future generations to appreciate and enjoy.

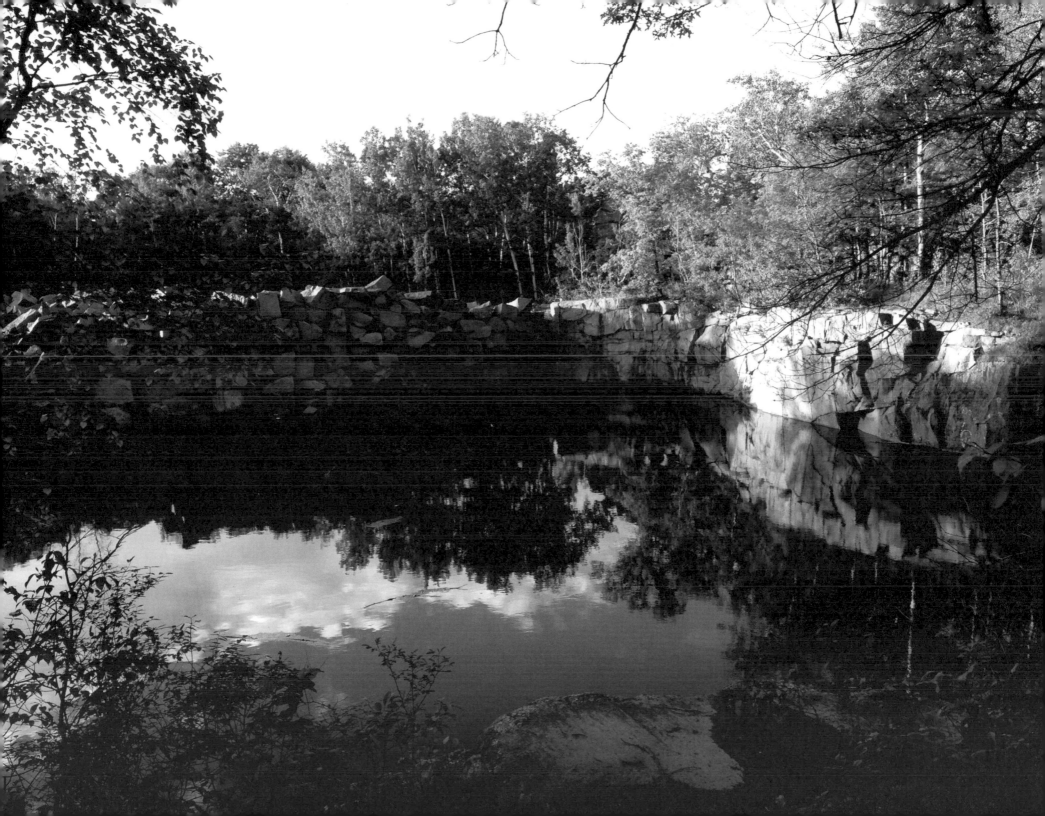

'HER

cloudiness,
and Tues-
night 5-10,
20-25. Sun
sun rises

The St. Cloud Daily Times

UPI Telephoto and UPI
Wire News Service
Los Angeles Times/Washington
Post News Service
Central Minnesota Pictures
See It First In The Times

No. 219 ST. CLOUD, MINNESOTA, 56301, MONDAY, FEBRUARY 27, 1967 28 Pages 7 Cents Delivered to your home 30c Per Week

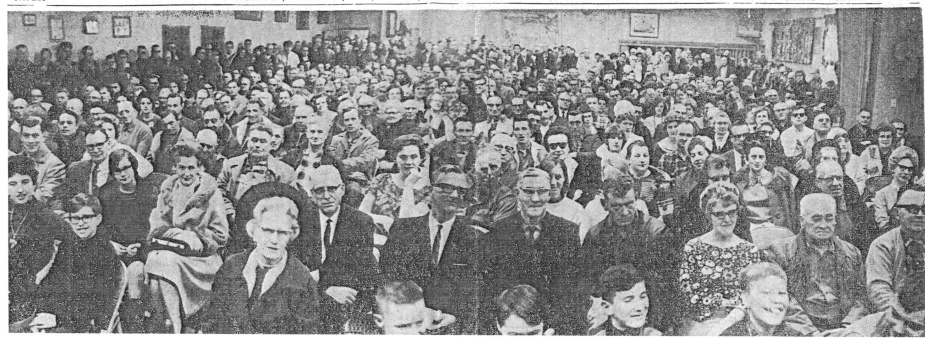

Record Crowd A standing-room-only crowd—called a record for Moose Lodge Hall in Waite Park—jammed the hearing (above) Saturday when state officials spoke on the controversial state park proposed for Stearns County. The crowd, heavily weighted against the plan, broke into applause when Rep. B. J. Brinkman, Richmond, said he opposed it. There wasn't even room for the Stearns County commissioners. Three of them (below) took refuge on a chair rack (left to right) Commissioners Edward Vos, Keith Maurer and Math Klassen, joining Edward O'Connell, chairman of the Stearns County Park Commision which proposed the park in the Avon Hills area. Commissioner Edward Emmel didn't fare that well. He had to join the standees along the walls. (Times photos)

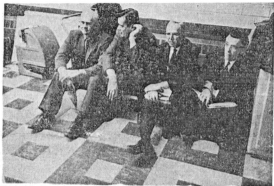

Brinkman Opposition Dims Prospects for State Park

WAITE PARK — Rep. B. J. Brinkman, Richmond Liberal, said Saturday he was strongly opposed to the controversial state park proposed south of Avon as long as "so many constituents were against it."

Brinkman's stand came as a surprise to most state park advocates including Sen. Henry Harren, Albany, who was expected to introduce the park bill later this session.

Harren said he had hoped to have Brinkman introduce the counterpart of the bill in the House of Representatives. Brinkman's stand against the proposed park drew an ovation from a large percentage of the more than 600 people who jammed the Moose Hall here for the public hearing on the park.

Brinkman, a representative from the 26th legislative district which encompasses a good share of Collegeville Township — a site selected by the Stearns County Park Commission as the most desirable site for a state park — said he did not expect a park bill to be introduced during the session and added he would vote against the bill if introduced.

Several parks officials including Y. W. Hella, state parks commissioner, attended the meeting to clear up apparent misinformation received by residents of Big Fish and Watab Lakes.

Lawrence M. Hall, St. Cloud, former speaker of the House of Representatives, acted as moderator for the meeting.

Brinkman in voicing his opposition to the proposed park said "The state park is the biggest issue before Stearns County residents in history. There is no land available (because of sentiment against the park by residents of the area) at any price.

"I'm suggesting we move the park to another area and if I'm wrong, prove to me I'm wrong."

Because of taxes lost to the county (one official estimated $14,000 a year), Brinkman — with tongue-in-cheek — suggested industry should be requested in Collegeville Township rather than a state park.

After the meeting, Harren conceded he was hoping Brinkman would introduce the bill on the House floor, but said he had no comment on what one official called Brinkman's "about face."

Another issue which appeared of great concern to residents was the possible condemnation of land should the legislature approve of the state park in Stearns County.

"The state legislature is very reluctant to grant condemnation for recreation facilities including a state park," Harren said, "In fact, during the last 12 years we have condemned land for park space only six times."

He said he would not include an eminent domain (condemnation) clause in the state park bill he hopes to introduce.

However, someone from the floor indicated, the state might condemn 100-feet right-of-way on County Aid Road 9 which would be needed as an access route from Interstate 94 into the park.

Several officials nodded but did not elaborate.

Harren, who is chairman of the Resources Committee, said the greatest recreation problem before the legislature was the location of state parks.

He said a sampling of opinion — such as Saturday's meeting — was the criteria lawmakers would rely on before making a decision.

"We have to go back to the legislature and tell them the people either want or don't want a state park in this area," he said. "We have to think about the future and a greater portion of the people in the state as well as this area; we just can't think of a few people. There has to be some sacrifices on both sides of the question."

At a Stearns County Commissioner's meeting earlier this month, Edward Vos, Albany, See Page 2 No. 4

Chapter 2

Death, Taxes, and Cold Spring Granite Doesn't Sell Property

GENESIS

THE CONCEPT OF CONVERTING abandoned granite quarries in the St. Cloud area into a state or regional park surfaced as early as the 1960s, when the State of Minnesota conducted a study of potential new state park sites throughout the state. That study, done with input from the National Park Service, was ultimately approved by the state legislature along with funding for thirteen new state parks, including Lake Maria, Glacial Lakes, Big Stone, and Banning state parks. Quarry Park, however, was not on the list or seriously considered at the time. A state park in the Collegeville Hills/Watab Lake area of Stearns County was proposed, but opposition expressed by State Representative B.J. Brinkman and the public at a hearing on Saturday, February 25, 1967, killed that initiative.

Chuck Wocken, Stearns County Parks director, who worked for Stearns County in various capacities from 1975 to 2013, remembers seeing a correspondence from the early 1970s between Ken Hopke, Stearns County Planning director at the time, and the State of Minnesota regarding the possibility of establishing a granite quarry park in Central Minnesota. Someone, perhaps a county commissioner, suggested that Ken contact the state and resurrect the idea of establishing a quarry park. The Department of Natural Resources's response at that time was not encouraging. The letter basically said a "quarry park" would not be large enough for a state park and the liability issues were off the charts. It was a nice idea but they were not interested in it as a state park. In short, thanks but no thanks. And that's where the dream sat, on the shelf, for over fifteen years.

But Ken Hopke and Chuck Wocken, much to their credit, kept the dream alive by including the possibility of a quarry park in the 1989 update to the recreation section of the Stearns County Comprehensive Plan. In preparation for that comprehensive plan update, Wocken and Hopke presented to the Board of

Stearns County Commissioners an exceptionally thorough document entitled "Stearns County Recreation Plan Research Data," which was adopted by the board on July 7, 1987.

In that document, the state of Minnesota is quoted as being in support of quarries as potential recreation sites. In other words, the state wasn't opposed to seeing a quarry park developed at the county or city level, they just didn't envision abandoned quarries becoming a state park:

Because of their uniqueness and location near urban populations, quarries and surrounding land provide an opportunity to create historical, cultural and recreational facilities on former quarry sites. A study conducted in 1966 by the state, stated, "these areas represent potential recreation sites and should not be overlooked in considering any long range recreation plan." Increasing urbanization in St. Cloud Township warrants investigation of these areas as potential sites.

The Wocken/Hopke research data went on to say:

There are twenty-six, active and inactive, granite quarries located in four eastern townships:

TOWNSHIP	NO. OF QUARRIES	ESTIMATED ACRES
1. Rockville	2	21
2. St. Joseph	2	33
3. Wakefield	2	16
4. St. Cloud*	22	366
TOTAL	28	436

St. Cloud Township ceased to exist as a governmental unit after merging with the Cities of St. Cloud and Waite Park on December 30, 1995. Most of the twenty-two quarries indicated are now located in Quarry Park within the city of Waite Park.

Stearns County's first comprehensive plan was completed in 1970. The County Park Commission by laws state that everything the Park Commission recommends to the County Planning Advisory Commission or the County Board must be ". . . In conjunction with the Stearns County Comprehensive Plan." In other words, the park department had a vested interest in working to keep the comprehensive plan fresh and relevant. Hopke was the first planning director the county had. He came to Stearns County in the early days of shore land management legislation. Ken Hopke was an economist, and a graduate from St. Cloud State University. Chuck Wocken remembers Ken as "a great person, terrific personality and knowledgeable historian for Stearns County. No one could work an outline or a plan like Ken. The guy was an artist in planning." Ken knew the importance of gathering public input and building support for a project like Quarry Park. After all, he had seen the effects of the "not in my backyard" mentality that doomed the dream of a state park in the Collegeville Hills/Watab Lake area of Stearns County. Ken Hopke and Chuck Wocken made a great team.

The May 11, 1988, preliminary draft of an updated Stearns County Recreation Plan stated that "New county park sites (should) include a granite quarry lake near Waite Park" in eastern Stearns County (the most densely populated portion of the county). The final draft of the plan approved by the County Board on May 16, 1989, states:

New Facilities–County Parks

Granite Quarry Lake: One of the best opportunities to provide water-based recreational areas near the bulk of the county residents is in the reclamation of a granite quarry as a park. Through adequate planning, a quarry park could be provided near Waite Park and St. Cloud. Such a park could provide facilities for swimming, fishing, non-motorized boating, picnicking, walking/skiing trails, formal gardens, and granite industry interpretive center.

The County's Recreation Plan is part of a larger planning document. With the passage of the May 16, 1989, updated Recreation Plan, Stearns County now had a comprehensive plan that specifically highlighted the desirability of transforming and reclaiming abandoned granite quarries for recreational purposes. Official plans are important because they can lead to action, funding, and real results!

Generally, when Stearns County needs property for park purposes, the county only deals with willing sellers. Meridian Aggregates Company, for example, might have been willing to sell some its property for a park, but it looked like they would be in operation for decades or longer before such a possibility could come to fruition. What other game in town was there? Everyone knew that Cold Spring Granite owned some old quarries. But, as Chuck Wocken was fond of saying, "There are only three things in Stearns County that you can count on: death, taxes, and Cold Spring Granite does not sell property. You can count on that." Chuck learned that the hard way a few years before, when he tried to lease forty acres from Cold Spring Granite in Rockville for a canoe access on the Sauk River. They would have nothing to do with it because it might impair the future potential for that site. Stearns County park staff didn't know of any options other than a future abandonment of the Meridian Aggregates quarry. The Park Department had a concept and a strategic plan that needed a magic wand!

One day in 1990, Bill Fahrney from the St. Cloud Area Economic Development Partnership stopped into Wocken's office and said, "Chuck, we've got an economic development idea here for turning some of these ugly rock piles littering the landscape in the St. Cloud area into jobs. We have to know who is going to own the property before we start any sort of a project."

Chuck asked, "What property are you talking about?"

Bill said the old Hundred Acres quarry site in St. Cloud Township. Chuck laughed at him and said, "Death, taxes, and Cold Spring Granite doesn't sell property are three things you can count on in Stearns County."

Bill said, "No, it's for sale."

Wocken replied, "No, Bill, it's not for sale. They don't sell property. They don't even lease property."

Fahrney said, "No, it's for sale. I was just talking to the mining manager over at Meridian Aggregate, and he said Cold Spring has it up for sale. I'm going to put a meeting together. Will you come with me to Cold Spring Granite headquarters if I can set up a meeting?"

Chuck said, "Sure, I'd be glad to come."

Bill Fahrney's vision, from his jobs-creation point of view, was to take these rock piles and crush them, "beautifying" the landscape by getting rid of all these grout piles and creating a usable product. The idea was to have Meridian Aggregate move the rocks to their primary crusher or crush them on site. To some, these piles of waste rock represented a resource. The downside was that the grout piles could contain steel drilling rods that might clog up a mining company's multi-million-dollar crushers. In addition, equipment was at risk taking grout piles apart, due to instability created by removing rock from the bottom of the grout pile.

When I purchased my quarry in Waite Park in 1974, I asked one of the granite companies if they would be interested in crushing my granite, taking some of the rock off the land, if I decided to sell some of the grout piles. The answer was, "No, it's less expensive and safer to blast new rock than to try to load and transport old grout to a crusher."

Clearly, in 1974, the time had not yet come to economically crush and "recycle" granite grout piles. Fortunately, from a park perspective, some of those little mountains of waste rock will "litter" the landscape of Central Minnesota forever!

Bill Fahrney called Chuck, saying a meeting had been arranged and was taking place at Cold Spring Granite headquarters (which at that time was located in the Carlson Towers in Minnetonka, Minnesota). Bill also invited the economic development director for the county, Bob Swanberg, and Marlyn Libbesmeier, the chairman of St. Cloud Township, to go along. The four drove down to visit Cold Spring Granite Vice-Presidents George

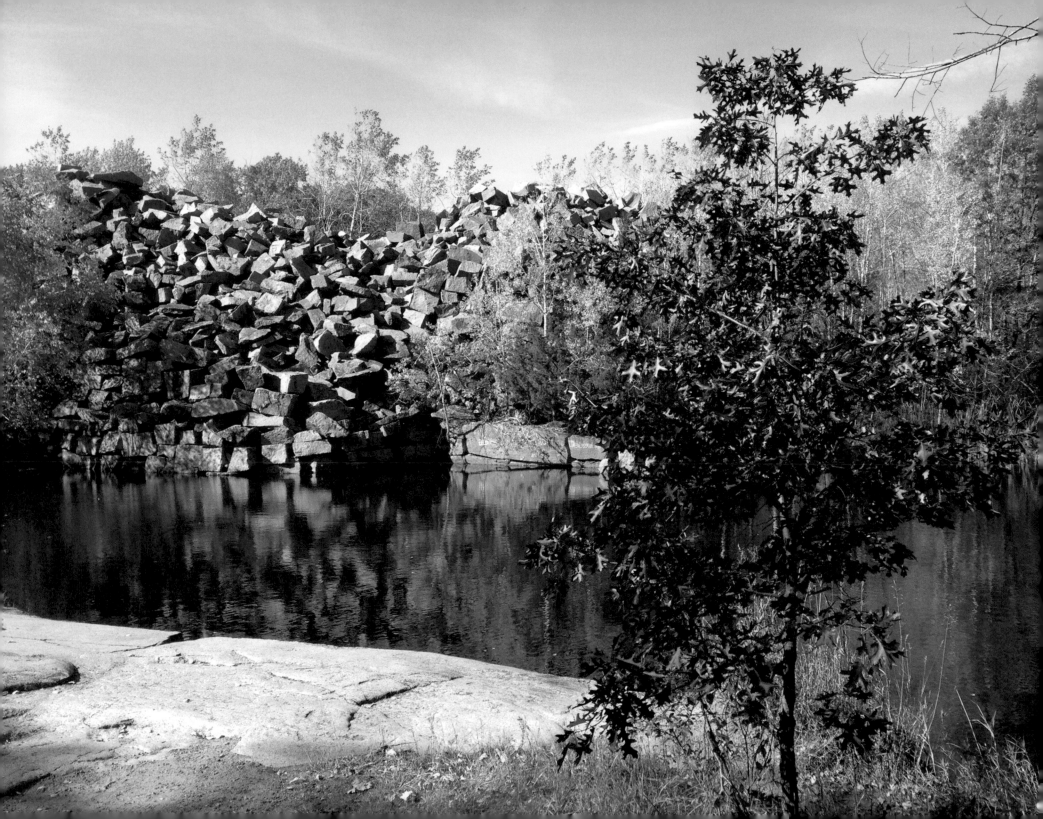

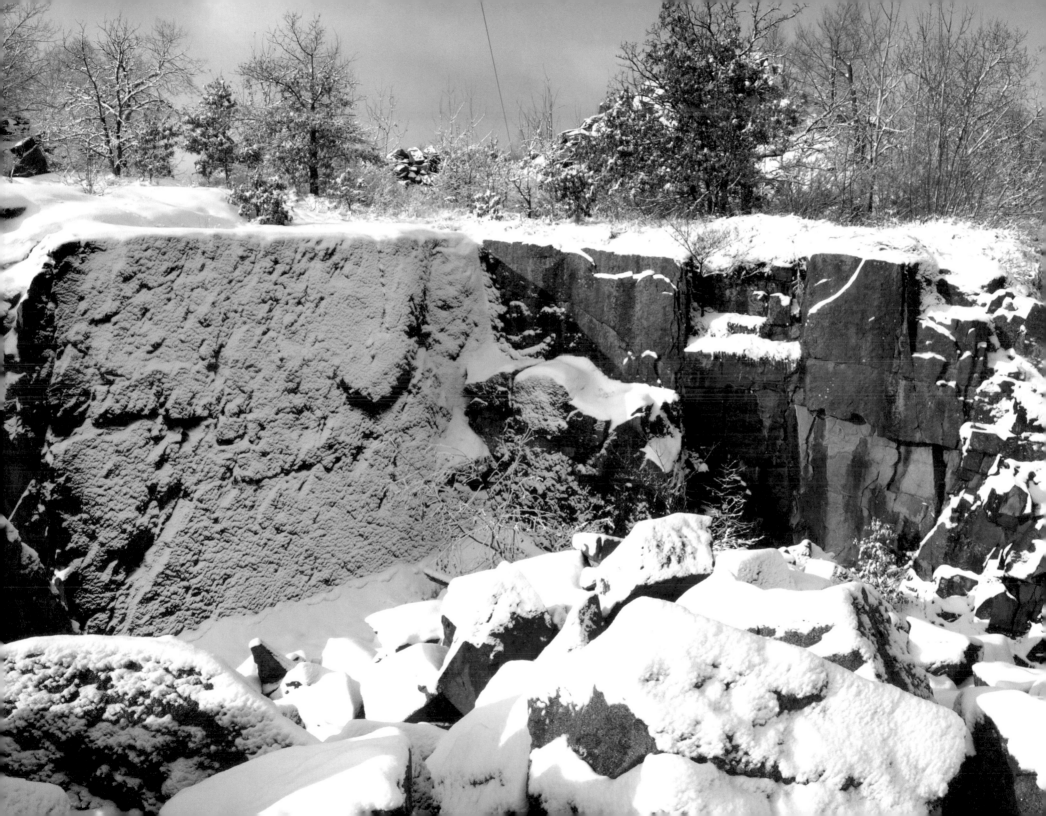

Schnepf and Marshall Johnson. Although Pat Alexander, president of Cold Spring Granite, wasn't at this particular meeting, he ultimately was the one who approved the sale of the property. Wocken made sure to take the county's comprehensive plan along in a file folder just to show there was indeed some interest in the county creating a quarry park.

Cold Spring Granite Vice-President Marshall Johnson said, "Yes, we have five parcels. We had fifty recommended for sale, but only five are available for sale at this time."

Chuck remembers trying to calm his heart palpitations because this was sounding too good to be true—a willing seller with a 220-acre site, with twenty abandoned quarries in it, and a site that' had unofficially been used for recreation by the St. Cloud area for decades! Yes, area residents treated it like park land for years, but it was privately owned.

People were fishing, snowmobiling, mountain biking and camping out at "Hundred Acres Quarries" for decades. Infamous quarry "beer busts" took place out there for years. Some magazine even published a list of "Nude Beaches in the USA," and the quarries were featured in that directory! But, truth be told, most swimmers kept their pants on and the beer parties were pretty tame. It was a place where people already went swimming. Many folks learned to swim at the quarries. It matched culturally. The county had a willing seller, so Chuck slid the Stearns County Comprehensive Plan over to the Cold Spring executives and indicated to them, "We are interested in talking to you. They continuted that Stearns County would like to provide a quarry lake park in the St. Cloud area. The Cold Spring folks said, "Well, that's interesting." Finally someone asked the big question: "How much is it for sale for?" They said $240,000 for 220 acres, roughly $1,090 per acre. With Stearns County's interest in this property for a park, the St. Cloud Area Economic Development idea to crush the grout piles at the "Hundred Acres" site was, thankfully, put on hold. Cold Spring Granite graciously took the property off the market and held it until the wheels of local government could begin to turn at Stearns County!

STATE REPRESENTATIVE BERNIE OMANN DELIVERS A MUCH NEEDED "EARMARK"

Now the county had a willing seller, but no money. A few weeks later, Wocken got a jaw-dropping call from the county administrator, George Rindelaub, saying that one of our local legislators, Bernie Omann, asked what the county could do with one-quarter of a million dollars. Bernie was a member of the Appropriations subcommittee of the Environment and Natural Resources Committee and was in a position to influence the 1991 appropriations bill. Bernie did a little "horse trading" and came up with $250,000 for Stearns County parks! Representative Omann discussed with Parks Director Wocken the possibility of putting the dollars toward improvements at Mississippi River Park, which happened to be located in Bernie's legislative district. But Chuck had a few other needs he felt took priority.

Wocken and the county staff were beside themselves. How to best spend $250,000? Chuck, not wanting to appear too presumptuous, said, "We could use it for a geological atlas for the county, or a biological inventory by the DNR's County Biological Survey (which would be useful for overall planning), or we could buy granite quarry land for a park!"

Wocken shared the unique opportunity that was taking shape with Cold Spring Granite, and Bernie quickly agreed that purchasing land to create a quarry park would be a tremendous use of the dollars. That's what happened. The state appropriated $250,000, and now Stearns County had a willing seller and one-quarter million dollars. What's the likelihood of that ever happening again? Many are convinced it will never happen again. But for this particular park, the stars were indeed beginning to align!

"Hundred Acres Quarry," with its twenty pools, acres of prairie and oak savannah, and magnificent wetlands, represented a park opportunity with acreage incomparable to any other quarry property available. The Meridian Aggregate site (formerly the J.L. Shiely site) held the promise of adding a large body of water, but it would be just that, mostly water. With

the Meridian Aggregate site, what would park visitors do in the winter? Cold Spring Granite's "Hundred Acres Quarry" site allowed more than just aquatic recreation. This gave the Park Department year-round capability. The rock piles that some considered "an eye sore" represented beautiful little mountains for those with eyes to see . . . a "mini version" of the Black Hills or the Boundary Waters, right off the bus routes, right here in St. Cloud!

Park Director Chuck Wocken and now-retired Planning Director Ken Hopke reviewed the history, land value, and recreation potential of all the properties under consideration. Both agreed the clear choice was to go with the Cold Spring Granite "Hundred Acres" site, and so Chuck Wocken recommended that to the County Board of Commissioners.

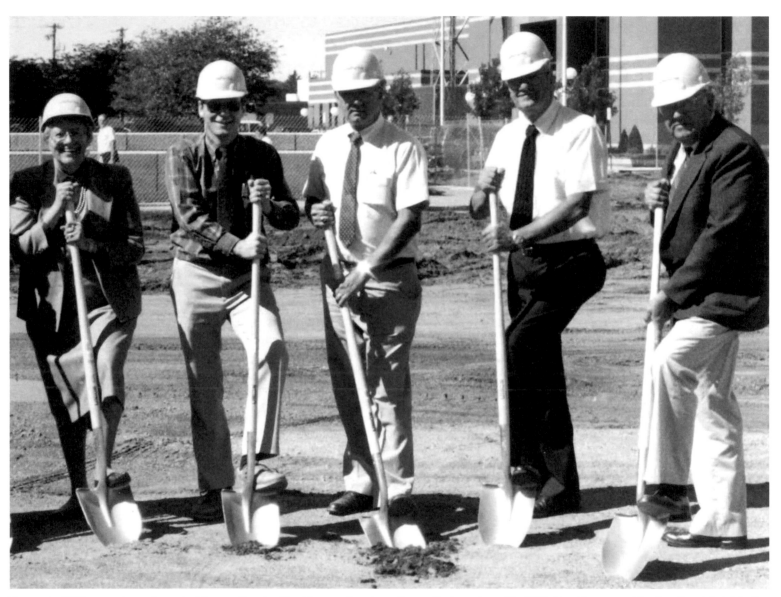

The early 1990s were busy times in Stearns County. The Stearns County Board broke ground for the new County Administration Center on September 5, 1989, and approved the purchase of property from Cold Spring Granite for Quarry Park on June 23, 1992. Breaking ground for the New Administration Center are, left to right: Commissioners Rose Arnold, Mark Sakry, Bob Wensman, Keith Maurer, and Bob Gambrino. (Courtesy of Stearns County)

Chapter 3

Right Place at the Right Time

COUNTY COMMISSIONERS ARE FOND of saying that "As a commissioner, you need at least two friends to get anything done." In other words, on a five-person county board, you need a majority of three votes to pass a motion. Compared to the state house with 134 representatives, or Congress with 435 house members, county commissioners have pretty good odds of affecting change by passing motions, ordinances, policies, or setting budget priorities, such as local funding for county parks.

However, even on a five-member board, reaching consensus is often difficult. Commissioners Bob Gambrino and Rose Arnold, for example, were eventually strong supporters of funding for Quarry Park, but in the early days even they needed a lot of convincing. On Tuesday, March 26, 1991, Parks Director Chuck Wocken brought the possibility of purchasing Cold Spring Granite's "Hundred Acres" site to the Stearns County Board of Commissioners. I had a difficult time containing my excitement for this project. A March 27, 1991, *St. Cloud Times* article documented Commissioner Gambrino and Commissioner Arnold's concerns: ". . . Rock piles left near the quarries at the Cold Spring Granite site could create a hazard and liability problems for the county, cautioned commissioner Bob Gambrino." "County residents may question the county's willingness to pay for a park in the midst of budget troubles, said board chairwoman Rose Arnold. 'There is no money for this in our budget.'"

At the March 26, 1991, meeting, I tried every argument I could think of to keep the potential purchase of the Cold Spring property alive;

100 Acres Quarry may become park

By ROXI REJALI
Times Staff Writer

Stearns County will look into the possibility of converting an abandoned granite quarry, southwest of Waite Park into a recreational lake.

And due to recent budget belt tightening, the county may try to raise private donations to buy the property.

The proposed site, known as 100 Acres Quarry, is a popular site for swimming and beer parties.

Commissioners directed county parks director Chuck Wocken Tuesday to investigate the possibility of reclaiming the quarry. They also instructed him to investigate other quarry sites around the county that might be available in the future.

Cold Spring Granite Co. is offering a 220-acre parcel for sale near Stearns County Road 137, Wocken said. Appraised value is $250,000.

One hundred acres is the minimum recommended size for Stearns County parks, he said.

"We're looking, we've got a site available and it's kind of triggering the process," he said.

A county recreation plan adopted in 1989 includes a granite quarry lake in the St. Cloud area. The county park system doesn't include a quarry lake.

The park could be used for swimming, fishing, non-motorized boating, walking or cross-country skiing trails and a granite industry interpretive center.

The Cold Spring Granite site includes 18 quarries ranging in size from 2 acres to a fraction of an acre. Quarry depths range from 99 feet to shallow. Rock piles up to 50 feet high stand near the quarries.

The parcel also includes 20 acres of meadow and 5 acres of marshland.

However, rock piles left near the quarries at the Cold Spring Granite site could create a hazard and liability problems for the county, cautioned commissioner Bob Gambrino.

County residents may question the county's willingness to pay for a park in the midst of budget troubles, said board chairwoman Rose Arnold. "There is no money for this in our budget."

The county recently cut about $243,000 from this year's spending to balance state budget cutbacks. Larger cuts are expected in the next round of budget cuts from the Legislature.

The county could try to raise private donations to buy the property, said commissioner Mark Sakry.

The county could decide to buy the whole parcel and sell parts of it to private developers, he said.

Another possible site for the park is an active quarry near Waite Park owned by Meridian Aggregates Co., Wocken said.

Used with permission of the *St. Cloud Times*.

Quarries long overdue for park designation

There are few places like our granite quarries in the world. I've been waiting and wondering when our Stearns County and St. Cloud Park and Recreation department would see that this could be one of the best nature parks in the state.

They're remote, beautiful and yes, can be a little dangerous for the careless. The water is clean and is one of the best swimming and diving areas around. Whether for recreational swimming or nature walking, the quarries are unequalled in their beauty and serenity.

My recreational use of the quarries started in the early '60s and I visit them at least once a week through the summer months and sometimes through the winter. As youngsters, we were sometimes swimming every day. A winter walk through the quarry woods will reveal to you central Minnesota's wild beauty at its best.

When visitors, especially college students, ask me what there is to see and do in St. Cloud, I like to show them our quarry areas. It would be hard to find a better place to swim, study or to just lay and listen to the wildlife around you.

The quarries have been virtually unchanged over the years since they were abandoned. The best nature/wildlife classroom for our students in schools is in our own backyard.

If we pass up this opportunity to purchase the 100 Acres Quarry it will probably soon become another community of private homes. We will lose all access to it and it will only be a memory of what was.

I am asking ... commissioners of the county parks to purchase *all* of the quarry site. The funds and citizen interest *are* out there. The price is not insurmountable. ...

I am asking that all of you "quarry people," ..., swimmers and nature walkers alike who have enjoyed the quarries and want to help take part in preserving them to call commissioners and let them know how you feel. ...

Lastly, if this park does become a reality, let's hope they don't turn it into a paved parking lot with a lot of fences. Keep it as it is! Upkeep should be little to nothing. If we put some good heads together, liability can be worked out. There are many safe high diving areas. I'm sure many people would be willing to help.

Let's get on the phone, people; we're going to need your help!

Ed Burns
St. Cloud

Letter to the editor in the April 5, 1991, edition of the *St. Cloud Times*. (Used with permission)

"The county could try to raise private donations to buy the property, said commissioner Mark Sakry." And then I added, in what admittedly was a rather "half-baked" idea, "The county could decide to buy the whole parcel and sell parts of it to private developers (to recoup county costs)." Park Director Chuck Wocken pointed out that, "Another possible site for the park is an active quarry near Waite Park owned by Meridian Aggregates Company." Obviously, in these early discussions, there was interest in creating a quarry park, but where and exactly how big the park should be were issues still very much up in the air. It helped that County Administrator George Rindelaub could see the potential for a major new county park right in the metro area. And in the years that followed, George's support for county bonding for park purposes played a key role in helping Quarry Park ultimately grow to nearly 700 acres. Wocken presented the availability of the Hundred Acres Quarry site to the Stearns County Park Commission on March 13, 1991, just two weeks before bringing the issue to the County Board. In most cases park initiatives get discussed at the Park Commission prior to being sent to the County Board of Commissioners. That was true in case of Quarry Park as well.

Fortunately, the county board did give Chuck Wocken the green light to "investigate the possibility" of reclaiming for park purposes the Cold Spring Granite property known as "Hundred Acres Quarry." At the March 26, 1991, County Board Meeting, we also instructed him to investigate other quarry sites around the county that might be available in the future. It's always better to proceed with some "baby steps" on such issues rather than not proceeding at all. Most issues in government at all levels tend to move at a glacial pace, and because of all that due diligence, golden opportunities are often lost to the private sector, which generally can react more quickly. Fortunately, in the case of the "Hundred Acres" Cold Spring Granite site, there was a genuine interest on the part of several members of the Alexander family, the founders of Cold Spring Granite, that this land should become a park someday. In addition, public support for establishing a quarry park began to percolate, as evidenced in a letter to the editor submitted by St. Cloud resident Ed Burns that appeared in the April 5, 1991, edition of the *St. Cloud Times*. Burns issued a call to arms for "quarry people" to contact their county commissioners in support of establishing a quarry park!

In my July 2011, taped interview with Park Director Chuck Wocken, in preparation for this book, Chuck recalled his thoughts regarding Cold Spring Granite and that important March 26, 1991, County Board Meeting:

Mark, we went along on a handshake and a promise for two years with Cold Spring Granite! It took the county that long to get the funding nailed down and to fully examine the property for any environmental hazards and liability concerns.

Yes, park staff went to the County Board on March 26, 1991, and here comes a big coincidence. When would you ever expect to go to a county board proposing to buy 220 acres that have twenty abandoned quarries, used for swimming and recreation? What are

the chances that the vice chair of the board loves quarries and actually lives on a granite quarry near the place that's being proposed for the park? You were just totally in favor of the idea. No one could plan this! (Laughter) I really feel that we had a bit of divine providence in play on this whole thing . . . the right people were in the right place at the right time to make this happen. Maybe divine providence had a role in other county park projects as well. How did we ever get to the point of having 2,600 acres of outdoor recreation land in Stearns County, a place that was traditionally very conservative, agriculturally oriented. How did that happen? Now the soon-to-be chair of the County Board, you, Mark Sakry, who lives on a granite quarry that you bought when you were practically just a kid, were in a position to make Quarry Park happen!

Actually, I was twenty-one years old when I purchased 9.5 acres of quarry property for my future home for just $5,500 in 1974. You might say I was in the right place at the right time for that opportunity as well.

With approval by the County Board to explore the county's options, the wheels were now in motion regarding the "Hundred Acres" site. But County Board members and Park Department staff needed to complete a period of "due diligence" before any purchase agreement would even be considered, let alone approved and signed.

A WALK IN THE PARK

IN PREPARATION FOR the March 26 board meeting and in response to the Park Commission's interest in the property, Chuck Wocken wrote to Marshall Johnson, executive vice-president of Cold Spring Granite, on March 15, 1991, requesting a tour of the "Hundred Acres" site.

Commissioner Rose Arnold and I joined Scott Rinn and his wife, Rosemarie (Alexander) Rinn, on April 10, 1991, along with Chuck Wocken and Don Sieger, a Cold Spring Granite mining operations engineer, for a wonderful "walk in the park." It was a chance to do a little visioning of what the park might eventually look like. Scott and Rosemarie Rinn liked the idea of an amphitheater for outdoor concerts, or some other arts focus to this park.

Chuck suggested the possibility of the park providing an outdoor venue for various concerts or an annual festival. Tanglewood, for example, a festival venue in Lenox, Massachusetts, hosts a major annual outdoor jazz festival in addition to other community events. (It's also the summer home for the Boston Symphony Orchestra.)

Those of us on the walking tour also liked the possibility of one day building an interpretive center at the park to focus on the local history of the granite industry. St. Cloud was known for decades as the "Nitty Gritty Granite City." Why not preserve for future generations a working quarry, demonstrating how granite quarrying was done in the early days? After all, as Chuck pointed out, if the Minnesota Iron Range can preserve its rich history with a little help from the State of Minnesota, why not a similar effort in Central Minnesota to promote tourism and a celebration of this important industry?

Another interesting proposal for an abandoned quarry in the Waite Park area (not necessarily the Hundred Acres site) was put forth some years earlier by Reverend Mo Stevens, a local pastor at First Presbyterian Church of St. Cloud. Pastor Stevens suggested a bible garden in a quarry setting with granite sculptures. The feasibility study showed that with Minnesota's long, cold winters, it might be too limited a season for such a project to pay for itself. In other words, a bible garden was more likely to succeed in the southern United States with the potential for year-round visitors and year-round revenue. (One can assume year-round religion would also add to the economic success of such a venture!)

The walking tour of the Hundred Acres site was a success! Scott and Rosemarie Rinn supported the idea of selling the property for a county park. Commissioner Rose Arnold, board chair at the time, began to see

In the Stearns County Board Room in 1994. This group of county commissioners served from 1991 to 1998, critical years in the development of Quarry Park and Nature Preserve. Left to right: Mark Sakry, Rose Arnold, Bob Gambrino, Leigh Lenzmeier, and Henry Dickhaus. (Courtesy of Stearns County)

great potential for the project. Chuck Wocken and I were totally convinced the Hundred Acres property, and all the rare beauty it offered, should be preserved for future generations. Most important, Pat Alexander, CEO and chairman of Cold Spring Granite, ultimately approved the sale of the property at the $240,000 price that had been discussed, along with an in-kind donation of $130,000 in land value, based on an independent appraisal of the 219-acre parcel.

DESTINY . . . IN SPITE OF LIABILITY CONCERNS

PARK STAFF MADE A COMPELLING argument to the County Board that Stearns County should be interested in the park. They presented the comprehensive plan and the Park Commission bylaws. Everything was in sync with the com-

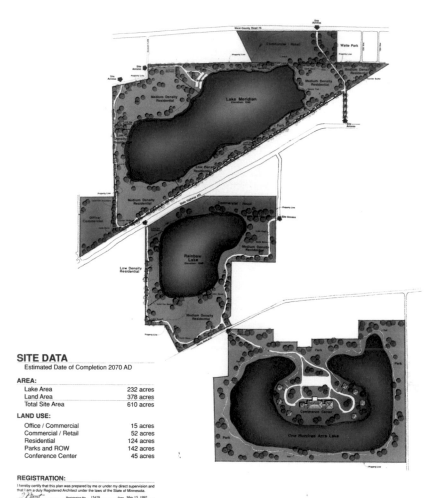

SITE DATA
Estimated Date of Completion 2070 AD

AREA:

Lake Area	232 acres
Land Area	378 acres
Total Site Area	610 acres

LAND USE:

Office / Commercial	15 acres
Commercial / Retail	52 acres
Residential	124 acres
Parks and ROW	142 acres
Conference Center	45 acres

REGISTRATION:
I hereby certify that this plan was prepared by me or under my direct supervision and that I am a duly Registered Architect under the laws of the State of Minnesota.
Registration No. 15429 Date May 13, 1992

MERIDIAN AGGREGATE QUARRY RECLAMATION
ST. CLOUD, MINNESOTA

STUDIO FIVE ARCHITECTS
Studio Five Architects
1170 Ford Center
420 North 5th Street
Minneapolis, MN 55401
612-339-0605

Used with permission.

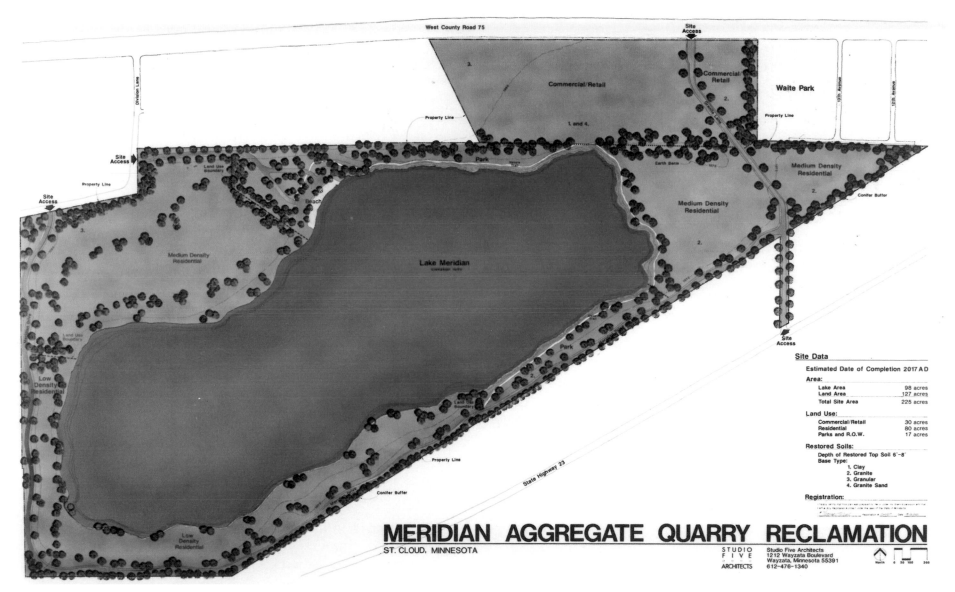

West County Road 75

Site Access

3.

Commercial/Retail

Commercial/Retail

Waite Park

12th Avenue

13th Avenue

Property Line

2.

1. and 4.

Property Line

Division Lane

Site Access

Property Line

Land Use Boundary

Park

Earth Berm

Medium Density Residential

Site Access

Property Line

Beach

Medium Density Residential

Conifer Buffer

3.

Medium Density Residential

Land Use Boundary

Lake Meridian

2.

2.

Low Density Residential

Park

2.

Land Use Boundary

Property Line

Conifer Buffer

Low Density Residential

State Highway 23

Site Data

Estimated Date of Completion 2017 A.D.

Area:

Lake Area	98 acres
Land Area	127 acres
Total Site Area	225 acres

Land Use:

Commercial/Retail	30 acres
Residential	80 acres
Parks and R.O.W.	17 acres

Restored Soils:

Depth of Restored Top Soil 6'-8'
Base Type:
1. Clay
2. Granite
3. Granular
4. Granite Sand

Registration:

MERIDIAN AGGREGATE QUARRY RECLAMATION

ST. CLOUD, MINNESOTA

STUDIO FIVE ARCHITECTS

Studio Five Architects
1212 Wayzata Boulevard
Wayzata, Minnesota 55391
612-476-1340

North 0 50 100 200

STEARNS COUNTY PARK DEPT.
425 S. 72nd AVE.
ST. CLOUD, MN 56301
(612) 255-6172

August 20, 1991

Tom Kranz
Outdoor Recreation Program
Minnesota Department of Trade and
 Economic Development
Community Development Division
900 American Center Building
150 East Kellogg Boulevard
St. Paul, Minnesota 55101-1421

RE: GRANITE QUARRY PARK ACQUISITION PROJECT

Dear Tom:

The enclosed Phase I and Phase II applications propose that Stearns County acquire property in the St. Cloud metropolitan area for a granite quarry park. The granite outcroppings of the St. Cloud/Waite Park are unique in the State of Minnesota. With their proximity to the major population of Stearns County, and the future provision of attractive bodies of water for swimming and fishing, the park(s) could yield a significant statewide tourism destination as well as needed water-based recreational facilities for the urbanized portion of Stearns County.

Three separate parcels are identified as being potentially capable of supporting recreational facilities. Appendix E indicates ownership of the parcels. Appendix G, H and I picture preliminary concepts as to how the separate parcels could be developed. Facilities are indicated for swimming, water access, fishing, picnicking, granite industry interpretation, cross-country skiing, walking trails, and camping. Because of the nature of granite quarrying, the sizes of the lakes being created and the timetable of their availability is difficult to determine. Parcel #1 is planned to contain about a 100 acre lake. Parcel #2, when mined, may have a 50 acre lake. Parcel #3 currently has eighteen quarries ranging in size from a fraction of an acre to 1.3 acres. These could be connected or enlarged.

If negotiations are unable to yield a granite quarry park suitable for public recreation, alternate parcels containing waterfrontage within the county will be examined for acquisition.

Sincerely yours,

Charles B. Wocken,
Park Director

CBW/hj

Enclosures

Park Director Chuck Wocken, at the county board's direction, examined other possible sites for a "Granite Quarry Park." In this letter to the state, Wocken refers to a reclamation plan being considered by Meridian Aggregates that would have resulted in the Cold Spring site being heavily quarried and unavailable as a park for many decades. Clearly, Quarry Park as we know it would not have become a reality. (Courtesy of the Stearns County Park Department)

prehensive plan—we had a willing seller and we had money. Whoa! It was destiny! But there were plenty of hurdles ahead. We looked at the property, and there were potentially more liability concerns on that piece of property than all the county parks in the state of Minnesota put together. Remember, we were looking at an industrial site. It was unmonitored, and had been unused since 1959. Stearns County needed to know what was buried out there. What was in those quarries? Any toxic chemicals? What glowed in the dark? Any environmental liabilities? In other words, what was the county getting into?

Stearns County conducted an environmental review in 1991-1992 and looked at almost every bump and depression in the park. The Parks Department divided the site into nine sectors, and staff and volunteers walked the various sectors and documented everything we saw that looked unusual. We actually came across some very unusual things. We came across some yellow lady slippers in the woods, and cactus and blueberries on or near granite outcroppings. We did borings next to each of the sites where there was a depression or a bump just to see what was in there. Environmental services staff studied approximately fifty locations. Staff did shovel tests, or borings, and came up with nothing, except on the north side of the property next to the old Liberty Granite Company site, which was then owned by Bob and Bernice Sis. There was a paint spill in there. The scientific guidelines that the MPCA (Minnesota Pollution Control Agency) would use suggested that we should

evacuate all residents within twenty miles! It turned out somebody just spilled some paint. Seriously, there was a pile of fifty-five-gallon drums there, so we knew we might have a larger issue to deal with. Chuck Wocken recalls, "We bartered with Bob and Bernice Sis that we would clean up the paint spill if they would give us the derrick. That's how we got the derrick. They agreed and we made the swap! The derrick would highlight some wonderful history. The whole idea of the derrick was to bring a little of the history of the granite industry to the public. Show visitors to the park how these huge chunks of granite were lifted out of the quarries for decades."

Surprisingly, given the reputation the Hundred Acres site had as unused, unmonitored and inhabited by teenagers with reckless abandon for generations, the site proved to be environmentally clean! That was not quite the case for the quarries themselves. Quarries had all sorts of objects thrown in them over the years, including a kitchen sink. Volunteers from the Underwater Sports shop organized an underwater clean-up and, using a winch to pull out the heavy items, they also found a refrigerator or two, shopping carts, a sailboat, a Laz-E-Boy recliner, couches, ice chests, and a ton of things that were most likely leftovers from beer busts. It was virtually an underwater college campus! Divers also took some valuable digital video that showed the clean water and healthy fish. That helped sell the idea of protecting these quarries for park purposes.

As part of the Park Department's due diligence, Chuck Wocken contacted several quarrying operations that were responding to a national trend promoting "reclamation for recreation." He even joined the American Society of Surface Mining and Reclamation to develop contacts with knowledge in this emerging field. Waukesha and Racine counties in Wisconsin both have quarries that have been refurbished or restored for recreation. They happened to be limestone quarries and considerably larger in surface area than those at Quarry Park, but they offered a good example what can be done to result in a win-win situation for both the mining industry and local communities.

Norman Dietrich, a registered engineer and landscape architect from Iowa State University, was also a member of the American Society of Surface Mining. Norman visited the Hundred Acres site and couldn't believe the potential for a park. He was excited, to say the least. Eventually, Mr. Dietrich interviewed with Stearns County for a possible job as a contract landscape architect for planning and designing the park, but ultimately Stearns County hired the firm of Brauer & Associates from Minneapolis. Wocken also invited a staffer from the Iron Range Resource Rehabilitation Board (IRRRB) to come down and look at the site. His reaction was, "Holy criminy, this is great! I don't know exactly how you handle the reclamation, but this has wonderful potential for a park!"

Clearly, it was time to bring in John Barrows, the loss control engineer from the Minnesota Counties Insurance Trust (MCIT). Keep in mind, Mr. Barrows represented the statewide insurance trust that underwrote the county on any lawsuit due to liability of any kind. If the trust ruled that this former industrial site was not insurable as a park, it could be the deathblow for the entire project. After spending half a day at the site and reviewing aerial photos, Chuck Wocken and John Barrows walked to the top of the rock pile just east of "Melrose Deep 7" quarry, which is now the main swimming quarry. There is a great view of the St. Cloud area from up there. Barrows took in the view and said, "You know, there's no reason that the public shouldn't be able to enjoy this view. But you've got to control the access (which means some fencing). You have to design it with safety in mind, and you have to manage it. You can't just open up and let it go."

Wocken and I were overjoyed to hear John Barrows's assessment. I had been saying for two years, during the due diligence period, "If they can open Yellowstone or Glacier National Park to the public, with all those inherent dangers and potential lawsuits, we ought to be able to open up little Quarry Park to the public!" Managing the park, enforcing rules, and posting signage to keep people off the granite grout piles were critical to

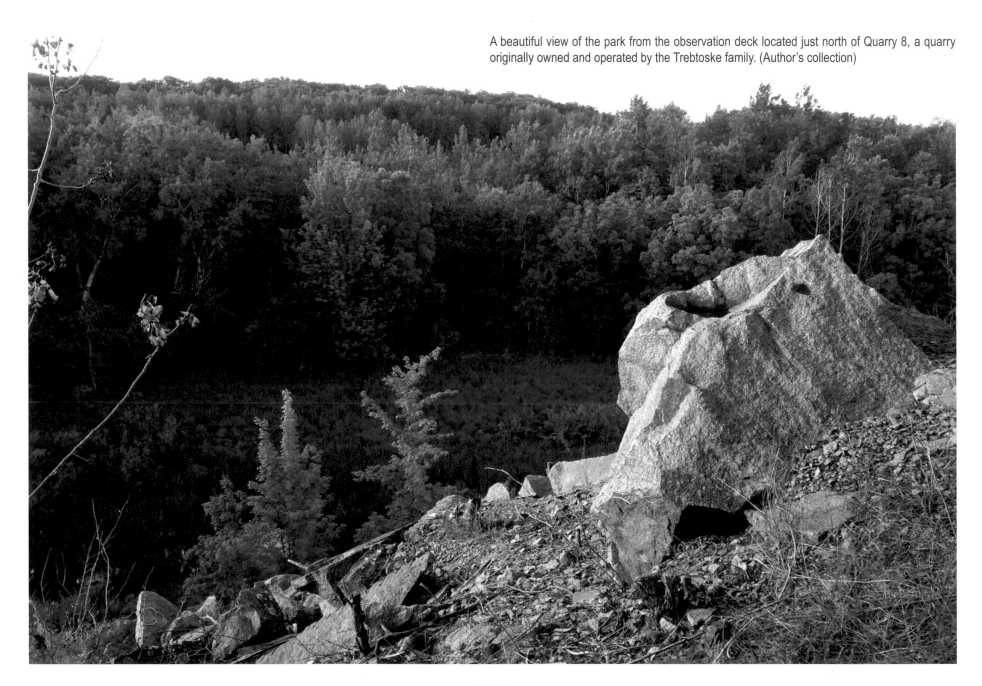

A beautiful view of the park from the observation deck located just north of Quarry 8, a quarry originally owned and operated by the Trebtoske family. (Author's collection)

In the heart of the original 210 acres of Quarry Park purchased from Cold Spring Granite lies a magnificent prairie and wetland. Here visitors to the park take in the sights and sounds of that unique environment in the summer, including croaking frogs and toads, water birds, and wild roses in bloom. (Both photos from Author's Collection)

STEARNS COUNTY PARK DEPT.
425 S. 72nd AVE.
ST. CLOUD, MN 56301
(612) 255-6172

March 15, 1991

Marshall Johnson
Executive Vice-President
Cold Spring Granite
601 Lakeshore Parkway, Suite 1500
Minnetonka, Minnesota 55343

RE: HUNDRED ACRES QUARRY SITE

Dear Mr. Johnson:

At the March 13, 1991 Stearns County Park Commission meeting, I
present the availability of the Hundred Acres Quarry site for
purchase. The Park Commission discussed the value placed on the
site, as well as site physical characteristics and adjoining land
uses. The Park Commission instructed me to explore the
availability of this quarry site further. The Commission expressed
an interest in viewing the site in person. I will talk to Mr.
Schnepf to see about a visit in the coming month. Thank you for
the aerial photo with the boundary lines and the quarry depth
information.

Sincerely yours,

Charles B. Wocken,
Park Director

CBW/hj

cc: George Schnepf
 Bill Fahrney
 Bob Swanberg
 Marlyn Libbesmeier
 Rose Arnold

Courtesy of the Stearns County Park Department.

achieving the safe park experience we all wanted to provide for park visitors.

This was a time of transition on the County Board. Leigh Lenzmeier and Henry Dickhaus were elected in the fall of 1990 and began their four-year term of office in January 1991, replacing outgoing Commissioners Keith Maurer and Bob Wensman. Chuck Wocken recalled earlier discussions at the Board where Keith Maurer and Bob Gambrino shared their fond memories of swimming at the quarries as kids. Remember, the county's recreation plan, approved in 1989, included the goal of a establishing a "granite quarry lake" in the St. Cloud area. Both Keith Maurer and Bob Gambrino had extensive insurance background in their professional lives. They were no strangers to liability issues. So one might have expected more resistance to the notion of transforming abandoned granite quarries into a public park. Wocken said he just about fell out of his chair when Keith Maurer said, "Oh, yeah, I used to swim in those quarries all the time. They're great. Are there still any trout in there?"

Then Bob Gambrino added, "Oh, we used to have a game, we'd grab the biggest rock we could carry, get up on the ledge, jump in and see who could hold on to the rock the longest underwater before they came up. It was like going down as deep as you could until you were so frozen cold in the deep water that you let go of the stone and you swam back up!"

Remember, these were the insurance guys talking about the great times they had as kids at the quarries! Newly elected commissioners Leigh Lenzmeier and Henry Dickhaus also supported both exploring the possibility of a establishing a quarry park and the initial purchase of 219 acres from Cold Spring Granite in 1992.

Look closely to glimpse Minnesota's 'glacial polish'

Minnesota is famous as a land of ice and water. Ten thousand lakes and endless months of winter snow do get noticed, after all. The marks that ice and water leave upon the land, however, are subtle.

Still, if you look in the right places, some things are unmistakable.

Take, for instance, the rocks in Quarry Park at the east end of Quarry 13 and the south end of Quarry 2 (the swimming quarry). Both show granite ledges with exceptionally smooth, rounded surfaces. So smooth you need to be careful walking on them in the rain.

ROBERT WICHMAN
GEOLOGY

———

They truly are "slippery when wet."

These ledges showcase something called "glacial polish," and there are other examples around St. Cloud.

Like the finish on a granite countertop, glacial polish is the result of a lot of tedious rubbing and scraping. Modern stoneworkers polish granite (and other stones) by buffing them with abrasive grits of ever-decreasing size. The final polishing stage uses powders of diamond or silicon carbide finer than many dust particles. Glaciers, on the other hand, have neither power tools nor diamond dust. But that doesn't mean glaciers are without power, or without powder.

As ice is softer than most rocks, ice alone cannot scratch granite, let alone scrape it or shape it. But ice can hold other rocks. And if that ice is hundreds to thousands of feet thick, some of those rocks will grind into whatever lies beneath. Thus, as a glacier moves, the grinding of rock on rock builds up a layer of sand and clay beneath the ice.

If water gets down there — and only the coldest of cold glaciers are frozen to their base year-round — that mix of sand, clay, silt and water becomes a slurry of grinding compound. With all the weight of the glacier above for elbow grease, it's not surprising that years of ice flow could shape and polish the rock below.

Nevertheless, glacial polish tends to occur only in scattered patches.

Partly, that reflects the mixture of debris at work. If the slurry has rock chips mixed in, they will gouge and mar any polish as it forms.

Also, if the debris gets too thick, ice can slide on that without scratching bedrock at all. But just as important is the fact that few rocks can hold onto glacial polish if it does form.

Remember, the glaciers melted here some 10,000 years ago. Since that time, our rocks have been lashed by weather, and only a (very) few rocks can ignore that.

At Quarry 13, there is a diabase dike right next to the polished granite. And while it was clearly shaped by ice, its surface has a rougher, grainier texture; only the raised lines of few, thin quartz veins still preserve the original ice-cut surface.

So, while glacial polish may not preserve the mirrored finish of our modern monuments, we can only hope that our efforts will last as well.

———

This is the opinion of Robert Wichman, a geologist and professor who has explored many of Minnesota's state parks with a particular interest in their rocks. He can be reached at newsroom@stcloudtimes.com.

Courtesy of Robert Wichman and the *St. Cloud Times*.

Public support for establishing Quarry Park was kindled with every news article that appeared in the *St. Cloud Times*. Letters to the editor confirmed what many of us knew well, that preserving granite quarries for a variety of recreational uses was a topic that would excite the public! When visiting local service clubs, Chuck Wocken made a habit of asking community volunteers, "If you were to get a visitor from a foreign country, where would you take them to show them the sights of Central Minnesota?" They all said *to a quarry*, except we can't get there because they're all privately owned. That was soon to change!

Two years of due diligence had been completed. Cold Spring Granite agreed to a price of $240,000 for 219 acres. Everyone agreed that the remaining $10,000 from the $250,000 state bonding money should go toward the cost of fencing the park. Securing the property until the county was ready to officially open the park was in keeping with the Minnesota Counties Insurance Trust's recommendation to manage the risks involved with this property.

At our June 22, 1992, meeting, the County Board authorized purchasing Hundred Acres Quarry from Cold Spring Granite Company at the $240,000 price tag originally discussed. Some members of the public questioned the sale price since the county assessor's office listed the market value at only $59,500. It was clear to the County Board that the assessor's estimate was unreasonably low if one considered the property's "highest and

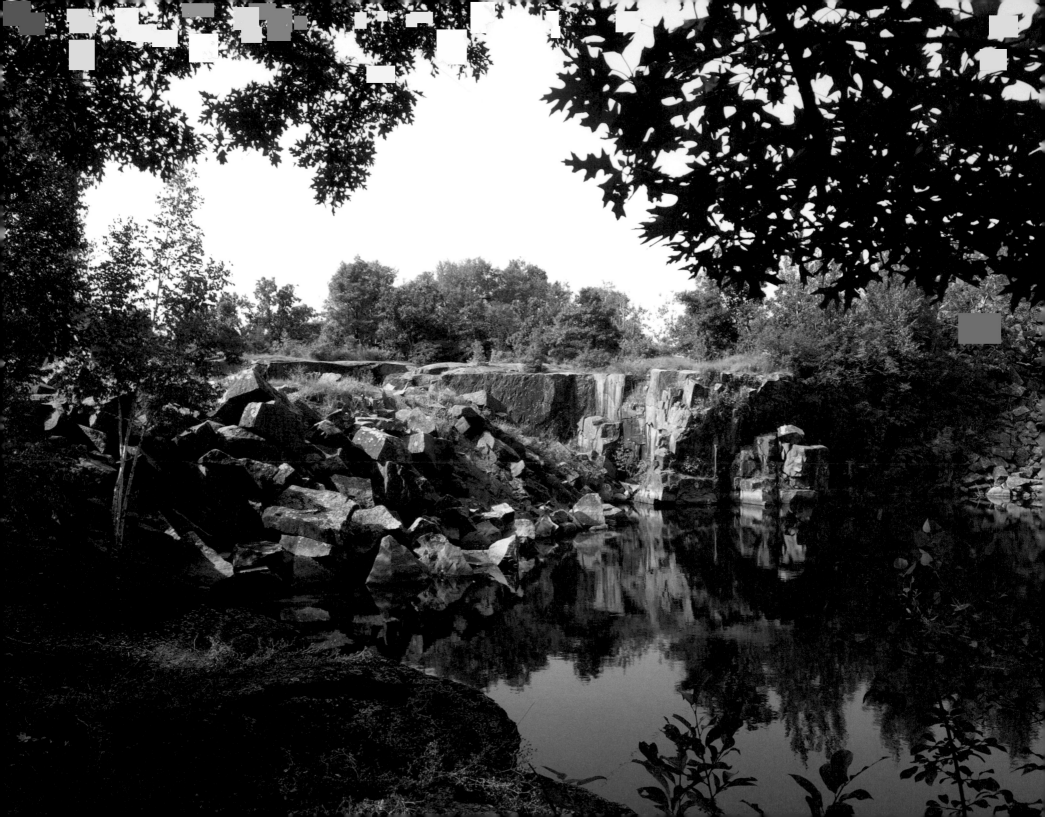

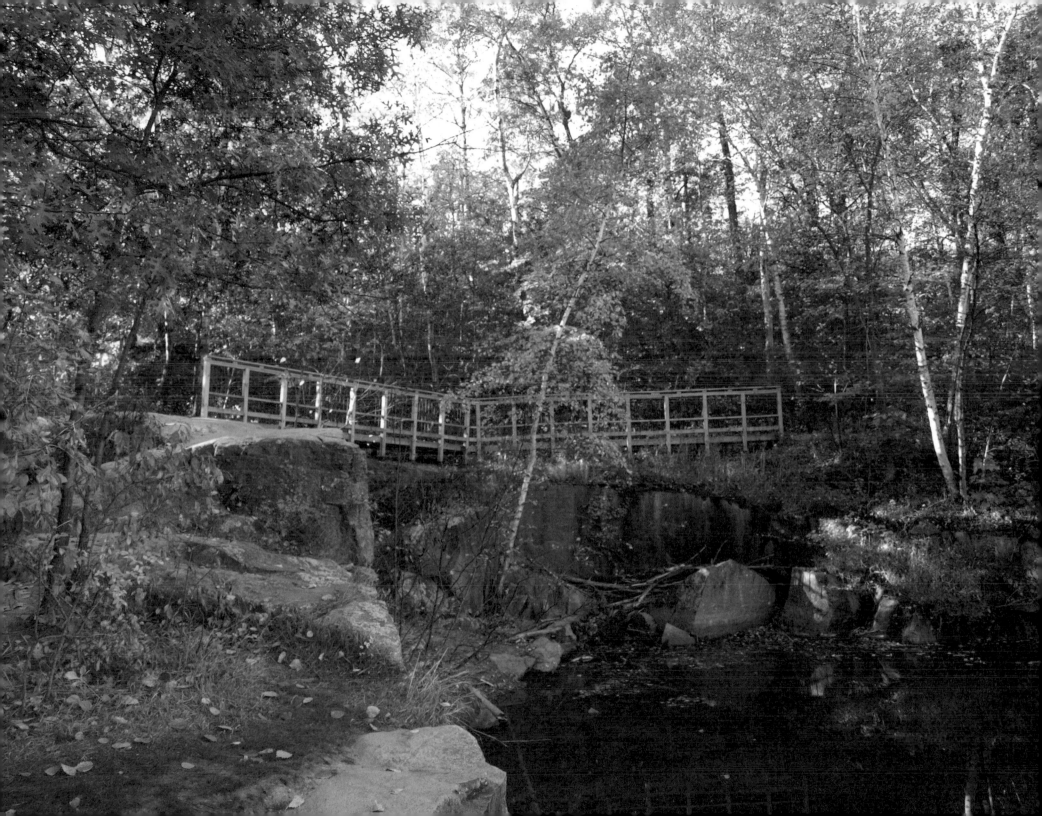

best use." The assessor's low appraisal was based on the parcel's classification for agricultural use. Cold Spring Granite's sale of the property for $240,000 was extremely generous, since an independent appraisal valued the property at $370,000, resulting in a $130,000 donation from Cold Spring Granite!

It took an additional six months of due diligence and survey work, but finally, on Monday, December 21, 1992, at 9:00 a.m., as chair of the County Board, I signed the papers to purchase the land from Cold Spring Granite for $240,000. In my twenty-two years serving on the Stearns County Board of Commissioners, this was without question my favorite project and most memorable moment! Little did I know at the time that my "lobbying" and politicking to help Quarry Park grow to nearly seven hundred acres had only just begun. Other local elected officials had their own plans for the property located south of the initial Hundred Acres Quarry site. And those plans did not include an expansion of Quarry Park.

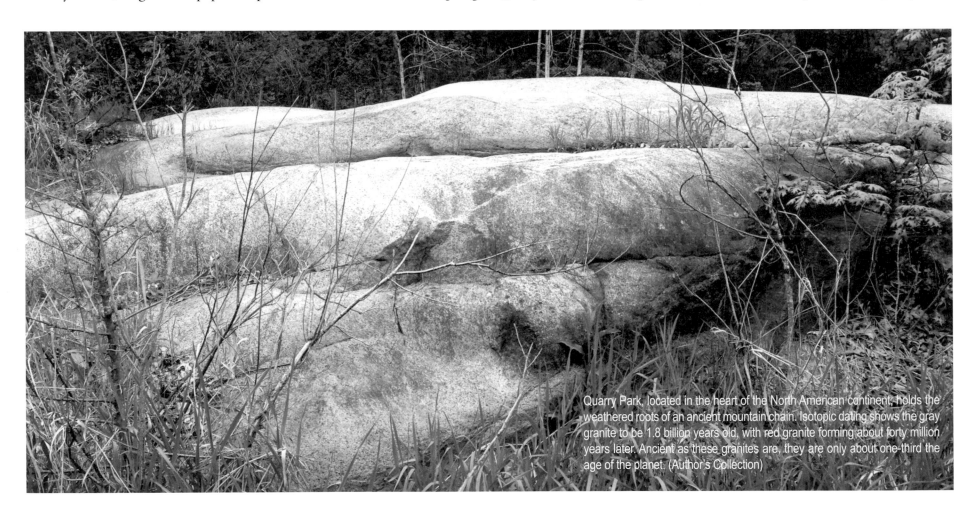

Quarry Park, located in the heart of the North American continent, holds the weathered roots of an ancient mountain chain. Isotopic dating shows the gray granite to be 1.8 billion years old, with red granite forming about forty million years later. Ancient as these granites are, they are only about one-third the age of the planet. (Author's Collection)

Quarry site found to be free of toxins

Times Staff Writer

Stearns County now will build recreation area

A proposed granite quarry park near Waite Park has earned a clean bill of environmental health.

Stearns County agreed in June to buy the 243-acre parcel in St. Cloud Township to develop a park but was waiting for the results of an environmental study before clinching the deal.

The county wants to develop the land, known as 100 Acres Quarry, into areas for swimming, fishing, boating, picnicking and hiking.

Earlier this year, the county ordered an environmental study to find out if the site's soil or water had been contaminated by chemical or hazardous waste.

The study, approved Tuesday by county commissioners, concluded that there is no chemical contamination.

And no cases of hazardous waste contamination have been recorded at the site, according to the Minnesota Pollution Control Agency.

Developing the land into a park will take several years, said county board Chairman Mark Sakry.

The environmental study was one of the county's last steps before finalizing a purchase agreement Aug. 21 with Cold Spring Granite Co., said county Coordinator George Rindelaub.

Money to pay for the $240,000 worth of land will come from a $250,000 state grant. The remaining $10,000 will be used to fence the property.

Old cars, appliances, carpeting and other trash have been dumped into the quarries over the years.

Main attractions at the proposed park would be 20 pits that at one time were mined for granite rock. The property also includes meadows, forests and granite rock piles up to 50 feet high.

At least two deaths have been recorded on the site. One was a drowning and the other was from falling off a rock pile.

One part of the environmental study prepared by a St. Cloud State University biology professor examined eight of the site's 20 largest and most accessible quarries. Only one quarry showed signs of chemical contamination — described in the document as a "heavy scum of oil" on the surface. The source of the oil could not be found.

Quarry/2B

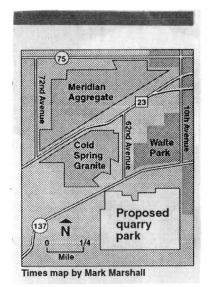

Times map by Mark Marshall

From Page 1B

Quarry

Researchers saw bass, sunfish, minnows and frogs in the quarry.

Water in the quarries' upper depths is as clear as the water found in Lake Superior and northern Minnesota lakes, the study said.

Based on tests, water in the quarries' upper levels has not been contaminated by toxic materials, the study said.

However, the quarries' small fish populations may be caused by very low doses of toxic substances that could prevent them from reproducing.

The materials could include copper, zinc and asbestos from automobile parts; lubricating oil and waste rock left over from rock cutting; and PCBs from refrigerators. Polychlorinated biphenyls can cause cancer.

Parts of the study completed by St. Cloud State cost about $1,500. County staff did the rest of the study.

August 5, 1992. Used with permission of the *St. Cloud Times*.

[33]

The term "reclamation for recreation" was coined by landscape artitect Anthony Bauer. This concept of reclaiming industrial property for park and recreational purposes has grown in popularity throughout America. "Rails to trails" applies this same concept to abandoned railroad right of ways, resulting in "linear parks" for bikers, hikers, skateboarders, and snowmobile enthusiasts. (Author's Collection)

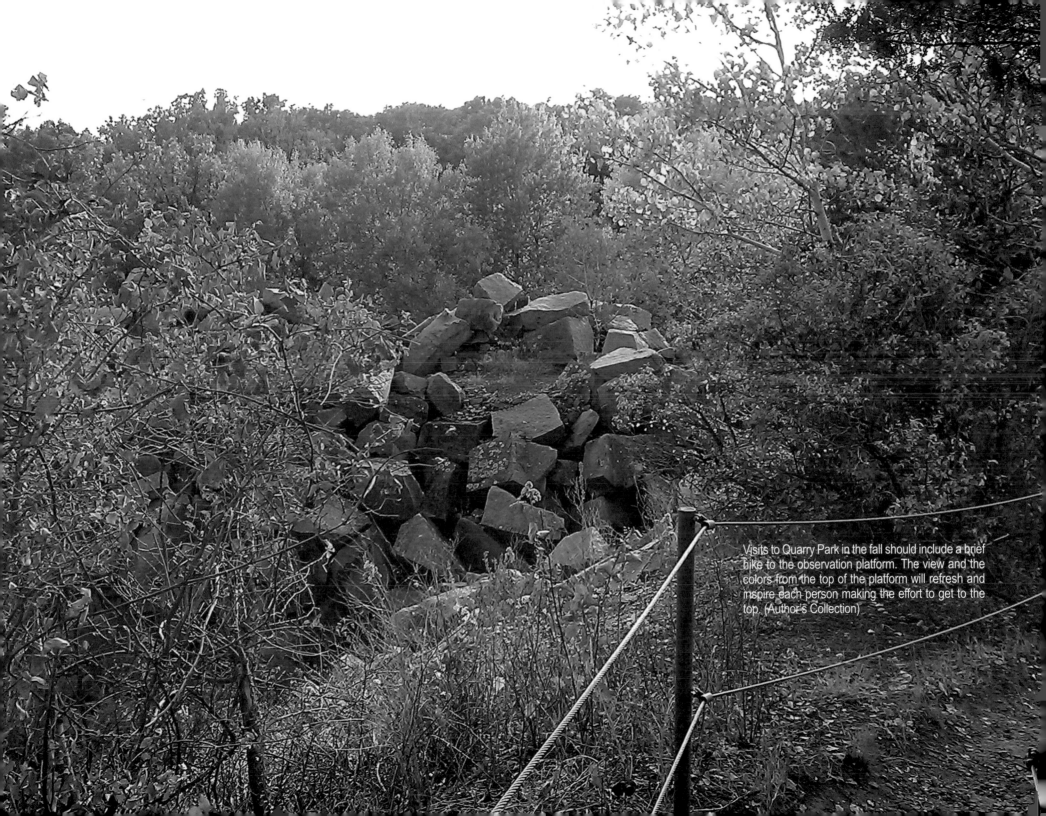

Visits to Quarry Park in the fall should include a brief hike to the observation platform. The view and the colors from the top of the platform will refresh and inspire each person making the effort to get to the top. (Author's Collection)

Stearns board buys, plots new quarry park

By SHAWN SAUNDERS

Times Staff Intern

If you enjoy sitting or swimming in the quarries on a hot summer day, the Stearns County Board of Commissioners has heard your plea.

Tuesday, commissioners unanimously approved spending $240,000 to buy unused land from Cold Spring Granite Company to develop a park which includes 18 quarries.

The land is southwest of Waite Park near Stearns County Highway 137. The area is known as "100 Acres Quarry" to some. Cold Spring Granite purchased the 220-acre lot from Melrose Granite in 1957, but never mined it.

The money that will be used to purchase the park comes from a $250,000 state grant given to the county. The remaining money will be used to build fences around the property.

The county is seeking an additional $220,000 state grant to use for research and planning of the new park.

County park officials want to thoroughly check the land for any scientific factors.

Factors that need checking are the

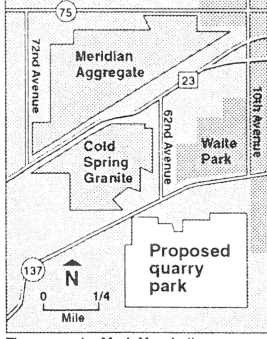

Times map by Mark Marshall

bedrock and water in the quarries. This will help to determine if the quarries are safe for swimming.

Concerns over safety of the park were on commissioners' minds.

Quarry/**2B**

From Page 1B

Quarry—

There have been two deaths on the property, according to the commissioners. Although Cold Spring Granite hasn't met any lawsuits, the commissioners say that a number of trespassers on the land have been injured in the past, and they don't want it to happen again.

Dangerous areas on the property will be fenced off and signs posted where necessary. "We won't be an absentee owner," Wocken said.

Park officials estimate that it will take years to complete the project. Wocken said construction of the park wouldn't begin until all research has been completed, which could take up to two years. "This could easily be a 10-year project," he said.

But it'll be worth the wait, said Mark Sakry, chairman of the board of commissioners. "This is something that will affect many, many generations," he said.

June 24, 1992. Used with permission of the *St. Cloud Times.*

[36]

County defends quarry purchase price

By ROXI REJALI
Times Staff Writer

Stearns County has agreed to pay more than four times the amount its own assessor says the land is worth for an abandoned granite quarry it plans to develop into a park.

County officials acknowledge the discrepancy between the county assessor's appraisal of the land's market value and the amount they have agreed to pay for it.

The county assessor's office lists the 220-acre St. Cloud Township parcel with a 1992 market value of $59,500. But county commissioners agreed in June to buy the land near Stearns County Road 137, known as Hundred-Acre Quarry, for $240,000 from Cold Spring Granite Co.

County Board Chairman Mark

Officials cite difference in appraisal methods

Sakry said the discrepancy is based on differences in the way the land is classified by various appraisers:

■ In contrast to the county assessor's appraisal of $59,500, a 1990 appraisal by Cold Spring Granite set the land's value at $250,000, said county Parks Director Chuck Wocken.

■ An appraiser hired by the county set the market value at $320,000 for a parcel that is about eight acres larger than the site the county has agreed to buy.

"Given the discussions that took place between Cold Spring Granite and the county, I felt that was the very best

deal we could get," Sakry said.

The county had expected to finalize the purchase Friday, but that has been postponed because the final step of a property title search has not been completed, Wocken said.

A $250,000 state grant, which the county received last year for site purchase and improvements, will cover the $240,000 price tag.

The county has applied for an additional $220,000 state grant to study the land's geology and hydrology.

The county-hired appraiser concluded that the land's "highest and best use" was for parkland, wildlife sanctuary or

recreational use. "Highest and best use" yields the highest land value.

The private appraisal, conducted by St. Cloud Appraisal Inc. and paid for by the county, was required as part of the state grant awarded last year, said county Coordinator George Rindelaub.

In contrast, county Assessor Gary Grossinger said his office's appraisal of the same parcel was based on its classification for agricultural use. That's because it borders another Cold Spring Granite-owned parcel that is used for

Quarry/**4A**

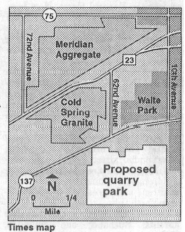

Times map

From Page 3A

Quarry

growing crops, he said.

"We valued the property as it's being used — not at its highest and best use," Grossinger said. "The highest and best use for that property may be for a residential development."

Market value is typically the highest value a buyer will pay, Grossinger said. It also determines property taxes paid on the land.

"It's actually garbage," Grossinger said of the proposed park site. "It really doesn't have use for anything other than hunting, maybe, or if somebody wants to risk putting a residential development in there."

The agreed-on purchase price turned out to be a bargain, Sakry said. "As it turned out, even with the appraised value, we still got a pretty good price on it, in that it came in quite a bit under the new appraised value."

The county had tried unsuccessfully to get Cold Spring Granite to donate all or part of the property, he said.

The proposed park may include swimming, fishing, camping and boating facilities and an interpretive center focusing on the granite industry. The property has wooded and meadow areas and several deep quarries that have filled with ground water and rainwater.

The county plans several public meetings over the next year to discuss the plans, Sakry said. Although county officials won't know how much improvements will cost until plans are finalized, the county's park commission is studying how to raise private donations for the projects, Sakry said.

While Sakry said he hopes that some parts of the proposed park could be open in three years, the total project could

take up to 10 years.

If developed, the proposed granite quarry park would be the only one of its kind in the country, Wocken said. Reclaimed limestone quarries have been developed in the Milwaukee area, he

said.

"It's a unique natural feature, with a lot of cultural overtones," he said. "You couldn't find another piece of property, I would say, that tells a story like this one does, in Central Minnesota."

August 22, 1992. Used with permission of the *St. Cloud Times*.

[37]

St. Cloud Times, Tues., Dec. 22, 1992

Stearns board OKs purchase to turn quarry into park

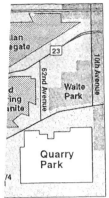

By ROXI REJALI
Times Staff Writer

Nature lovers may be able to hike, swim, fish and cross-country ski by 1997 at a planned granite quarry park near St. Cloud.

Stearns County on Monday finalized its $240,000 purchase from Cold Spring Granite Co. of an abandoned quarry site for a park.

The 228-acre site is in St. Cloud Township near Stearns County Road 137. Known as Hundred-Acre Quarry, the site is popular for beer parties.

The new park will be the county's 12th, and the closest to St. Cloud.

The park will offer a unique way to showcase the rolling, wooded property and the region's ties to the granite industry, said Chuck Wocken,

county parks director. "It'll be a place to go, close to town, where you can get in the woods and be amongst nature."

The property includes 100-foot-deep quarries that have filled with water.

"It's going to be the most unique thing about Central Minnesota," said county board Chairman Mark Sakry. "It'll certainly draw people from the state of Minnesota and probably beyond."

Plans for the park haven't been finalized, although they could include camping, picnicking, scuba diving, mountain biking and rock climbing. The park could include a year-round interpretive center featuring equipment and exhibits on the granite industry and an outdoor amphitheater for concerts and park programs.

"The quarries are miniature lakes that have been culturally made," Wocken said. "These are really the one chance to do water-based recreation activity, which is the thing that Minnesotans are interested in."

The county could be interested in buying adjacent land to expand the park to 700 acres, he said.

Public input at planned meetings in 1994 will help officials finalize park plans.

It could take years to fully develop the site, Sakry said. "They're going to want to see it up and running next summer, and that's not possible. We can probably have some things open, some walking trails or something, within a couple years, two or three years."

Stearns County commissioners agreed this

summer to buy the site, but the purchase was delayed while a property title search was completed.

A $250,000 state grant will cover the purchase price and installing fencing around the property this spring. It's too early to estimate final costs for developing the site, but the county plans to apply for more state money after a master plan is developed in 1995, Wocken said.

In July, the county hopes to work with St. Cloud State University on a study of the site's geology and water quality. The county has applied for a $50,000 state grant, to be matched by $50,000 by the county in private donations and staff time.

The county plans to work on fund-raising with the Central Minnesota Community Foundation.

Closing on the purchase of the original 219-acre Cold Spring Granite site, commonly known as "Hundred Acres Quarry," at the Stearns County Administration Center, 9:00 a.m. Monday, December 21, 1992. Left to right: Auditor/Treasurer Hank Kohorst, County Board Chair Mark Sakry, Cold Spring Granite Vice-president George Schnepf; State Representative Bernie Omann, and Tom Wenner, contracted legal council for Stearns County. (Courtesy of Stearns County)

Mark Sakry, Tom Wenner, and George Schnepf review the final language for the historic purchase of "Hundred Acres Quarry," the first acquisition establishing Quarry Park. (Courtesy of Stearns County)

[38]

Chapter 4

Waite Park Weighs In

FOR THE MOST PART, county government makes decisions for the unincorporated areas of a county. County commissioners work closely with townships and to a lesser degree with city governments. For example, most planning and zoning authority in incorporated cities supersedes county zoning established by the county for the "rural areas" of the county. Prior to the establishment of Quarry Park, all county parks in Stearns County were located in the unincorporated areas of the county. Proposing a *regional* park that could grow from 220 acres to nearly 700 acres within the *city* of Waite Park was a whole new animal, and not everyone in Waite Park city government liked the idea of Stearns County buying up all that developable property and removing it from the city's property tax rolls.

Since the new park was located in the city of Waite Park and my commissioner district included Waite Park, the task of convincing the city to support Quarry Park in their planning and zoning documents fell on my shoulders. In more than one Waite Park City Council meeting I found myself pleading with the council and mayor to see the wisdom of preserving this unique landscape and recreational treasure.

Drawing future expansion boundaries for the ultimate "build out" of Quarry Park and Nature Preserve became a hotly contested issue. Stearns County spent several years in the mid-1990s negotiating the purchase of various parcels to add to Quarry Park and Nature Preserve.

The park's master plan, developed by Brauer & Associates Ltd., includes the following overview and acknowledgments:

In mid-1994, the Stearns County Board of Commissioners commissioned Brauer & Associates Ltd. to prepare a master plan for Quarry Park and Nature Preserve. An ad hoc advisory committee was formed to represent the county and public and oversee the project. A technical advisory committee and user-group advisory committee were also formed to participate in the planning process. Public meetings were held to gain public participation to ensure outcomes were in line with public sentiment.

The planning team, led by Brauer & Associates, Ltd., would like to thank the Stearns County Board of Commissioners and committee members for providing their insight and understanding of the concerns and needs of county residents. We would also like to thank the individuals that attended the public meetings. The participation of committee members and public allowed us to prepare a master plan that reflected the unique character and intrinsic qualities of the county and park.

County Board of Commissioners

Robert Gambrino

Rose Arnold

Henry Dickhaus

Mark Sakry

Leigh Lenzmeier

Ad Hoc Advisory Committee

Don Bauer

Joseph Hall

Steve Poissant

Dale Schleppenbach

James Boie

Steve Antony

Ann Brown

Prentiss Foster

Edward Richardson

Ray Pontinen

Joseph Chovan

Mark Sakry

Jay Vachal

Technical Advisory Committee

George Shurr, Ph.D.

Doug Pearce

Steve Saupe, Ph.D.

John Podobinski

User-Group Advisory Committee

John Peck

Mark Spychala

Dennis Warner

Bruce Stainbrook

Ed Bouffard

Linda Peck

Muriel Spychala

Steve Zinsli

Marty Tabor

Our appreciation is also extended to Park Director Charles Wocken for Stearns County Park Department, who took the time to attend many meetings and provide his insight and understanding of the site and local conditions and provide guidance on difficult planning issues.

One of those difficult planning issues was how to convince the City of Waite Park that a regional county park was indeed in the best interest of the city. At a City Council Meeting, Al Ringsmuth (recently retired mayor at that time) stated "Over my dead body" would the county buy up such a large area in the heart of Waite Park. Letters exchanged between the former mayor and myself captured the mood in December 1998.

from the desk of
Alcuin J. Ringsmuth
Retired Mayor of Waite Park, Minnesota
134-3rd Street North
Waite Park, MN 56387-1206
320-252-1575
December 30, 1998

Mr. Mark Sakry
Stearns County Commissioner
413 - 10th Avenue South
Waite Park, MN 56387

Dear Commissioner Sakry,

As I observed the joint meeting of my City Council and Planning Commission with the Stearns County Commissioners and Park Board on December 19, 1998, I couldn't believe the determination you seemed to have to gut the heart out of the City of Waite Park's most attractive potential residential housing sites. What really bothered me was the fact that you, yourself, have located your own home site in a similar area but now think that the public has no right to the same amenities. I also am amazed that you showed so little concern for Waite Park's Planning Process since the merger with St. Cloud Township.

I have no problem with Quarry Park and Nature Preserve as it currently exists but I do think the planning process should have taken in Waite Park's concerns about future city development as the merger talks went on at the same time. I understand some commissioners even questioned developing a county park in what obviously was going to be in the center of the City of Waite Park. You and the state may have the right to acquire more property but you also have a moral obligation to be a good citizen of the city where you live. This means taking into consideration the reason for the merger in the first place. You should have known that the expansion of Waite Park was planned when a sewer district was first discussed in 1970, even though St. Cloud Township chose not to be involved in serious planning and tried to stall every attempt by property owners in the township to annex to get city services.

To the point--I don't believe the County should acquire any more of the City of Waite Park's prime residential property for park purposes and I will try to alert the public (who I don't think realize what is being proposed) to the same concerns.

Very sincerely yours,

Alcuin J. Ringsmuth

Author's Collection.

COUNTY OF STEARNS

Mark Sakry
County Commissioner - Second District

413 S. 10th Ave. • Waite Park, MN 56387 • (612) 252-5022

January 10, 1999

Mr. Al Ringsmuth
134 - 3rd Street North
Waite Park, MN 56387

Dear Al:

Thank you for your letter regarding Stearns County Quarry Park & Nature Preserve. I was reminded how differently all of us view the world. Have you heard of the "separate realities" all human beings experience because of our various life experiences? This Quarry Park expansion is a good example. You state in your letter that you can't believe the determination I seem to have to "gut the heart out of the City of Waite Park's most attractive potential residential housing sites." My world view, on the other hand, is that Stearns County is not gutting the heart but rather preserving the heart of Waite Park's most unique residential area. Hopefully, we can preserve this rare, natural amenity for all future generations to enjoy, as well as for the endangered wildlife and plants that call it home.

There seems to be a contradiction in your own position on this matter. It's hard for me to believe that as Mayor you strongly supported Meridian's blasting and quarrying expansion (instead of housing sites), but now you oppose preserving a unique natural area for a park because you want to see more housing sites!

As you mention in your letter, I am indeed fortunate to live near a quarry. It has been a wonderful place to raise a family and I feel very blessed. In fact, for many years I considered donating my quarry to the City of Waite Park upon my death because I thought it would make a beautiful city park. Now that Waite Park has a unique, regional Quarry Park that appears less likely. However, I am still considering donating some land to St. Joseph Cemetery for a poetry corner or prayer and reflection area. My point is, I have always wanted to find a way for the maximum number of people to enjoy the quarry treasures located here in Waite Park. My separate reality tells me that that is being a good citizen of the city and county where I live.

When your great, great grandchildren look back at what "Grandpa Al" did for the city, I'm sure they would be more impressed that Grandpa supported preserving Central Minnesota's most unique geologic wonder for them and all children to enjoy on a hot, summer's day, than that Grandpa supported land developers so a few more expensive homes could be built overlooking the quarries in an exclusive housing area where no

other City residents are welcome. Given the reality of how quickly all land in Central Minnesota is being developed, what does it mean to be a good citizen or a wise public official?

Stearns County's planning process has taken into consideration Waite Park's concerns about future development. It should be noted, however, that the desirability of preserving unique quarry property for park purposes was identified in Stearns County's planning process years before merger talks took place affecting Waite Park and portions of St. Cloud Township. As plans for Quarry Park came closer to reality, I did my best to keep Waite Park well informed of the County's intentions. You may recall, you stated at those City Planning Meetings (referring to the expansion), "That will never happen."

Most communities (even those with limited land area) would "give their right arm" for a unique, natural attraction like Quarry Park. As a county park, the City has the advantage of another unit of government paying for the maintenance of a facility that meets many of the recreational and open space needs of Waite Park residents. In addition, the park will create an economic and cultural "draw" for new businesses and housing. The proposed park expansion may seem large by city standards, but the minimum acreage for a regional park is 1,000 acres. Even with the proposed land purchases, Quarry Park will not reach that threshold.

In short, please look at the many positives this park presents the residents of Waite Park. You state in your letter that the public needs to be "alerted" to the County's plans to expand the park. I would submit the public is well aware of the proposed expansion and they overwhelmingly support it. The St. Cloud Times has run numerous stories on this issue, including a map of the proposed expansion area that actually indicates more land than Stearns County intends to purchase. No one, other than yourself, has called me to express opposition to Quarry Park being expanded.

I understand that the City of Waite Park has legitimate concerns about how the Park will affect the City's ability to pay for various road and infrastructure improvements. Please be assured I will do everything within my ability to make sure Stearns County treats Waite Park fairly and proves to be a "good neighbor" regarding all issues concerning Quarry Park.

Again, thank you for sharing your concerns regarding Stearns County's wishes to expand Quarry Park & Nature Preserve. Best wishes for the new year!

Sincerely,

Mark Sakry
Stearns County Commissioner - District 2

cc Mayor Rick Miller
Waite Park City Council and Planning Commission Members

"Affirmative Action / Equal Opportunity Employer"

Author's Collection.

Stearns officials question growth around park

2-12-97

Waite Park plan won't allow for expansion of Quarry Park, county leaders say

By Jerry L. Carter
TIMES STAFF WRITER

Whether Quarry Park and Nature Preserve winds up great or mediocre depends largely on whether Waite Park officials realize its potential, Stearns County officials said.

"If the final outcome is that the park doesn't get any larger, the entire Stearns County will be shortchanged," said Chuck Wocken, Stearns County parks director. "It would be sad to see homes on every granite outcrop."

Wocken and some county commissioners want to see the park, at Stearns County Road 137 and Minnesota Highway 15, grow up to three times its 220-acre size. However, Waite Park officials remain concerned further expansion south of the park would take too much prime real estate off the tax rolls.

Waite Park officials will unveil a draft comprehensive land use plan at 6:30 p.m. Thursday at the city hall. The plan does not include expansion space for Quarry Park. In three different suggested scenarios for land use around the park, all would be zoned for residential growth, and none would designate the park as a recreational growth area.

"If we limit the size of the park it may be a limiting proposition to Waite Park," said Mark Sakry, a Stearns County commissioner. "If the park can't handle a regional draw then it can't support more business flow. It also won't make property values around it increase more."

Most regional parks cover more than 1,000 acres, which county officials never expect to reach.

Sakry, who lives in Waite Park, plans to attend the planning and zoning commission meeting Thursday to voice his concerns about limiting the park's size.

"I would argue that the development spawned by a popular regional park, rich with historical and natural interpretive opportunities, will more than make up for the residential tax base lost to park expansion," Sakry said in a letter he sent Monday to Waite Park Mayor Rick Miller. "In fact, all properties surrounding the park will increase in value and generate more taxes because of their proximity to

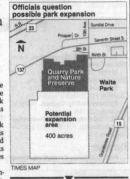

Officials question possible park expansion

Quarry Park and Nature Preserve

Waite Park

Potential expansion area

400 acres

TIMES MAP

▼ **Growth**

the park."

Sakry said he would expect high-priced homes, hotels, restaurants, bed and breakfast establishments, art galleries and gift shops to spring up in Waite Park. "This park is a gift to Waite Park and the surrounding communities," Sakry said.

Wocken also doesn't buy the "we are losing tax base" theory, he said. "When you create open space it translates into higher property values in the expanded area. Just look at the property values around a Hennepin County Park Reserve. There will be a lot of people who will want to pay more to live next to a regional park."

Miller said city officials aren't trying to limit the growth of the park, they only want to look out for Waite Park's best interests. Zoning the land around the park recreational would limit its value.

"We are not going to dedicate part of the city for only park land," Miller said.

Miller said if the county wants the park to expand, it can bid for the property like any other developer and make a rezoning request.

"Someone along the line has blown this whole thing out of proportion," Miller said. "Waite Park isn't against Quarry Park. I think there would be a lot more people visiting our businesses when the park is completed, and I like the idea of hotels and restaurants coming to the area."

400 acres leads to rift in Waite Park

City officials argue Quarry Park expansion would remove prized land from tax rolls

By Jerry L. Carter
TIMES STAFF WRITER

Some Stearns County officials would like to see Quarry Park and Nature Preserve grow by 400 acres. But officials in Waite Park, where the park is located, say such a plan takes too much prime real estate off tax rolls.

"I personally find it a problem that the county wants to expand the park that much," said Carla Schaefer, a Waite Park City Council member. "If $200,000 homes were put on the property, that would be a tax advantage (to Waite Park), but more park land wouldn't benefit us."

Stearns County commissioners advised their attorney Tuesday to review a $225,000 draft purchase agreement for 30 acres of land south of the park. The agreement would allow the county to seek a $105,000 grant from the Department of Natural Resources to help purchase the property.

The land, owned by Helen and Robert Trisco, has been sought by commissioners for more than a year.

County officials in a comprehensive plan for the 220-acre park have identified about 400 acres south of the park as a potential expansion area. That includes the Triskos' 30 acres, a 265-acre

Officials question possible park expansion

Quarry Park and Nature Preserve

Waite Park

Potential expansion area

400 acres

TIMES MAP

piece and a 60-acre piece.

Property purchased for the park would be taken off tax rolls and would limit nearly land-locked Waite Park from developing more residential housing.

City officials see the property, because of its scenic attributes and granite outcroppings, as prime land for more-expensive housing projects. High-priced homes are something the city has little of, said Steve Poissant, head of Waite Park's planning commission.

"They are looking at taking a lot of land off the tax rolls, and there is nothing the city can do," Poissant said. "They

Please see PARK, 5A ▶

Please see PARK, 5A ▶

Park

have some great plans (for Quarry Park), but how much is going to be good enough. Isn't the 220 acres they have good enough?"

The Triscos talked to Waite Park Planning Commission members and the City Council about developing six 5-acre lots on their land for high-priced homes. Their property, which they bought five years ago, became part of Waite Park in the St. Cloud Township merger agreement.

Although the city can't stop the county's land purchase, commissioners worry city officials will rezone other land in the park area in the city's new comprehensive plan. Its agriculture zoning allows recreational uses; residential zoning would not allow such a use.

The plan is expected to be finished in two months.

"I don't think they realize how much money this park could bring their's and surrounding communities," commissioner Mark Sakry said. "I think we need to talk with them again about the importance of Quarry Park."

Chuck Wocken, Stearns County parks director, recently met with Waite Park council members, and Sakry said he thinks more meetings are needed.

Poissant said he doesn't think the comprehensive plan will have to deter the county from buying more acreage for the park. The property's increased value now that it is part of the city should accomplish that.

"I think they will only get a percentage of the land they want," Poissant said. "We are hoping the Triscos are setting a precedent of what the going price is for the land."

Earlier this month, Wocken said he was shocked at a certified appraisal of the Triscos' land that listed its value at $210,000.

"This is the problem with piecemeal acquisition," Wocken said. "If we would have known what we had when we first agreed to purchase the first 220 acres from Cold Spring Granite, we would have tried to purchase more."

The land was cheaper when it was part of St. Cloud Township, he said.

Some commissioners also are concerned about the price the Triscos asked for the property. The county paid $240,000 for the initial 220 acres of the park, which was valued at $370,000. The land is similar to the Trisco property.

"We are in a difficult spot," commissioner Leigh Lenzmeier said. "It is going to be very tough to get other property if every time we go to the table we are looking at $7,000 to $10,000 an acre."

Lenzmeier and Commissioners Rose Arnold and Henry Dickhaus said they don't support the proposed purchase agreement. They want the Triscos to donate more of the land.

The Triscos already have knocked off $25,000 from their asking price, calling it a donation to the park.

The Triscos said they would prefer their property become part of the park, but they are not in a position to give it away.

"We are visiting with a financial accountant and have not ruled it out," Robert Trisco said about seeking ways to reduce the county's cost of purchasing the property.

Helen Trisco said that as long as they "keep talking" with county commissioners, they will try to come up with an alternative.

COUNTY OF STEARNS

Mark Sakry
County Commissioner - Second District

413 S. 10th Ave. • Waite Park, MN 56387 • (612) 252-5022

March 10, 1997

Dear Mayor Miller and
Waite Park City Council & Planning Commission Members:

I am writing in response to the February 26th St. Cloud Times Article, **"400 Acres leads to rift in Waite Park."** I am sorry to hear that some Waite Park officials apparently believe an expansion of Quarry Park and Nature Preserve would be a detriment to Waite Park's future growth and tax base.

I believe it is fair for Waite Park officials to ask the question "How much is good enough... isn't the 220 acres (of park land) the County already has good enough?". The Stearns County Board has also asked this question and we have based our desire for park expansion on sound planning recommendations. Certainly by <u>city</u> park standards a 220 acre park is very large. However, **according to the National Recreation and Park Association's <u>Open Space Standards and Guidelines</u> (see enclosure), the recommended acreage for a Regional Park Reserve is 1,000+ acres.**

Obviously, Stearns County will not be able to meet this standard (even if we were able to purchase all 400 acres identified in Quarry Park's Comprehensive Plan, which, admittedly, is not likely.) I mention this standard only to point out one of the reasons the County Board is interested in acquiring additional property for Quarry Park. **A regional park, particularly this unique regional park, needs significant acreage to handle anticipated demand.**

Some might ask, "Should a regional park be located in a growing urban area?" "Don't 600 or 1,000 acre parks belong 'out in the country'?". I would like to share with you a good example where foresighted planning lead to a park reserve in a very fast growing urban area. Hennepin County's Elm Creek Park Reserve is 5,000 acres in size! 1,200 acres are located in the City of Maple Grove alone, with the remainder located in the cities of Champlin and Dayton. "You can't compare our area to the Twin Cities," some might say... ... but in the not too distant future we may well wish we had!

What about the tax base issue? **I would argue that the development spawned by a popular regional park, rich with historical and natural interpretive opportunities, will more than make up for the residential tax base lost to park expansion.** In fact, <u>all</u> <u>properties</u> surrounding the park will increase in value and generate more taxes because of their proximity to the park. Not only will you see high priced homes constructed (if that is your tax base of first choice and you zone accordingly) but you will also see a dramatic expansion of more highly taxed commercial property such as hotels, restaurants, bed and breakfast establishments, art galleries, gift shops, etc. Just talk to the folks down at the Convention and Visitors Bureau. They are convinced that Stearns County Quarry Park and Nature Preserve will soon be <u>the</u> major tourist attraction in our area... and there it will be, in all its glory... right in the heart of Waite Park!

Some may say County Commissioners are thinking "too big" in planning for this park. Perhaps we are, but I would caution Waite Park City officials and Planning Commission members about thinking "too small" regarding this unique park and nature preserve. Many a city would die for such a positive enhancement to their community. **Please don't attempt to "zone out" what is likely to become Waite Park's greatest asset and attraction!**

Finally, let me remind you that most elected officials in Central Minnesota (Waite Park included) have talked passionately about the importance of **good planning and preserving "green space"** for our children, grandchildren and for the many generations yet to come. Now, when we all have an opportunity to make a real difference and set aside a significant recreational, historical and spiritual resource for future generations... let's not throw it away!

Thank you for carefully considering the expansion needs of Stearns County Quarry Park and Nature Preserve when finalizing the City of Waite Park's Comprehensive Plan. I will be attending this Thursday's Planning Commission meeting if you have any questions or wish to share your concerns.

Sincerely,

Mark K. Sakry
District 2 Stearns County Commissioner

Enclosure

OUR | **Times** | **VIEW**

Rush to re-zone in Waite Park ignores value of park land

Land south of Quarry Park is marginal for development, would add to metropolitan area's only regional park

Before Waite Park City Council members recklessly rezone the area south of Quarry Park and Nature Preserve, they should consider whether residential development really is a viable or best use of that land.

Area residents have a wonderful beginning for a regional park in the 228-acre Quarry Park and Nature Preserve, and Stearns County eventually would like to expand the park to about 700 acres.

A Minneapolis consultant has recommended three scenarios to the Waite Park City Council, all of which assume *residential development* on 137 to 180 acres of the 449-acre area where the county hoped the park would expand.

Yet based on data prepared by the consultant, that land is the least developable of all the areas suggested for residential development — 37 percent buildable, where other areas are 75 percent to 100 percent buildable.

The area is bedrock, which the consultant acknowledges is "potentially only suitable for park, agriculture, sewered residential sites ..." and is poorly suited for on-site septic systems.

Drain fields for septics in that area would be crazy; installing city sewer and water would be an expensive engineering challenge.

Quarry Park should be viewed by council members as an asset and attraction, giving Waite Park an identity and providing a place where active young people (and the young at heart) can participate in outdoor activities.

True, the park won't have swing sets or slides or tennis courts. But it has scenic value with quarry pits, woodlands, open prairie land, wetlands, bedrock outcroppings. It provides a host of year-round activities — hiking, biking, rock climbing, cross country skiing, scuba diving, nature study.

At a time when all communities are seeking activities for young people, Quarry Park fills a need in Waite Park and the region as a whole.

For its part, Stearns County must be sensitive to Waite Park's concerns about an expanded park and should work to help the city with potential costs in infrastructure and services that could come with having a major regional tourist attraction.

Waite Park is doing a good thing in preparing a comprehensive land use plan for the first time. But as council members move forward, they should study the nature of the land more thoroughly and remember the value of open space for the city's quality of life.

Waite Park has an irreplaceable natural resource within its boundaries that it should not hastily or thoughtlessly give up.

WHAT DO YOU THINK?

Should Waite Park maintain current zoning that allows park uses in the 449 acres south of Quarry Park? Or should city council members re-zone that land for residential development? What factors should be considered in making a decision? Send your views to: St. Cloud Times, P.O. Box 768, St. Cloud, MN 56302 or e-mail to SCTIMES@CLOUDNET.COM.

YOUR VOICE

The St. Cloud Times encourages readers to contact elected officials directly with city concerns. All addresses are Waite Park, MN 56387.

MAYOR
Rick Miller
156 5th Ave. N
253-1129

CITY COUNCIL MEMBERS
Paul Ringsmuth
515 Aberdeen Dr
251-7326
Carla Schaefer
5 - 8th Ave. N
259-1515
Donald Steichen
42 - 12th Ave. S
252-3024
Roman Thielen
229 - 2nd Ave. N
251-2168

WAITE PARK CITY HALL
252-6822

Support Quarry Park expansion for quality of life

New York City without Central Park. Minneapolis without Lake of the Isles Park. St. Cloud without Munsinger Gardens.

Anyone can see that these communities would be poorer places to live had it not been for visionary individuals who saw more than prime real estate when they planned for those areas.

This contrasts sharply with the shortsightedness of some Waite Park city officials who object to the projected expansion of Quarry Park on the grounds that it is taking land off the tax rolls.

A number of studies have demonstrated that not all residential development is necessarily a tax gain for a community. Even in those cases where it is, increased wealth in city coffers is only valuable to the extent that it contributes, ultimately, to the quality of life for all citizens in that community.

"Places of the heart", such as historic buildings and beautiful natural areas are being seen more and more by communities across the country as essential to the integrity, character, and livability of their cities. Visioning exercises, being engaged in by numerous entities in our community and elsewhere, always find environmental features at the top of the list of what people feel is valuable about where they live. As urbanization continues and the population of this area continues to grow, these natural areas will only become more cherished.

It is too bad that some Waite Park officials do not appreciate the jewel in their midst that is Quarry Park. They should be thanking Stearns County and all of its citizens that they have been so blessed. They should be doing what they can to enhance this priceless resource.

It is too bad that some Waite Park officials do not appreciate the jewel in their midst that is Quarry Park. They should be thanking Stearns County and all of its citizens that they have been so blessed. They should be doing what they can to enhance this priceless resource.

I long for the day when I hear a city official, in any municipality, say "We have enough shopping malls, enough parking lots, enough fast food restaurants," just as some officials in Waite Park seem to be saying "we have enough Quarry Park."

We hear a lot these days about balancing protection of the environment with development. When God's architecture finally becomes as valued as yet another of man's edifices and the dollars it can generate, then maybe we will have finally come close to some kind of balance.

And if all of this is lost on Waite Park officials, who seem to be saying that the only things of value are those that can be measured in dollars generated, then they should still be able to see Quarry Park as the magnet it will be for people and dollars as the next century unfolds. It would behoove them to support the expansion of Quarry Park, rather than gripe about it.

Eva Wallinga

CO-CHAIR, SIERRA CLUB-BIG RIVER GROUP

ST. CLOUD

Both articles used with permission of the *St. Cloud Times*.

SUNDAY
Sept. 28, 1997

TIMES PHOTOS BY MIKE KNAAK

Mike Lee, a botanist/plant ecologist, walked through a wetlands surrounded by woods in Quarry Park. Wetlands are among types of protected areas in a proposed environmental ordinance in St. Cloud.

City scrutinizes natural areas

Proposed rules attempt to balance protection, rights of property owners'

By Kendra E. Johnson
TIMES STAFF WRITER

If St. Cloud's natural resources aren't protected now, they could be damaged or destroyed by the enormous growth and development expected in and around the city in the next several years.

That's what members of a St. Cloud environmental task force made up of property owners, developers, government officials, scientists and environmentalists say as they rush to finish an ordinance that would protect the city's natural areas that house rare plant species and animals.

The St. Cloud Environmental Task Force on Monday plans to present an update of their proposed ordinance to members of the City Council, Housing and Redevelopment Authority and Planning Commission.

After the meeting, task force members want to amend the proposed ordinance to accommodate city officials' requests.

Public information meetings are being planned for October to get residents' opinions about the ordinance. Task force members are shooting for mid-November to bring a final draft to the Planning Commission.

A study of St. Cloud's natural resources done last year by a

The tubercold rain-orchid is a state endangered species. It is found is throughout the St. Cloud area.

Twin Cities firm showed a variety of rare plants and animals that are unique to the area.

Native prairies, wetlands and rock outcroppings that house

rare plant species such as cacti, cattail marsh, wet meadow and willow swamp and animals such as the red-shouldered hawk are among the few found on public and private property throughout the city and area that need protecting.

In addition, the Minnesota Department of Natural Resources is conducting a Minnesota County Biological Survey.

The results netted so far — various species and their locations — will be included in the proposed ordinance for protection purposes.

Environmentalists say the protection of these plants and animals is important because of their rarity.

Other cities also are likely to take up the task of creating an environmental ordinance, some members say.

Waite Park planning commission members will meet Thursday with members of the Audubon Society, a local environmental group, to hear a presentation on the rare species in that city.

Waite Park Planning Commission member Steve Poissant said that doesn't mean the city is considering such an ordinance, but said that he wouldn't be surprised if one developed later.

Environmental task force alternate member Mike Landy said, "Anyone who has a conscience about Mother Earth

should want to take care of it."

Environmentalists say this ordinance is paramount to the fate of the rare plants because of the tremendous growth in the St. Cloud area. St. Cloud's population is expected to increase by 20,000 households, or 50,000 people, by the year 2015.

Some legal protection of wetlands is in place, and 5 percent of new residential subdivisions must be dedicated to park space.

However, if more efforts are not made to protect natural resources and preserve high-quality natural areas, they will be developed and lost forever, task force members say.

Mike Lee, a botanist/plant ecologist working with the biological study, said, "The growth is putting pressure on the species."

The more people who move in and the rapid rate at which land is swallowed up increases the chances of damage or destruction to the plants, he said.

"Hopefully, the ordinance can direct the growth so that it has the least impact on some of the things," he said.

Lee said the biological studies usually take about two years. One was recently completed in Sherburne County. Benton County's survey is being completed now.

Quarry Park ready to open, wants visitors

See park, lend support to $7 million bond proposal in 1998 legislative session

After five years in the making, Stearns County's 250-acre Quarry Park will open for daily public use beginning this week. As soon as the signs are delivered and put up, the gates will open. Get your annual parking permits now.

This rustic park, long a dream, became reality when hikers, bikers, cross-country skiers, environmentalists and other citizens groups joined with the Stearns County Parks Department to forge a plan and a unique partnership.

Volunteers groomed trails, counted birds and plants, helped restore prairie areas. Residents this year donated $40,000 to help acquire the 30-acre Trisco property to add to the park. The state provided $250,000 in the 1995 bonding bill to do the first phase of park preparation.

Now the local community, with backing from Gov. Arne Carlson, must press the Legislature to approve $7 million to acquire more land and develop the park.

Reps. Joe Opatz and Jim Knoblach of St. Cloud, both on the Capital Investments committee, will have to take the lead in seeing this project through the bonding process. They must not allow the Minnesota Amateur Sports Commission's desire to build an events center in St. Cloud to derail the Quarry Park proposal.

Timing is of the essence. Much of the money would go toward land acquisition in a large portion of the former St. Cloud Township that merged with Waite Park. Pressure to develop that area is high. The land should be acquired before prices, already becoming outrageous, become more so.

The Department of Natural Resources notes that the proposed expansion area "represents the most significant remaining example of the Central Minnesota granite outcrop community."

A 50-acre oak forest has trees between 100 and 120 years old. The area has a breeding population of red-shouldered hawks and some Acadian flycatchers, both on the state's "special concern" list, and the tubercled rein-orchid plant, on the state's "endangered" list. Residential development would threaten the habitat, the birds and the plants.

The department notes that acquiring this area "is the only opportunity to protect an intact, landscape-scale portion of this community" and says that the large, natural woodland setting and rare species make this "one of the most important sites in this part of the state."

It could all disappear without timely action.

Quarry Park is the only proposed bonding project in Central Minnesota that preserves major acreage for the future. Of the $7 million requested, $2 million would go toward land acquisition, $2 million toward building a learning and interpretive center, an outdoor classroom and a maintenance center, and $3 million toward site improvements.

St. Cloud residents should see the park for themselves during the holidays and then ask legislators to support the $7 million bonding proposal. Quarry Park is a gem of a resource for active young people in our community and a unique part of the state's cultural and natural heritage.

WHAT YOU CAN DO

To visit the park, go south on 10th Avenue South in Waite Park to Seventh Street South. Take a right and go 0.7 of a mile to the entrance. A daily parking permit is $2. To buy an annual permit for $10, write a check to "Stearns County Auditor-Treasurer" and mail to Stearns County Parks Department, 455-28th Ave. South, Waite Park, MN 56387. Park hours are 8 a.m. to 4 p.m., seven days a week. To contact legislators to express views on the $7 million bonding proposal, use the list below.

December 21, 1997. Both articles used with permission of the *St. Cloud Times*.

County digs for Quarry Park help

Half-cent sales tax likely to be proposed

By Jerry L. Carter
TIMES STAFF WRITER

Stearns County commissioners intend to ask St. Cloud and other area city and county officials if they would support Quarry Park and Nature Preserve financially.

With the discussion of a regional events center in St. Cloud being supported by St. Cloud, surrounding cities and three area counties, Stearns commissioners wonder why other local governments don't help with building Quarry Park.

"We are providing a regional service with Quarry Park. Why can't we get some regional support?" County Commissioner Mark Sakry asked. "They want county support for a regional events center, so why shouldn't we ask for help for a regional park?"

County officials suggested if the events center were supported by a sales tax, as has been proposed by several people on the events center task force, why not just add another half cent to support Quarry Park, Sakry said.

"Maybe we could make that a one-cent tax and include Quarry Park," said Sakry, who also is a member of the events center task force.

The draft plans for the $50 million Central Minnesota regional events center show a 140,000-square-foot building that could seat up to 18,000 people.

Designs have been prepared so the center could host football, basketball, softball, soccer, tennis, volleyball, wrestling, circuses, tractor pulls, concerts and conventions.

Officials from area counties and cities that would support the center are still trying to figure out where it would go and how the area would pay for its half of the project. One option mentioned is the half-cent sales tax.

Today, Sakry plans to suggest the park tax to the other members of the events center task force at its 4:30 p.m. meeting at the St. Cloud Civic Center.

"It won't hurt to ask," said Stearns County Commissioner Rose Arnold.

Stearns commissioners would like to generate funds to help pay for the planning and expansion of the 250-acre Quarry Park.

The county will soon be hiring consultants to design an interpretive center and other amenities.

Those improvements may be completed by a $7.7 million state bond that county officials plan to pursue at the Legislature next year. With or without the state funding, the county plans to move forward with the project and continue to look for funding sources.

The state money would be used to buy up to 300 more acres, and to build the interpretive center and expand the parks services.

Quarry Park has hiking, biking and skiing trails that wrap around scenic areas created decades ago when the Cold Spring Granite Co. mined the granite.

Trails overlook scenic granite quarries and are the home to many rare plants and animals.

December 10, 1997. Used with permission of the *St. Cloud Times*

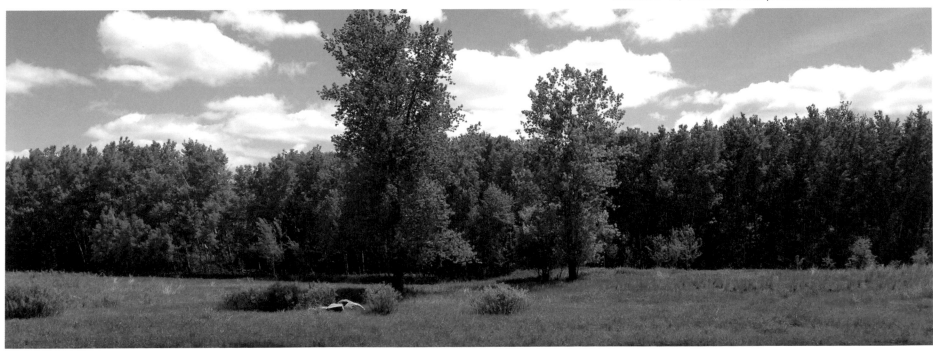

Quarry Park opens to little fanfare, large expectations

Park is county's gift to public this holiday season

By Jerry L. Carter
TIMES STAFF WRITER

Stearns County's gift to the community this holiday season will be a pristine, rugged, regional park located in the midst of a rapidly growing urban community.

"It will be a silent opening, but we want people to get in some hiking still this year, and, if we get snow, some skiing too," Stearns County Parks Director Chuck Wocken said of the 250-acre Quarry Park and Nature Preserve.

The park officially opened Wednesday, Wocken said.

Years in the making, Quarry Park's opening marks the success of preserving one of the areas most beautiful and nearly untouched natural areas, which comes with a deep history about the granite quarrying industry, officials say.

"Quarry Park will be like a small Yellowstone Park for Central Minnesota," Stearns County Commissioner Rose Arnold said. "People from all over will flock to it, but mostly it will be a place for the locals to enjoy."

The first phase of the park project, which began this summer, is nearly completed. It includes an entrance, parking area, an over-

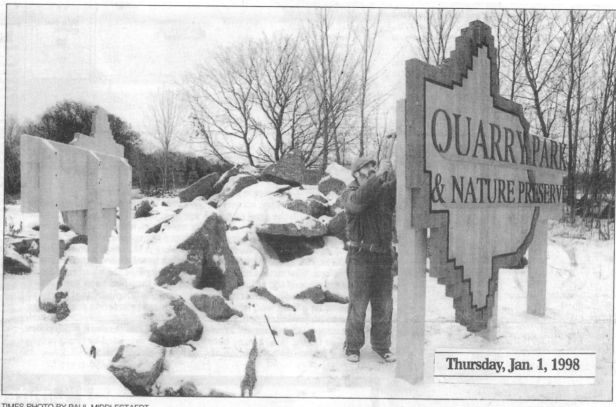

Thursday, Jan. 1, 1998

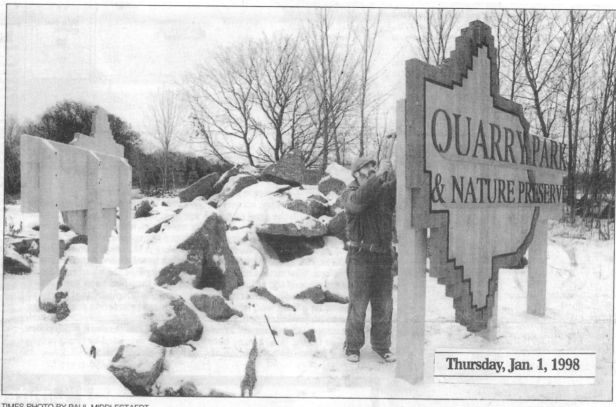

TIMES PHOTO BY PAUL MIDDLESTAEDT

Jim Burke, a park maintenance worker, put the finishing touches on the entrance signs to the Quarry Park and Nature Preserve. The signs, which greet visitors along Stearns County Road 137, were made in-house by the Stearns County Park Department.

SUCCESS IN '97

look from the top of a granite rock pile, a viewing area between two quarries, a swimming platform and a pathway that ties them all together, Wocken said.

Crews at the park, just off Stearns County Road 137 southwest of downtown Waite Park, are finishing clearing trees for trails and officials are trying to figure out who will open and close the gates.

When all the details are finished and figured out, the park will have about 3 miles of groomed trails.

Cost of the first phase didn't exceed the $250,000 appropriated to the project through a state bonding bill.

Granite dust and chips have been used to make the 10-foot-wide, handicapped-accessible trail that will link the 220-acre park from east to west. Wood decking, metal rails and granite boulders will be used for platforms.

The park has a swimming deck on the Melrose Deep Seven quarry — complete with a floating deck.

Please see **QUARRY, 2A** ▶

KEY EVENTS IN COUNTY
■ Government issues in 1997/**6A**

NINE-DAY COVERAGE

Sunday:	Crime and safety
Monday:	K-12 education
Tuesday:	Higher education
Wednesday:	City government
Today:	County government
Friday:	The Legislature
Saturday:	Entertainment and sports
Sunday:	Growth
Monday:	Health

Quarry

The quarry has always been a popular illegal swimming hole for kids, Wocken said. They will soon find a safer environment to splash in.

This year was just a start to the park, Wocken said. Next year could bring more land acquisition and new additions.

The land in Quarry Park was owned by local granite companies until 1992, although quarrying operations ceased in the mid-1950s. Stearns County purchased the first 220 acres in 1992 for about $200,000 and added it to parks system.

At the beginning of 1997, the county bought 30 more acres, for the about the same amount they paid for the first 220.

The property where the park is located was annexed into the city of Waite Park in 1995, which drove up land values.

Wocken and county officials plan to ask the state for $7.7 million next year for phase two, which includes building an indoor learning center and restoring the area to its pristine state with oak savannas and prairie areas.

"Our first priority will be land acquisition," Commissioner Mark Sakry said. "We need to secure the property to the south of the park so it isn't lost forever."

Officials want to nearly double the size of the park next year and are in negotiations with some landowners. It will cost about $2.17 million for the expansion.

Besides buying land, the county also wants to increase services at the park and preserve the quarrying history.

A quarry derrick will be reconstructed as a park centerpiece. Eventually, an interpretive center, an outside classroom and a maintenance center will be built.

They will all use natural elements and materials used in the quarry business to give the park a rustic look, said George Watson, president of Brauer and Associates, the consulting firm designing the park.

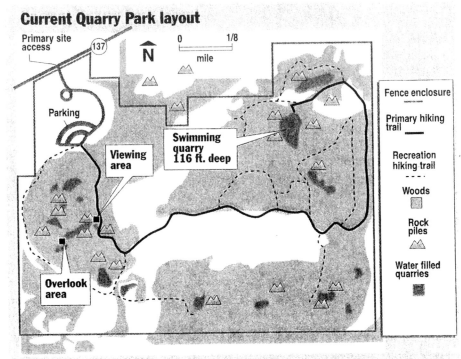

Current Quarry Park layout

Primary site access

Parking

Viewing area

Swimming quarry 116 ft. deep

Overlook area

0 1/8
mile

N

Fence enclosure

Primary hiking trail

Recreation hiking trail

Woods

Rock piles

Water filled quarries

Source: Stearns County Park Department

TIMES MAP BY MARK MARSHALL

Used with permission of the *St. Cloud Times*

Quarry Park expansion plans meet resistance

Waite Park officials worried about potential political, financial fallout

By Kirsti Marohn
TIMES STAFF WRITER

Expanding Quarry Park and Nature Preserve may be more costly — both financially and politically — than Stearns County officials first thought.

Waite Park city officials aired several concerns Saturday about the proposed park expansion during a meeting with county commissioners, the county park board and interested citizens.

Waite Park is concerned that the county's plan to purchase an additional 393 acres for the park will hurt the city by taking valuable land off the tax rolls and forcing changes in its long-range plan for road improvements.

The county has approved a $2.67 million bond to acquire property to the south of the existing 252-acre park, with help from a $1 million Reinvest in Minnesota grant through the Department of Natural Resources.

A larger Quarry Park does not necessarily benefit Waite Park, Mayor Rick Miller said.

"This isn't cheap to the city of Waite Park," Miller said. "I'm not saying it's good or bad, I'm saying it's not cheap."

Among the concerns expressed by Waite Park city officials:

■ Expanding the park will remove land from the city's tax base — land that the city had targeted for high-priced housing developments.

■ The park expansion would change plans to extend 33rd Street South (Waite Park's 19th Street South) to connect with Minnesota Highway 15.

■ A larger park may cause more parking and security headaches.

■ Plans to renovate 10th Avenue South, on the eastern edge of the park, would have to be changed.

■ About 325 acres of existing or expansion park land is included in an 800-acre drainage basin from Second Avenue South, which the city plans to renovate in the future. The city had planned to assess property owners for the drainage, for an estimated $630,000 in revenue.

■ City officials also wonder who would be assessed for road improvements along park land.

Stearns County officials also just recently learned that a Waite Park ordinance may require them to get city approval for subdividing some of the property they wish to purchase.

County commissioners expressed some frustration that Waite Park is dragging its feet on the park project, which they say a majority of county residents support.

"I'm not sure Waite Park would want to get in the way by not granting a subdivision," Commissioner Mark Sakry said.

Sakry provoked the ire of some Waite Park officials when he suggested that the county might simply ask the state, which does not have to abide by

Please see **PARK, 6A** ▶

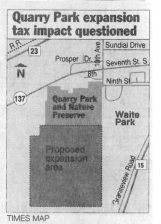

Quarry Park expansion tax impact questioned

TIMES MAP

FROM PAGE 3A

Parks

local ordinances, to purchase the land and sell it to the county.

"We don't want to play that game, but the county board is determined to get this project done," Sakry said.

The proposed expansion includes many granite rock outcroppings, the only remaining undeveloped area in Stearns County with such formations, said Bob Djupstrom, superintendent of the DNR's Scientific and Natural Areas.

The area also is home to the rare red-shouldered hawk and the endangered tubercled rein orchid, Djupstrom said, which have thrived in the combination of wetlands and forests. He called the park expansion "the last opportunity to really preserve that large block of habitat."

Land purchased through RIM funding would not be developed, but rather left natural with a trail around the perimeter. Hiking, snowshoeing and cross-country skiing would be allowed.

Some commissioners and park board members argued that a large regional park will be a boon to Waite Park, attracting higher-priced homes, restaurants, hotels and gift shops.

"This park is going to draw a high-quality residential development around it," said Dick Hall of St. Cloud, a member of the county park commission.

Djupstrom agreed, saying similar natural areas in the Twin Cities have attracted large homes around them.

"They do become a very big local draw," he said.

County officials also noted that developing the land in the proposed expansion area would be difficult because about 15 percent of the land is home to the rare orchid and would be affected by the Endangered Species Act. About 25 percent has granite outcroppings at or just below the surface, meaning it is possible but difficult to develop.

Waite Park leaders said they are not necessarily opposed to Quarry Park. The city has never taken a stand on the issue until now, Miller said.

"The park can be a great thing for the city of Waite Park," Miller said. However, he noted that "your park is getting bigger than what we started with."

Waite Park city officials agreed to consider the subdivision issue at their Jan. 12 city council meeting. They asked the county to pay the cost of the drainage assessments. County commissioners said they would consider it.

"I'm glad that we have the issues on the table with this," Commissioner Rose Arnold said. "I hope to address all of these issues, but at this time, I don't know how."

County leaders said they are anxious to move forward with the project.

"We think it's time to close the deal on this Quarry Park expansion," Sakry said.

Although Quarry Park officially opened to the public on Wednesday, December 31, 1997, a Quarry Park groundbreaking ceremony took place on July 1, 1997.

On Sunday, June 14, 1998, in spite of early and continued resistance to *expansion* of the park, the City of Waite Park promoted Quarry Park's grand opening as part of its annual Spass Tag Festival. Clearly, Waite Park residents were enjoying Quarry Park from its earliest days!

There's an interesting answer to the question, "How do you eat an elephant?" The answer: "One bite at a time." That's a bit how Stearns County proceeded with its efforts to expand Quarry Park . . . one parcel at a time! After the initial purchase of 219 acres from Cold Spring Granite in 1992 and the 1996 purchase of the Mike and Lois Lehmeier two-acre parcel at the entrance to the park, the next parcel purchased was thirty acres from Bob and Helen Trisko. The Triskos' private residence is located just north

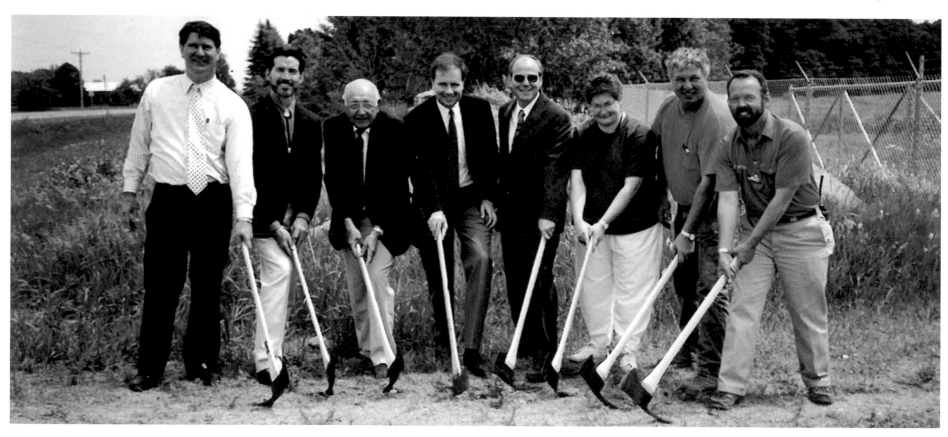

Quarry Park groundbreaking, July 1, 1997. Left to right: County Administrator George Rindelaub, landscape architect Jeff Schoenbauer, County Commissioner Bob Gambrino, State Representative Jim Knoblach, County Commissioner Mark Sakry, St. Cloud State hydrologist Jean Hoff, general contractor for Phase I development, Mike Watercott, and Stearns County Park Director Chuck Wocken. (Courty of Stearns County)

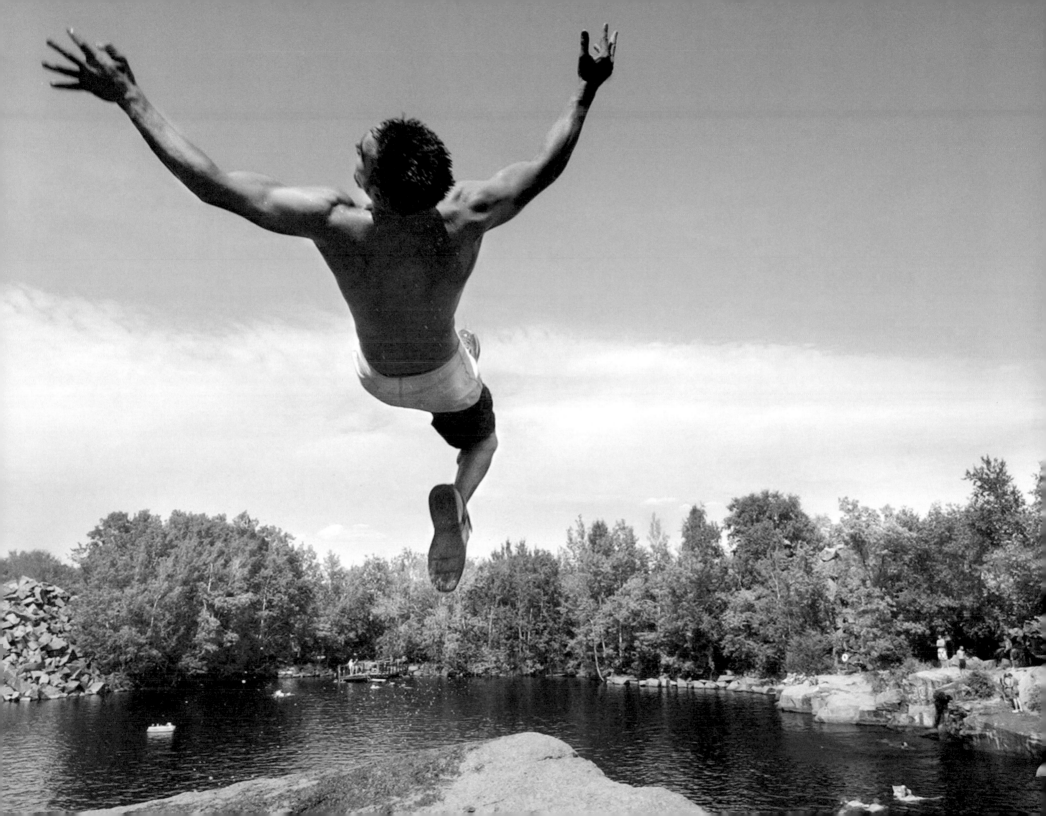

Waite Park wavers on park plan

Land acquisition would remove key properties from city's tax rolls

By Kirsti Marohn
TIMES STAFF WRITER

Hoping to keep the expansion of Quarry Park and Nature Preserve on track, Stearns County commissioners are looking for ways to address Waite Park's concerns with the project.

Waite Park officials have expressed concern that expanding the park may not benefit the city because it would interfere with the city's road improvement plans and would remove prime land from the city's tax rolls.

The county board agreed on Tuesday to try to have answers to Waite Park's questions about the expansion before another meeting with the City Council on Jan. 30. The board also appointed a committee to study the issues.

"We need everybody that can answer those issues that...(were) brought up," said Commissioner Rose Arnold.

The county needs Waite Park's support for the project, because the City Council needs to approve subdivisions of five parcels of land before they can be sold to the county, said Chuck Wocken, county parks director.

The county has given initial approval for a $2.67 million bond to acquire 393 acres to the south of the existing 252-acre park in Waite Park. Grant money from the Department of Natural Resources would help pay for the land acquisition, which includes wetlands, 120-year-old forests and granite rock outcroppings. It also is home to some rare species, including the red-shouldered hawk and the endangered tubercled rein orchid. Much of the park expansion would be kept natural.

The county is working against the clock to purchase the land for the expansion. The purchase agreement between the Trust for Public Land, which is working for the county, and landowner Marlyn Libbesmeier for 133 acres expires March 31. The county also is concerned that property values will increase.

One of Waite Park's concerns is that if Stearns County buys the land, it cannot assess property owners for drainage when it renovates Second Avenue South. The city estimates that 325 acres of existing or expansion park land is included in an 800-acre drainage basin, worth an estimated $630,000 to the city in assessment revenues.

Commissioner Mark Sakry, also a member of the park commission, said one way to avoid paying Waite Park for the assessment values could be to hold off on the assessments until the county received federal funding to extend 33rd Street South (Waite Park's 19th Street South), on the south side of the park, to connect with Minnesota Highway 15. Some of the federal funds probably could be used to pay for the drainage assessments, Sakry said.

The county will ask Waite Park to discuss the subdivision issue at its Jan. 12 City Council meeting. A public hearing also must be held.

The commissioners will meet again with Waite Park City Council and county park commission members on Jan. 30 at 9 a.m. at Waite Park City Hall.

Used with permission of the *St. Cloud Times*

"Where's Waldo?" Can you spot the groundhog out on a stroll to find his shadow? The furry rodent, also called a marmot (*Marmot monas*), is famous for predicting spring. If he sees his shadow, there will be six more weeks of winter; if he can't, spring is on the way. Of course, this practice of pulling a woodchuck from its den on February 2 to see if he can see his shadow makes a lot more sense in Pennsylvania, where it started, than in Minnesota, where we almost never have spring begin in early February . . . or early March . . . and sometimes not even in early April. (Courtesy of the Stearns County Park Department)

Waite Park

CITY NEWS

Summer, 1998 Volume II, Issue III

Grand Opening
QUARRY PARK & NATURE PRESERVE
Huge Success!

The grand opening of Quarry Park & Nature Preserve was held in conjunction with Waite Park Spass Tag on Sunday, June 14.

Events at the grand opening included wildlife, plant, geology and history tours of the park. Tours were given by local volunteer experts on various aspects of the park. John Decker led tours on the history of the park and granite quarrying. Ralph Gundersen & Linda Peck led tours on the habitat that provides a home for wildlife. Tours on the geology of the park were given by Jean Hoff, and Steve Saupe led tours on its plant life.

Free horse drawn trolley rides were provided by Golden Shoe Stables. Waite Park Cub and Boy Scouts, Mel Kramer, and other adult volunteers, served free refreshments and snacks.

The entrance to Quarry Park & Nature Preserve is getting an addition. A small gatehouse is being constructed. This gatehouse will be the place to purchase a park sticker and obtain information about the park. Those people arriving at the park when the gatehouse is not staffed may purchase a park sticker at the pay box next to the gatehouse.

A park sticker is required for each vehicle driving into Quarry Park & Nature Preserve. The purchase of the sticker gives the park users the responsibility of bearing part of the cost of the park operation. A one-day sticker for a car is $2; for a bus it is $15. A one-year sticker for a car is $10. The park sticker system is similar to the system used in state parks. Vehicles without park stickers can be ticketed.

Another new addition to the park is a bike trail. It is the primary trail in Quarry Park & Nature Preserve. Park commissioners decided that this trail should be open for family and recreational bicycling. The trail is a ten foot wide granite dust trail running from the parking lot to the swimming quarry, a distance of one and two-tenths miles.

Visitors to the park have been requesting the use of this trail so

(Continued on Page 2)

From Our Mayor:

The results of the Citizen Survey will be in the next issue of the newsletter. You can still bring your survey to City Hall or mail it with your water bill.

Inside:

Scouting Activities Become "Adventures" with Volunteer Help!... Page 2

Spass Tag Festival Abounds With Winners...Page 3

PLUS MUCH MORE!!

of the park, but they also owned a thirty-acre parcel, located in the park's proposed expansion area, southwest of the "Hundred Acres" site. The Trisko thirty acres includes one of two quarries historically known as "Holes Brothers Quarries."

The County Board experienced "sticker shock" when we saw the certified appraisal completed on the Trisko thirty-acre parcel come in at $210,000. The Trisko asking price was originally $275,000, but they agreed to a $250,000 selling price after knocking off what they considered a $25,000 donation. Ultimately, the county agreed to the $250,000 price tag. The per-acre cost was $8,333, compared to the purchase from Cold Spring Granite just four years earlier at $1,091 per acre! However, it should be noted Cold Spring Granite was exceptionally generous to sell the large parcel for $240,000, since the certified appraisal came in at $370,000. Commissioner Leigh Lenzmeier commented, "We are in a difficult spot. It is going to be very tough to get other property if every time we go to the table we are looking at $7,000 to $10,000 an acre." Stearns County paid $145,000 toward the Trisko parcel and received a grant for $105,000 from the Minnesota Department of Natural Resources (DNR) to cover the balance.

As it turned out, the next large purchase to expand the park, the 133-acre parcel from Marlyn and Esther Libbesmeier, sold for $8,335 per acre, a couple dollars more per acre than the Trisko property.

Used with the permission of the *Waite Park City News*.

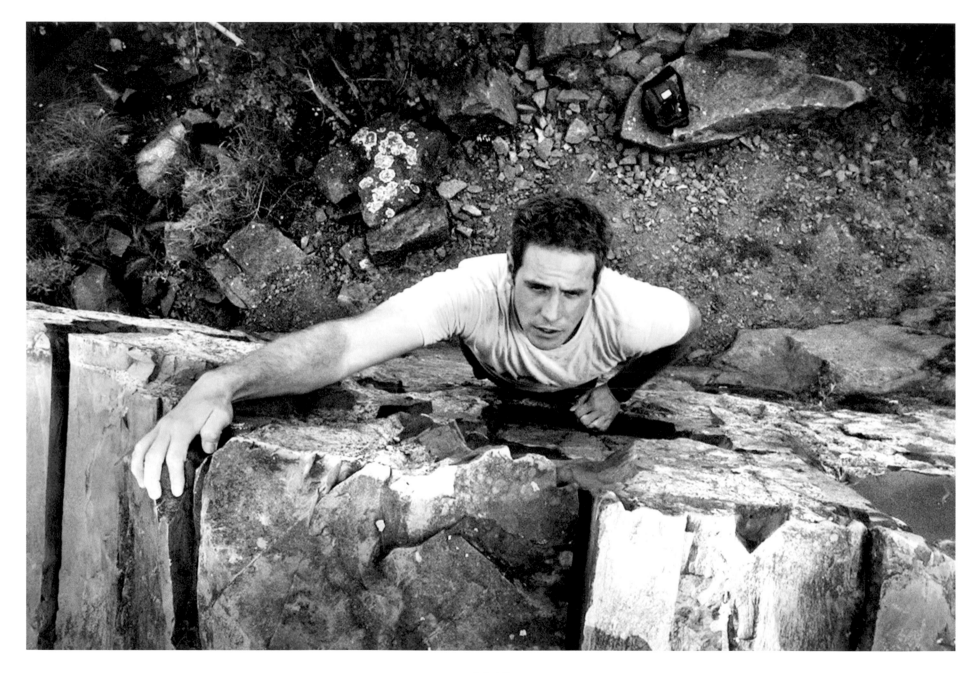

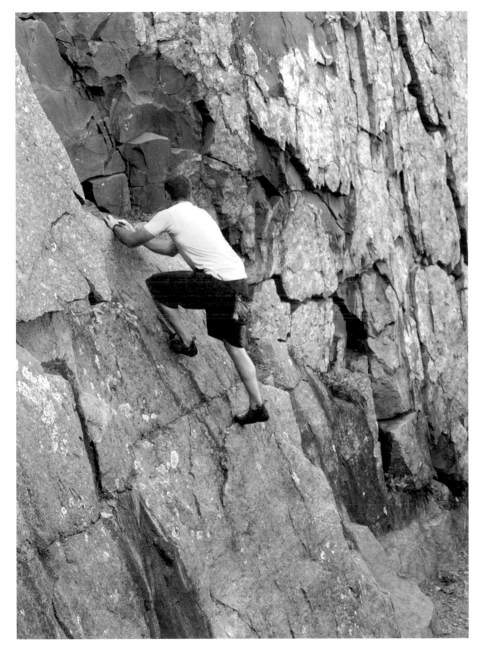

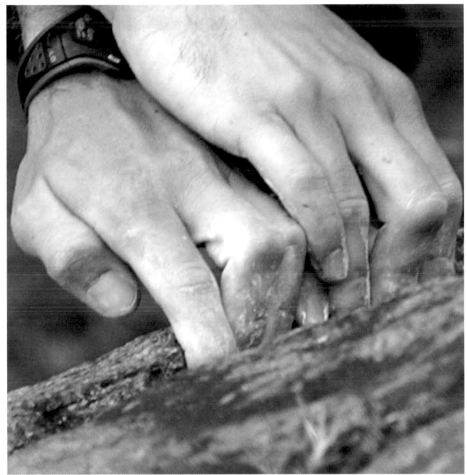

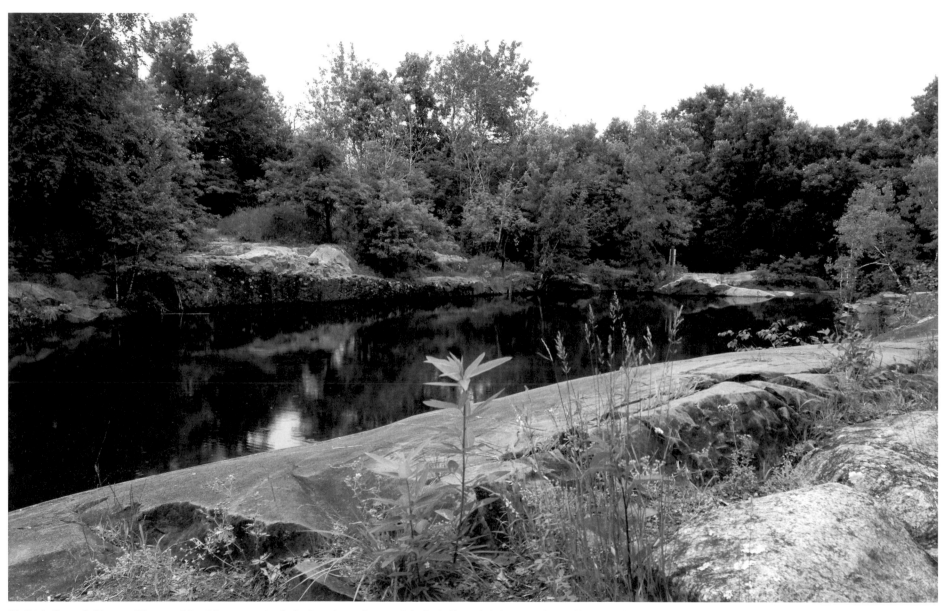

"Bathtub Quarry" (Quarry 13) earned its nickname not only for its unique elongated, bathtub-like shape but because scuba divers found a real discarded bathtub at the bottom of the quarry. It was left there, and now it's a popular site for scuba diving and taking underwater photos with divers sitting in the tub. (Author's Collection)

Chapter 5

How Big Should This Park Be?—The Community Weighs In

N MID-1994 STEARNS COUNTY went out for bids to hire a landscape architect to assist in the planning process for Quarry Park. The contract was awarded to Brauer and Associates (a landscape architectural firm) from Golden Valley, Minnesota. Jeff Schoenbauer, landscape architect from the firm, served as the project manager. Several public information meetings took place in 1994 at Discovery School in Waite Park to seek input on what kind of activities should be included in the master plan for Quarry Park. Schoenbauer and Chuck Wocken did an excellent job hosting the hearings and incorporating the public's wishes into the master plan. At these meetings the public began to see the potential for a regional park. By definition, a regional park is generally 1,000 acres or more. The ultimate "build out" for Quarry Park at nearly 700 acres began to take shape.

The State of Minnesota gives special recognition and protection to areas qualifying for and designated as a Scientific and Natural Area (SNA). Minnesota Department of Natural Resources (DNR) Botanist/Plant Ecologist Michael Lee explains how the SNA portion of Quarry Park differs from the more "active" and developed areas in Quarry Park:

> In general, SNAs do not have developed trails, unless they were there when the land was acquired by the DNR. Other than parking/access points and some interpretive signage, the idea is to leave the land in an SNA in its natural state, undeveloped and unimproved (trails fall under the category of recreational

improvements). People are free to hike and explore the land as they like, but trails are not typically developed or maintained for that purpose.

The perimeter trail at Quarry Park SNA was somewhat of an exception as it was constructed after the land was acquired and the SNA was dedicated. This exception was a compromise between the county and the SNA program to allow for a slightly improved recreational experience for hikers (to connect to the existing county park trail system, to provide a significant increase in trail length/mileage in the larger park unit, and to connect to county park land on the south side of the SNA). The perimeter trail also serves as a fire break for prescribed burning, used periodically to manage the fire-adapted woodlands, outcrops, and wetlands in the SNA.

Over half of the acreage in Quarry Park and Nature Preserve is designated by the State of Minnesota DNR as a SNA, a Scientific and Natural Area.* SNAs are sometimes referred to as a State Natural Areas, as is the case on the brown, wood-routed sign located at the northwest entrance to the SNA.

This statement is accurate if the thirty-acre Trisko parcel is considered part of the SNA. Since the Trisco thirty was purchased with help from the DNR's Natural and Scenic Area grant program, it technically is not an SNA. However, for management purposes and because the parcel is SNA-quality habitat, essentially the same condition as the Libbesmeier parcel, Stearns County Park Department manages the Trisco parcel as part of the SNA.

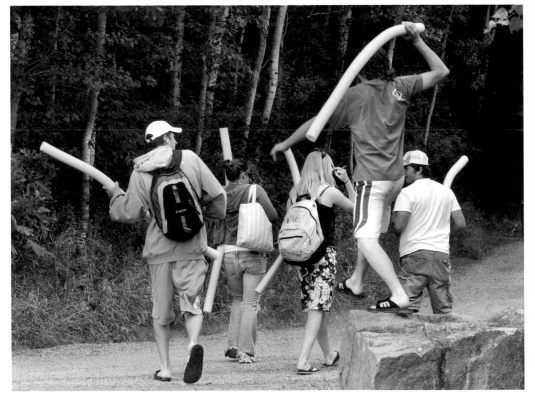

County maps park ideas

Advice from future users shapes possible Quarry Park designs

By Patty Mattern
TIMES STAFF WRITER

11-27-94

The wait for a new recreation area is far from over, but by January or February local officials hope to have a master plan for development of Stearns County's Quarry Park.

Development plans have been narrowed to two designs, and officials are soliciting public comment and ideas on the plans. Once a plan is chosen, it still will be five to seven years before the park opens, said Chuck Wocken, director of the Stearns County Parks.

Mountain bikers, hikers, rock climbers, skiers and nature lovers have had their hearts set on enjoying Quarry Park since Stearns County purchased the 228-acre parcel of land in 1992.

A local company began mining red granite at the site at the beginning of this century. The work left the land with many attractive characteristics for people involved in outdoor activities.

But the county has erected a fence and has tightly controlled the use of the land for liability reasons. Until the park is developed, local residents only get to use the park during specially planned events.

During the wait, future park users have given a lot of advice to park officials on how to develop the park and officials have listened, Wocken said.

Those ideas, and information gathered in several studies, directed a landscape architect from Brauer and Associates to create two prospects for the park.

The plans are similar.

In one, the entrance to the park comes off Stearns County Road 137 and parking is in the northwest field.

From the parking lots, people will step into an interpretive center where they can learn about the site's biology, geology and history. From the center, users will enter the active area of the park, which will include activities such as swimming, mountain biking and camping.

A soft-surfaced path will allow users to make their way through the park; a boardwalk over the wetland would allow people to enjoy that area.

The second plan brings visitors in through the same entrance, but a series of smaller parking areas are about 800 more feet into the park.

From there, visitors could take a paved path around the park's perimeter.

TIMES PHOTO BY KIMM ANDERSON

Stearns County Park Director Chuck Wocken uses quarry models like this one of Quarry 8, as well as aerial photographs and topographical maps, to help plan Quarry Park.

WHAT KIND OF PARK DO YOU WANT?

Stearns County and the St. Cloud Times want to know which plan for Quarry Park you prefer – Concept A or Concept B?

What recommendations or ideas do you have for the park?

Call 255-0447 before 8 a.m. Monday and tell us your preference as well as your ideas and suggestions. Please leave your name and daytime phone in case we have additional questions.

ST. CLOUD Times

Call in 255-0447

Park officials and park users favor the first plan, Wocken said.

"With the amount of land at our disposal, Plan A is going to do less damage to the land whereas Plan B routes roads through the park using up more land," said Marty Tabor, owner of Out-N-About Gear. Tabor has helped in park planning.

Plans for Quarry Park are heading in

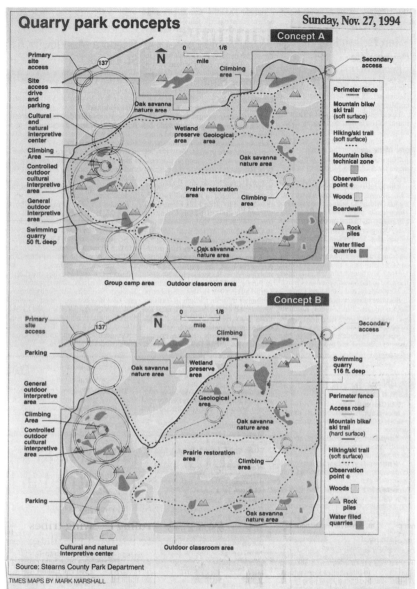

Quarry park concepts

Sunday, Nov. 27, 1994

Concept A

- Primary site access
- Site access drive and parking
- Cultural and natural interpretive center
- Climbing Area
- Controlled outdoor cultural interpretive area
- General outdoor interpretive area
- Swimming quarry 50 ft. deep
- Climbing area
- Oak savanna nature area
- Wetland preserve area
- Geological area
- Oak savanna nature area
- Prairie restoration area
- Climbing area
- Oak savanna nature area
- Group camp area
- Outdoor classroom area
- Secondary access

Perimeter fence
Mountain bike/ski trail (soft surface)
Hiking/ski trail (soft surface)
Mountain bike technical zone
Observation point
Woods
Rock piles
Water filled quarries

Concept B

- Primary site access
- Parking
- General outdoor interpretive area
- Climbing Area
- Controlled outdoor cultural interpretive area
- Parking
- Climbing area
- Oak savanna nature area
- Wetland preserve area
- Geological area
- Oak savanna nature area
- Prairie restoration area
- Climbing area
- Oak savanna nature area
- Swimming quarry 116 ft. deep
- Secondary access

Perimeter fence
Access road
Mountain bike/ski trail (hard surface)
Hiking/ski trail (soft surface)
Observation point
Woods
Rock piles
Water filled quarries

- Cultural and natural interpretive center
- Outdoor classroom area

Source: Stearns County Park Department

TIMES MAPS BY MARK MARSHALL

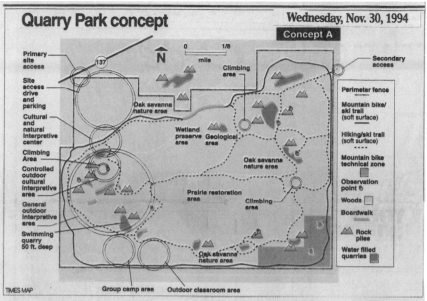

Quarry Park concept

Wednesday, Nov. 30, 1994

Concept A

- Primary site access
- Site access drive and parking
- Cultural and natural interpretive center
- Climbing Area
- Controlled outdoor cultural interpretive area
- General outdoor interpretive area
- Swimming quarry 50 ft. deep
- Climbing area
- Oak savanna nature area
- Wetland preserve area
- Geological area
- Oak savanna nature area
- Prairie restoration area
- Climbing area
- Oak savanna nature area
- Group camp area
- Outdoor classroom area
- Secondary access

Perimeter fence
Mountain bike/ski trail (soft surface)
Hiking/ski trail (soft surface)
Mountain bike technical zone
Observation point
Woods
Boardwalk
Rock piles
Water filled quarries

TIMES MAP

Readers want Quarry Park plan that preserves nature

Of 20 callers, 18 prefer Concept A

By Patty Mattern
TIMES STAFF WRITER

Quarry Park architects should not disturb the natural state of the land as they plan development of the park, Times readers said in a call-in this week.

The call-in offered readers a choice of two concepts for developing the 229-acre parcel, known as 100 Acres Quarry, purchased by Stearns County in 1992. It is not expected to open for several years.

"I would like to see the park left as it is as much as possible," said St. Cloud resident Elena White. "It seems like all you would need is a parking lot and forget about the fences and too much development. It's very nice the way it is."

Other callers agreed.

Lois and Chuck Head prefer more walking trails and less vehicle traffic.

"I really don't want the park covered with asphalt," Lois Head said. "The less asphalt the better."

Keep the trails out of the center of the park, so wildlife isn't disturbed, said caller Ken Hiemenz, of St. Joseph.

Maps laying out the two plans — concept A and concept B — appeared in the Times Sunday. Readers were asked for their opinions on the concepts.

Of the 20 people who responded, 18 said they liked concept A and two callers gave no preference.

In concept A, the entrance to the park comes off Stearns County Road 137 and parking is in the northwest field. From the parking lots, visitors step into interpretive center where they can learn about the site's biology, geology and history. Upon leaving the center, park visitors enter swimming, camping or mountain biking areas.

A soft-surfaced path would take users through the park.

The location of parking lots and a paved perimeter path are the main differences between the two concepts. A series of smaller parking areas would be developed further into the park.

Some callers suggested a few modifications to the plan.

Numerous readers said they wanted two swimming quarries in the park.

"My concern with concept A is that the swimming quarry appears to be half the size of swimming quarry in concept B," said Brian Buck, of St. Cloud. "Can we have the larger swimming quarry and is it possible to have both of those as swimming quarries?"

Caller Tim Groff said the plans do not

use the best quarries for swimming and he would like others to be considered as possible swimming areas.

"The two best quarries for swimming are Benzi 14 and Horseshoe?" Groff said. "They're smaller, but you could regulate passes so only a limited number could go to them."

On dry land, several callers disagreed about whether hiking and mountain biking surfaces should be hard or soft.

Mountain bikers prefer the soft surface, said one caller from Paynesville.

Other callers, however, were concerned about the handicap-accessibility of the trails.

"I'm wondering if plan B won't be better for handicap accessibility and a little bit easier for handicap people to get around in the park," said Tess Armstrong of St. Joseph, who added that her preference is plan A.

Craig Heurung, St. Cloud, reminded officials not to forget to include the history of the granite industry in the park plan something Stearns County Park Director Chuck Wocken has said that plans do include focusing on this industry.

Call in Results

ST. CLOUD Times

a direction that few county and city parks go, Tabor said.

Often parks are mowed fields with picnic tables where visitors can enjoy a picnic lunch and playground equipment, he said. Quarry Park has more opportunities.

"This park, it is a greater recreation park with rock climbing walls and

there is some good mountain biking," Tabor said.

Although Tabor knows it will take several years until an interpretive center is built, he said he believes parts of the park will be opened in stages for activities such as biking and hiking.

For now, the county will accept recommendations from the public. At the beginning of 1995, Wocken said, the

best of the two plans will probably be combined.

Once a master plan is drawn, the fate of Quarry Park rests on the county's ability to get funding, Wocken said.

"The million dollar question of when the park opens ties into the county allocating funds and landing some grants," Wocken said.

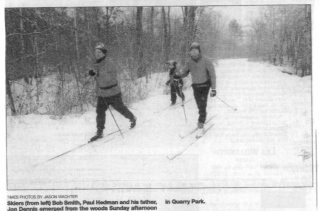

TIMES PHOTOS BY JASON WACHTER
Skiers (from left) Bob Smith, Paul Hedman and his father, Jon Dennis emerged from the woods Sunday afternoon in Quarry Park.

Hikers, skiers find haven at Quarry Park

Minimal snowfall, before today, means ski patrol has been on foot, not skis

By David Sáez
TIMES STAFF WRITER

Snow flakes rained down, slapping the remaining oak leaves dangling above the Quarry Park and Nature Reserve cross-country skiing and hiking trail.

This was the scene late Sunday in Waite Park as three skiers wrapping up a 45-minute tour of the trails were met by David Carlson.

Carlson, along with 11 other local skiers, is a volunteer ski patrol member for the park on Saturdays and Sundays. It is his job to scour the trails, make sure no one is lost or injured, and close the park at 4 p.m.

Minimal snowfall — at least until Sunday — has made the ski patrol more of a hiking patrol since this Stearns County public park officially opened on Dec. 31.

Hikers have made the most use of the park lately. On opening day, Carlson said, 30 cars filled the parking lot. Since, he said, he's sees about five cars a day on his two-hour shift.

"We just haven't had enough snow to ski," Carlson said.

The patrol members carry a radio that enables them to communicate with the sheriff's department if there's an emergency. There have not been any such occasions. In fact, he said, there have been no problems with littering.

Clean air and fresh snow drew St. Cloud resident Larry Campbell to the park.

Campbell, a social worker at Discovery Community School,

TIMES MAP

The park is off of Stearns County Road 137 in Waite Park. During the winter, it's open from 8 a.m. until 4 p.m.

A one-day park fee is $2, and an annual pass costs $10. For information, call the Stearns County Parks Department at (320) 255-6172.

With his tripod on his shoulder and field camera safe in his backpack, Larry Campbell headed for home after shooting black and white photographs Sunday afternoon in Quarry Park.

> What's neat is that you don't have to drive 50 miles to get here.
>
> **David Carlson**
> VOLUNTEER SKI PATROL MEMBER

spent time Sunday photographing one of the park's scenic overlooks. He said he was trying to capture the contrast of the snow settling on the mounds of granite stones. A pill-shaped icicle clung to his mustache.

"What's neat is that you don't have to drive 50 miles to get here," Campbell said. "Once we get a little bit more snow, people will start using the park more.

"Once people discover the park, they'll come."

Pete Theismann, who works part time as an assistant to the Stearns County park director, jokingly said that the most exciting day the park has had was opening day.

"It's been kind of disappointing because everyone was excited to get it open, and then it never really materialized."

He said about a foot of snow — not the 2 to 3 inches that had fallen by Sunday afternoon — would be best for cross-country skiing.

During winter, the 250-acre park is open from 8 a.m. until 4 p.m. for cross-country skiing, hiking, snowshoeing and ice fishing. It is the largest park in the Stearns County Parks Department system.

Bob Smith, Paul Hedman, and Jon Dennis, were the last three to ski the course Sunday. They talked about the ski-less, volunteer patrol member — about the skiing conditions.

"It's good gliding," Smith said. "In some of the areas there was only an inch of snow separating the granite chips.

"The snow's a little thin, but it's good to have some finally."

Poll shows support for Stearns park bond

Tuesday, Jan. 27, 1998

TIMES PHOTO BY JASON WACHTER
Nancy and Don Dockendorf skied the trails at Mississippi River County Park north of Sartell Sunday afternoon.

Poll: Most back Stearns park bond

Quarry Park expansion might hinge on local matching money

By Jerry L. Carter
TIMES STAFF WRITER

Being taken off the governor's bonding proposal list earlier this month spelled bad news for Quarry Park and Nature Preserve, but the good news is that a majority of residents are willing to increase their taxes to pay to expand the regional recreational area.

"People here are willing to pay to set aside natural areas for future generations," said Chuck Wocken, Stearns County parks director. "It's important that we acquire more land for the park before it is developed. People are willing to finish these projects even though it could mean higher tax levies."

Quarry Park, located in Waite Park, will be the county's best bet for getting a regional park in the midst of an urban area, Wocken said.

A recently completed parks survey says the majority of Stearns County residents polled would support a bond package to buy more land for Quarry Park.

The report says 55 percent of the people surveyed would support a $6 million bond issue to buy more land for Quarry Park and build an interpretive center.

Wocken plans to put together a bond package and bring it to the county board in about a month.

"If we want to be in serious discussion about still getting some state bonding money, we need to match the state dollar-for-dollar," Wocken said. "If we don't, then we can stop thinking about getting on the bonding bill."

Jane Bennett thinks the governor missed the mark by not including Quarry Park on his list of bonding proposals.

"He sure doesn't have his fin-

ger on the pulse of St. Cloud," said Bennett, who lives near Sartell.

In the survey, residents agree that Quarry Park is important and that the county should complete the park's development. Of those polled, 81 percent supported completing the Quarry Park project.

But despite not being on the governor's list, Stearns County residents can still get the park included in the bonding bill.

Bennett, a member of the Natural Parks and Trails Coalition, plans to rally support behind Quarry Park and other park projects in the area.

"It's important we preserve these areas," Bennett said. "We have to convince people to support these projects."

Wocken says he plans to ask for $7.7 million from the state, with the county willing to pick up half the costs.

"That is what we will ask for," Wocken said, "but realistically we would be willing to settle for $2.17 million, which will help us buy more land."

The park has 252 acres, but Wocken would like to see it grow by another 310 acres.

"Land acquisition is our top priority," Wocken said. "If we don't get the land, we probably won't ever have another chance at it."

Please see PARK, 5A ▶

Protecting our open spaces

▼

Environment

Stearns County open spaces survey

A survey of 400 people concerning open spaces and park land was conducted by Ridder and Braden Inc. Percentage of respondents who somewhat or strongly agree with the questions asked is shown.

With all the growth in our community, it is important that we protect natural lands and open spaces for future generations.
96%

Taking steps now to protect open space will preserve our quality of life and maintain the unique character of our community.
96%

An important part of a healthy lifestyle is taking time to enjoy nature by hiking and biking, or even just observing and studying nature much like it was years ago.
95%

If we don't fix our parks and protect natural areas now, we will lose our chance because of development and rising costs.
89%

With the increase of gang activity in our community, it is even more important that we have parks and activities for our young people.
87%

It is important to leave space near commercial development unused in order to buffer residential areas and preserve the beauty of our community.
86%

I would be more likely to support a bond issue for parks and recreation that an independent committee of citizens would decide how to spend the money, and that a public audit would be conducted to make sure the money was spent correctly.
82%

I would be more likely to support a bond issue for parks and recreation if it also included money to purchase land for protection as natural, open space.
74%

Source: Ridder/Braden Inc.

TIMES GRAPHIC

Stearns considers bonds for Quarry Park

County board looks for alternative in case state money is not allocated

By Jerry L. Carter
TIMES STAFF WRITER

Looking at alternative funding for Quarry Park and Nature Preserve, especially given the uncertainty of getting any state dollars,

Stearns County commissioners on Tuesday considered getting a capital bond.

"We want to know where we can get some money if we need it," Commissioner Mark Sakry said. "We are just talking to our financial people to see what our options are."

Commissioners said they were interested in getting a capital improvement bond that would not require a referendum to be approved.

The board would have to approve the bond with at least a 4-1 vote, and it would have a condition that if a certain number of citizens signed a petition, the bond would go to a referendum vote.

"It's what's called a reverse referendum vote," said Dan Hartman, one of the county's financial advisers. "It would be similar to the bond used in 1990 when we built the new courthouse; that bond did not go to a referen-

dum."

Commissioners also asked the county auditor-treasurer to see whether there was any money in the county's general budget that could be used for park acquisition. The board will wait to see whether the Legislature pays for some of Quarry Park.

"We want to be ready if we have to come up with some of the funds for Quarry Park," Commissioner Bob Gambrino said.

At the beginning of the month,

a bill that would provide $3.8 million in state money for completion of Quarry Park and Nature Preserve was introduced to the Legislature.

The money would pay for half the cost of the $7.7 million Stearns County project. Stearns County officials say they need the money to buy additional land, make safety improvements, complete trails and build a granite industry interpretive center.

Please see BONDS, 4A ▶

FROM PAGE 3A

Bonds

Stearns County would have to match any money the state contributes. The county has the authority to borrow money and pay it back over a number of years with increased property taxes.

While Quarry Park supporters want to complete the park as soon as possible, they see an urgency in purchasing the nearby land before it gets too expensive.

The county estimates it needs $2.17 million to buy 310 acres south of the park.

Rep. Jim Knoblach, R-St. Cloud, and Sen. Dave Kleis, R-St. Cloud, are the chief authors of the bill. It is expected that most other Central Minnesota lawmakers will support it.

The park, which is in Waite Park, opened Dec. 31. Park officials say in the first month they gave away 1,000 maps and collected $2,000 in donations. Quarry Park has been before the Legislature since

1992, when then-Rep. Bernie Omann got a $50,000 grant to study whether a park would work. In 1996, the Legislature put $250,000 into construction of the park.

LEGISLATURE '98

Stearns County officials anticipated that this year money for the completion of Quarry Park would be included in the governor's list of projects that receive state money. It was left out.

Those close to the situation doubt Quarry Park can get the full amount. Omann, who is chief of staff for Gov. Arne Carlson, said the governor might support $1 million for land acquisition.

The bill goes through the environment committees. If those committees do not recommend the project for the bonding bill, Knoblach and Rep. Joe Opatz, DFL-St. Cloud, can try to get it into the bonding bill in the House Capital Investment Committee.

Figure 4.2 - Quarry Park and Nature Preserve Master Plan.

POTENTIAL EXPANSION AREA
ON NORTH SIDE OF PARK

PRIMARY OUTDOOR
EDUCATION AREA

OAK SAVANNA
NATURE AREA

WETLAND
PRESERVE

CONTROLLED OUTDOOR
INTERPRETIVE AREA

OAK SAVANNA
NATURE AREA

GENERAL OUTDOOR
INTERPRETIVE AREA

RESTORED PRAIRIE
NATURE AREA

OAK SAVANNA
NATURE AREA

POTENTIAL EXPANSION AREA
ON SOUTH SIDE OF PARK

MASTER PLAN LEGEND

ACCESS ROUTE HIKING TRAIL

RECREATION HIKING TRAIL
(TRADITIONAL-STYLE CROSS-COUNTRY
SKIING ON SELECTED LOOP TRAILS)

MOUNTAIN BIKE TRAIL
(SKATE-STYLE CROSS-COUNTRY SKIING)

OVERLOOK/OBSERVATION POINT

SAVANNA/WOODLOT AREA

PRAIRIE AREA

WETLAND

GROUT PILE/ROCK OUTCROP

PROGRAM LISTING

A – FENCE ENCLOSURE
B – PRIMARY SITE ACCESS
C – MAIN ENTRANCE /
 CONTACT STATION
D – ENTRANCE DRIVE (ONE WAY)
E – PARKING LOT
F – INTERPRETIVE CENTER /
 TRAILHEAD BUILDING
G – OUTDOOR AMPHITHEATER
H – MOUNTAIN BIKE TECHNICAL ZONE
I – OPERATIONS AND MAINTENANCE
 FACILITIES (PREFERRED LOCATION)
J – OPERATIONS AND MAINTENANCE
 FACILITIES (SECONDARY LOCATION)
K – ROCK CLIMBING AREA
L – ICE SKATING
M – OUTDOOR CLASSROOM
N – GROUP CAMP AREA
O – RESTROOM
P – SWIMMING QUARRY
Q – PICNIC AREA
R – BOARDWALK
S – SECONDARY ENTRANCE
T – HISTORIC MINING SCENE
U – ACCESSIBLE OBSERVATION POINT

NORTH

0 200' 400' 600'
SCALE

Used with permission of the Stearns County Park Department.

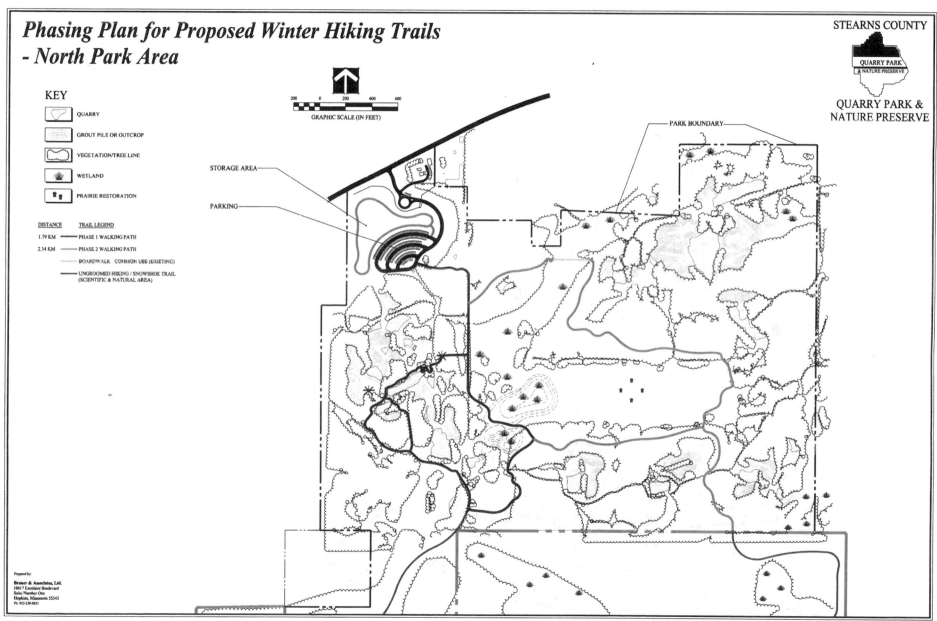

Phasing Plan for Proposed Winter Hiking Trails - North Park Area

STEARNS COUNTY

QUARRY PARK & NATURE PRESERVE

KEY

QUARRY

GROUT PILE OR OUTCROP

VEGETATION/TREE LINE

WETLAND

PRAIRIE RESTORATION

DISTANCE	TRAIL LEGEND
1.79 KM	PHASE 1 WALKING PATH
2.34 KM	PHASE 2 WALKING PATH
	BOARDWALK COMMON USE (EXISTING)
	UNGROOMED HIKING / SNOWSHOE TRAIL (SCIENTIFIC & NATURAL AREA)

GRAPHIC SCALE (IN FEET)

STORAGE AREA

PARKING

PARK BOUNDARY

Prepared by:
Brauer & Associates, Ltd.
10417 Excelsior Boulevard
Suite Number One
Hopkins, Minnesota 55343
Ph. 952-238-0831

Used with permission of the Stearns County Park Department.

[63]

Quarry Park asks for $3.8 million

Stearns County would match state funds for land, improvements

By Dave Aeikens
TIMES STAFF WRITER

ST. PAUL — Quarry Park supporters are seeking state help in sharing the cost of completing the park.

A bill that would provide $3.8 million in state money for completion of Quarry Park and Nature Preserve is expected to be introduced Monday.

The money would pay for half the cost of the $7.7 million Stearns County project. Stearns County officials say they need the money to buy additional land, make safety improvements, complete trails and build a granite industry interpretive center.

LEGISLATURE '98

Stearns County would have to match any money the state contributes. The county has the authority to borrow money and pay it back with increased property taxes over a number of years.

County commissioners plan to meet with a financial adviser Feb. 10 to discuss their options. The county would not have to hold a referendum to raise the money, but could if commissioners wanted.

While Quarry Park supporters want to complete the park as soon as possible, they see an urgency in buying the nearby land before it gets too expensive.

"The time factor is crucial for that. We need to finalize the size of the park before we can really get going on the site improvements," Stearns County Administrator George Rindelaub said.

The county estimates it needs $2.17 million to buy 310 acres near the park.

Rep. Jim Knoblach, R-St. Cloud, and Sen. Dave Kleis, R-St. Cloud, are the chief authors of the bill. It is expected that most other Central Minnesota lawmakers will sign on to support it.

The park, which is located in Waite Park, opened Dec. 31. Park officials say in the first month they gave away 1,000 maps and collected $2,000 in donations.

Quarry Park has been before the Legislature since 1992, when then Rep. Bernie Omann got a $50,000 grant to study whether a park would work. In 1996, the Legislature put $250,000 into construction of the park.

Stearns County officials anticipated that this year money for the completion of Quarry Park would be included in the governor's list of projects that receive state money. It was left out.

Most close to the situation doubt Quarry Park can get the full amount. Omann, who is now chief of staff for Gov. Arne Carlson, said the governor might support $1 million for land acquisition.

The bill goes through the environment committees. If those committees do not recommend the project for the bonding bill, Knoblach and Rep. Joe Opatz, DFL-St. Cloud, can try to get it into the bonding bill in the House Capital Investment Committee.

Knoblach said Stearns County will have to match whatever money the state contributes.

Knoblach said he sees Quarry Park as a statewide asset that would be an attraction for people from all over Minnesota.

"This is an opportunity to be what in many ways is equivalent to a state park," Knoblach said.

The county is prepared to match any state dollars it receives, Rindelaub said. Stearns County probably can raise the money to buy the land without state help, but wants to share the project with the state, Rindelaub said.

The county also has enough bonding authority to finish the project. However, commissioners would have to determine how much debt they want to impose on property taxpayers and whether paying for the park would jeopardize other county projects.

"It would be more difficult without state help," Rindelaub said.

Quarry Park gets $1 million, needs more

Matching grant goes toward land

— May 18, 1998

Recreation

By John Hoogesteger
TIMES STAFF WRITER

Quarry Park has qualified to receive a $1 million state matching grant to help expand the park.

Stearns County Parks Director Chuck Wocken said the grant has been approved through the Reinvest in Minnesota, or RIM, program, overseen by the Department of Natural Resources.

The grant comes in the wake of rejections in efforts to have money for Quarry Park specifically placed in the state bonding bill during the legislative session.

"Thanks be to God," Wocken said Friday after receiving news of the grant approval.

It's the first good financial news Wocken has received in awhile.

Wocken spent months lobbying unsuccessfully during the Legislature, first seeking $3.8 million, then trying to get $1 million, lastly hoping to salvage $150,000 and ultimately getting no dedicated bonding money.

Even before the session had

Please see QUARRY, 5A ▶

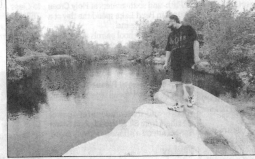

TIMES PHOTO BY JASON WACHTER

Chris Kurtz wandered through Quarry Park and Nature Preserve Friday afternoon looking for fish in the quarries.

Unexpected bike traffic creates quandary

By John Hoogesteger
TIMES STAFF WRITER

Quarry Park is experiencing unanticipated demand from bicyclists, and it's creating a dilemma for Stearns County Parks Director Chuck Wocken.

When the park opened in January, the parks department had made it a priority to complete walking trails. An unfinished mountain bike trail is not usable.

But bikers don't want to wait to use the park. And those bikers aren't just mountain bike riders.

"Bicyclists are deciding they want to share the walking trails," Wocken said. "Officially, those trails are not open for biking."

Wocken estimates that about a third of the people using the park are, in fact, using it for recreational biking.

Wocken said that while they anticipated demand by mountain bike riders, they did not anticipate demand by recreational bikers. Currently no such trails are planned for the park.

Park supervisors want people to use the park, and they don't want to upset bikers by chasing them off footpaths. But they also don't want bikers to usurp the footpaths.

"We have had discussions with the biking community," Wocken said.

Wocken said getting the mountain bike trail completed would at least help to ease the crunch. And the mountain bike path is dependent on the completion of a floating boardwalk, which Wocken hopes he can build in 1999.

Wocken hopes to hear by midsummer whether the park will receive a $50,000 grant for the boardwalk from the Department of Natural Resources' Outdoor Recreation Grant Program.

Both articles used with permission of the *St. Cloud Times.*

Quarry

ended, however, Wocken was lobbying to have legislators dedicate as much money as possible to grant programs such as RIM because he knew he needed to find alternatives to find money to buy land.

Legislators did respond and added money to RIM as the bonding bill progressed, although it still ended up being less than the governor's $11 million recommendation.

While Quarry Park officials can delay building a granite interpretive center, land for expansion probably will be lost if the remaining money cannot be found soon to make the estimated $2 million purchase.

"Acquisition is our No. 1 priority," Wocken said.

The additional 310 acres would more than double the size of the now 250-acre park.

With half the money committed, Wocken now will go before the Stearns County Board of Commissioners seeking funds to raise the other $1 million.

Wocken hopes the commissioners will approve bonding for the money.

"It's certainly something they need to discuss," Wocken said. "I can't say what they'll decide."

The RIM program requires that the land remain in its natural state. It can be used for recreation but cannot be developed.

Quarry Park gets $1 million grant for park expansion

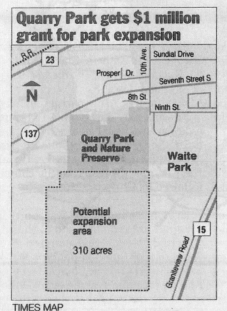

TIMES MAP

TO DONATE

People can send tax-deductible donations for Quarry Park to either the county or a private fund.

Checks made out to the Stearns County Treasurer can go to: Stearns County Parks, 455-28th Ave. S, Waite Park, 56387.

Donations to the Quarry Park Account can be sent to the Central Minnesota Community Foundation, 101 Seventh St. S, Suite 200, St. Cloud, 56301.

Wocken said the targeted land was slated to be the "nature preserve" portion of the park anyway, so that's not a problem.

The county cannot build trails in RIM land, but it would be able to encircle that land with a trail.

And, people would be able to use the land for hiking and cross-country skiing.

If the county chooses not to provide the other $1 million needed to match the grant, Wocken would have to scramble to find the money elsewhere.

Either way, in the wake of not getting dedicated bonding bill money, private donations are more crucial to the park than ever, Wocken said.

Two separate accounts exist for people to donate money to the park, one public and one private.

"Some people want to give money straight to the county and others want to keep private control over the money, so someone else is making the decision to allocate the money to the park," Wocken explained.

And Wocken remains on the lookout to find other grant programs and alternate sources of money.

"It's a matter of seizing opportunities when they arise," Wocken said.

The park should be able to get some money from the state's Natural and Scenic Area grant program. However, the earliest the parks department could apply for a grant from that program is 1999.

The program is designed to preserve scenic areas within urban areas, so the park would qualify. In fact, the Legislature increased the limit on the amount of grant requests that can be made to the program from $200,000 to $500,000 during the past session in part because Quarry Park proponents were there lobbying for money.

There is more than a million dollars in the fund, but its focus is on preserving land in the Twin Cities area.

Match state's $1 million grant for Quarry Park

Public supports Stearns County bonding to complete regional park

Denied state bond money this year, Quarry Park is on its own for land acquisition and park development. Commissioners should jump on a state matching grant of $1 million to acquire $2 million of land to double the size of the park.

At stake is 310 acres of land, a significant natural community in a portion of the former St. Cloud Township. The merger with Waite Park put that land under pressure for residential development.

The land must be acquired soon, or be lost forever.

The 310-acre proposed expansion area "is the only opportunity to protect an intact, landscape-scale portion of this community," according to the Department of Natural Resources.

The DNR notes that the large, natural woodland setting — a 50-acre oak forest with trees between 100 and 120 years old — and rare species — including a breeding population of red-shouldered hawks, Acadian flycatchers and tubercled rein-orchid plants — make this "one of the most important sites in this part of the state." The site also has the most significant remaining example of the Central Minnesota granite outcrop community.

The DNR has put up $1 million from the Reinvest in Minnesota program to acquire the land. Now it's up to county commissioners to match state funding. They should do so without delay, before already astronomical land prices escalate further.

The public would support the effort, according to a scientific survey conducted by Ridder/Braden Inc. in December. Eighty-one percent of those polled supported completing the Quarry Park project. Fifty-five percent said they would support a $6 million bond issue to buy more land for Quarry Park and build an interpretive center.

The priority at this stage, however, should be bonding for $1 million in land acquisition to match the state's commitment to the park. An interpretive center can wait.

The survey should give county commissioners the reassurance they need that the public is behind this effort.

Doubling the size from 252 acres to 562 acres would make Quarry Park a tremendous regional resource providing a host of year-round activities — hiking, biking, rock climbing, cross country skiing, scuba diving and nature study — for the young and young-at-heart throughout our community and the state.

Stearns County commissioners should act quickly to match the state grant.

WHAT YOU CAN DO

Contact county commissioners before their Tuesday meeting to express your views on bonding to match state funds for land acquisition for Quarry Park.

YOUR VOICE

The St. Cloud Times encourages readers to contact county commissioners with county concerns.

STEARNS COUNTY COMMISSIONERS

District 1: Bob Gambrino, Box 743, St. Cloud 56302 252-1578

District 2: Mark Sakry, 413-10th Ave. S, Waite Park 56387, 252-5022

District 3: Rose Arnold, 29353 Lindberg Lane, Avon 56310, 597-2775

District 4: Leigh Lenzmeier, 101 Seventh Ave. S, Suite 201, St. Cloud 56301, 251-0653

District 5: Henry Dickhaus, 635 Fifth Ave. N, East, Melrose 56352, 256-3507

Used with permission of the *St. Cloud Times.*

Focus on future and history in park project, not money

I'm responding to the question of whether to expand the Quarry Park project.

It's always sad when we have to let issues of money and taxes control our decisions, especially when the outcome can affect everyone.

The quarries are a tangible piece of St. Cloud history. This city really doesn't have many historical sites, which is why we need to preserve the ones we have. It's incredible that people are able to see the beauty and majesty of the granite that is our namesake. Let's not rob our children of the opportunity to experience history first hand.

The parks we presently have such as Riverside, Hester and Calvary, are relatively small. Opening up a large, beautiful park really would give the public an opportunity to immerse themselves in nature. Opening up trails would finally give hikers, bikers, skiers and nature lovers a place to dwell. It also would provide safe areas where people can run, bike and [in-line skate] away from the dangers of the streets.

Finally, I feel that we preserve what we value; a community filled with nature and history, or a place of materialism and acquisitions.

Lawrence D. Simmons

ST. CLOUD

Letter to the editor used with permission of the *St. Cloud Times.*

LEAGUE OF WOMEN VOTERS of the St. Cloud Area

October 29, 1998

Commissioner Mark Sakry
413 South 10 Avenue
Waite Park MN 56387

Dear Commissioner Sakry:

At our board meeting on October 22, 1998, the following resolution was passed unanimously:

> The League of Women Voters of the St Cloud Area supports the issuing of bonds for at least $2 million by Stearns County for the acquisition of additional park land for Quarry Park and Nature Preserve, including areas designated as Scientific and Natural Areas by the DNR, and for further development of the park.

This support is based, in part, on our local league position in "support of acquisition and retention of park land, recreational facilities, natural and semi-natural areas in the St Cloud area for present and future park and recreational needs."

We believe it is important to retain natural areas as part of our community's heritage, making a connection between the past and future generations. Natural preservation in the proposed new areas and active recreation in the current park make a good combination that is in conformity with the park's comprehensive plan. Preserved natural areas can be appreciated from a distance or from the edge in much the same way that people can enjoy being near a river or lake without always needing to be actively playing in the water. Furthermore, in a recent survey, the public expressed support for bonding to purchase land for preservation.

Stearns County is lucky to have an extremely hard working and innovative park director who presents you with this once in a lifetime opportunity to expand Quarry Park by acquiring a large, high quality natural area, with the help of a RIM Grant. We appreciate your leadership in support of this park expansion.

Sincerely,

Nancy Gundersen/cb

Nancy Gundersen
President

1807 Woodland Road
St. Cloud, MN 56304
October 30, 1998

County Commissioner
Stearns County
Administration Center
St. Cloud, MN 56396

Dear Commissioner.

I am writing in support of bonding for the expansion of Quarry Park on behalf of the Natural Parks and Trails Coalition, a group of St. Cloud area citizens working together to preserve our natural heritage through park land acquisition, natural area preservation and trail development. The Natural Parks and Trails Coalition facilitated a survey of public attitudes toward parks and open space issues for Stearns County in October 1997. The survey found that 96% of those surveyed agreed that "it is important that we conserve natural lands and open space for future generations." The survey also found that a majority of residents would support issuance of bonds to complete development of and expand Quarry Park.

Statements such as "taking steps now to protect natural areas will preserve our quality of life and maintain the unique character of our community" and "if we don't fix our parks and protect natural areas now, we will lose our chance because of development and rising costs" had 96% and 89% agreement respectively. With such a high level of agreement on these and other similar statements, it is evident that these issues have strong public support. We all need natural areas for our health and well-being. Expanding Quarry Park will help to preserve a unique natural area for future generations that might otherwise be developed and lost forever. As the county continues to grow at a rapid pace, it becomes increasingly important that the few remaining natural areas be set aside for the future. This Quarry Park area is particularly important as habitat for rare native plants, birds and animals, education and aesthetic reasons. If we do not act now, there may not be another opportunity.

Thank you.

Sincerely,

Ellen B. Heneghan

Ellen B. Heneghan
Chairperson, Natural Parks and Trails Coalition

Bond makes Quarry Park top priority

Stearns board OKs improvement plan for parks, trails

By Kirsti Marohn
TIMES STAFF WRITER

Purchasing more land for Quarry Park and Nature Preserve and the Lake Wobegon Trail officially became a top priority for Stearns County on Tuesday.

The board of commissioners approved a capital improvement plan, the first step in a $2.67 million bond project to improve the county's parks and trails.

The commissioners agreed to add $100,000 to the bond to purchase Soo Line property for the extension of Lake Wobegon Trail, but rejected a suggestion to add $100,000 to remodel the Law Enforcement Center's air intake system.

Outdoors/recreation

Several commissioners said they wanted the bond to include park projects only.

"I would hate to see this turned into anything else at this point," Commissioner Rose Arnold said.

The bond amount also includes estimated finance charges.

The capital improvement plan will be submitted to the Minnesota Department of Trade and Economic Development for approval. A public hearing on the bond will be 10 a.m. Dec. 8 in the board room of the County Administration Center.

Land acquisition is listed as the county's top priority in the improvement plan, with other realistic priorities including the development of existing Quarry Park property, constructing a park department maintenance and operations facility at Quarry Park and development at a site other than Quarry Park.

Other priorities, which the county probably will not have enough bond money for, include completing the Lake Wobegon Trail, expanding Two Rivers Lake Park and adding a swim area at Clear Lake.

Commissioner Mark Sakry said the county should tackle the land acquisition and the smaller projects first, then look at the larger projects if there is money left over.

Some citizens spoke in support of the park bond at Tuesday's meeting, including Jane Bennett of St. Cloud, who called the commissioners "visionary" for supporting the bond.

"I think it's going to be very important to the community, especially for the generations to come," Bennett said.

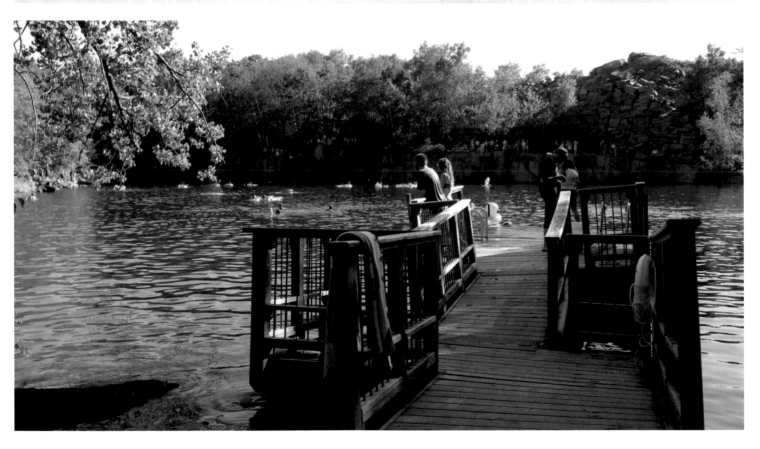

Bond approved for Quarry Park expansion

Stearns board OKs $2.5 million to help purchase 393 acres

By Kirsti Marohn
TIMES STAFF WRITER

Stearns County commissioners have approved a bond of more than $2.5 million for the expansion of Quarry Park and Nature Preserve.

The funding will allow the county to purchase 393 acres of land south of the existing park, with help from a $1 million Reinvest in Minnesota matching grant.

The board voted 4-1 Tuesday in favor of the $2,512,550 bond, with Commissioner Henry Dickhaus opposing.

Commissioners again agreed to make acquiring land the top priority of the expansion project, which has an estimated total cost of almost $4 million.

"If our goal is to acquire the land, that's what it should be," Commissioner Rose Arnold said.

Depending on the cost of purchasing the land, the project also may include, in order of priority:

■ Completing the park's main boardwalk.

■ Moving an old granite derrick, or crane, to the park and reassembling it.

■ Building an automatic gate at the park entrance.

■ Completing a secondary boardwalk.

■ Adding another quarry swimming facility.

■ Adding parking at Two Rivers Lake Park.

■ Building a maintenance/operations building.

■ Extending Lake Wobegon Trail.

However, if the cost of purchasing the land is too high, the county may not be able to finance any of those projects with the bond money.

Commissioner Leigh Lenzmeier said his goal is to acquire as much land for the park as possible, and not worry about developing it right now.

"I'm really not particularly interested in getting into the development game yet," Lenzmeier said.

The commissioners chose a middle-range bond from four choices presented by County Administrator George Rindelaub, which he said included

Please see **BOND, 5A** ▶

FROM PAGE 1A

Bond

"Chevrolet, Oldsmobile and Cadillac" options.

The proposals ranged from $1.8 million to purchase some land and tackle some of the development projects, to $3.3 million to purchase all the land and complete all of the projects, including the extension of Lake Wobegon Trail from Albany to Holdingford.

The remainder of the cost of the expansion project will be paid for through the RIM grant, a $50,000 Department of Natural Resources grant for the boardwalk and a $70,000 Community Foundation grant.

The board set a public hearing for Nov. 24 to draft a capital improvement plan for the project. Another public hearing on the bond will be at 10 a.m. Dec. 8, with a four-fifths majority of the board required to pass the bond.

After the bond is approved, the county financial manager will accept bids from bonding companies, probably sometime in February, Rindelaub said.

The county is required to spend any money it receives from a bond within three years or it loses it. Rindelaub recommended that the board include in its capital improvement plan more than it probably will do, so if the land acquisition is less costly than expected, the county can tackle some of the lower priority items.

Commissioner Mark Sakry argued that the county should not bond for less than $2.5 million because bonds for parks are rare. He said county engineer Doug Weiszhaar has said he needs the storage space that a maintenance building would provide.

Commissioner Rose Arnold said she believes the board should not go over its budget to finance the bond. The county has $190,000 budgeted in 1999 for the annual debt service on a bond.

"We have to decide what we can live with," Arnold said. "We can't have everything."

The estimated debt service on the $2.5 million bond is $201,946 a year over 20 years, Rindelaub said, although it may vary with interest rates.

WEDNESDAY
Nov. 11, 1998

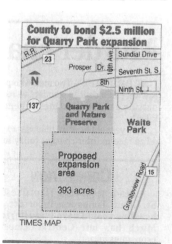

County to bond $2.5 million for Quarry Park expansion

TIMES MAP

Board votes for Quarry Park bond

Stearns County can purchase land to expand park

By Kirsti Marohn
TIMES STAFF WRITER

With very little controversy, Stearns County commissioners gave final approval Tuesday to a 15-year, $2.67 million bond to expand Quarry Park and Nature Preserve.

The bond will allow the county to purchase 383 acres south of the existing park, with help from state grants.

The bond required a four-vote majority. It passed 4-1, with Commissioner Henry Dickhaus opposing it.

"I think that this is a milestone action that the county has taken today," said Chuck Wocken, county parks director.

The 15-year bond will save the county about $400,000 in interest compared to a 20-year bond. Payments on the bond are estimated at $250,000 a year, based on current market rates. The first year's payment will be adjusted to less than $190,000, which is what the county budgeted for 1999, and the rest of the payments will be higher.

Two weeks ago, the board approved a capital improvement plan, outlining how the bond money will be spent. Acquiring land for Quarry Park was named

Please see **BOND, 5A** ▶

FROM PAGE 3A

Bond

as the top priority, with other park improvements listed as secondary.

The county is waiting for approval of the bond from the Minnesota Department of Trade and Economic Development.

Several residents came to the meeting to voice their support for the project. Nancy Gunderson, president of the League of Women Voters, said her organization has come out in favor of the bond.

However, Martin Nier, an advocate for the homeless and poor, said not everyone is in favor of it because of the expense of tax dollars, moderate though it may be.

"Really, there isn't that much support for it amongst the poor and handicapped," Nier said.

He recommended that city buses provide transportation to the park for those who cannot get there on their own.

Charlotte Stephens of St. Cloud, a supporter of the park expansion, argued that the park will be beneficial especially to the poor and disabled because they do not have any other access to natural areas.

"This is really a unique opportunity for the county to acquire this special area," Stephens said. She said the price tag is "a relatively low cost for providing a very valuable resource."

Commissioner Leigh Lenzmeier added that the county may decide to charge user fees only on weekends, encouraging weekday use and benefiting poor and disabled people who can use the park during the week.

December 9, 1998. Used with permission of the *St. Cloud Times*.

Quarry Park deal designed to offset Waite Park losses

Stearns will offer to bear more road costs in light of city's losses on park expansion

By Kirsti Marohn
TIMES STAFF WRITER

Stearns County commissioners and park officials will ask Waite Park Saturday to consider a new compromise on Quarry Park and Nature Preserve, hoping to keep the project on track.

A proposal, presented to the county board Tuesday by Stearns County Parks Director Chuck Wocken, calls for building an extension of 33rd Street South (Waite Park's 19th Street South) on the park's south edge. The county also would build a water control structure to reduce runoff from the park property.

Waite Park officials have complained that the city will lose about $600,000 in homeowners' drainage assessments if the county purchases 393 acres of additional land for Quarry Park.

Under the county's plan, the county would pay the construction costs of the 33rd Street project. Waite Park would benefit by getting the road without having to pay for it.

The 33rd Street extension would connect with Minnesota Highway 15, making a beltway around the metro area. The project probably will be on tap in the next 10 to 20 years, said County Engineer Doug Weiszhaar.

The county could seek state and federal funding for the road project, Weiszhaar said.

County commissioners agreed last month to consider Waite Park's concerns about the Quarry Park expansion before moving ahead. The two sides are scheduled to meet at 9 a.m. Saturday to discuss the issues again.

If Waite Park agrees to the compromise and approves the subdivision of the land the county wants to buy, the county will be free to move forward with the project. The county board already has given preliminary approval to a $2.67 million bond.

The county also may request that Marlyn Libbesmeier, who has agreed to sell 133 acres to the county for the park, lower his price to accommodate the drainage assessments. The Trust for Public Land has been negotiating purchase agreements with the landowners.

Commissioner Rose Arnold said it is wrong that the county is being asked to pay market value for the property plus the assessment costs, which are estimated at more than $260,000 for the Libbesmeier property.

"To me, if you're buying property, that's an absolute something to consider," Arnold said. "That's incredible in my mind."

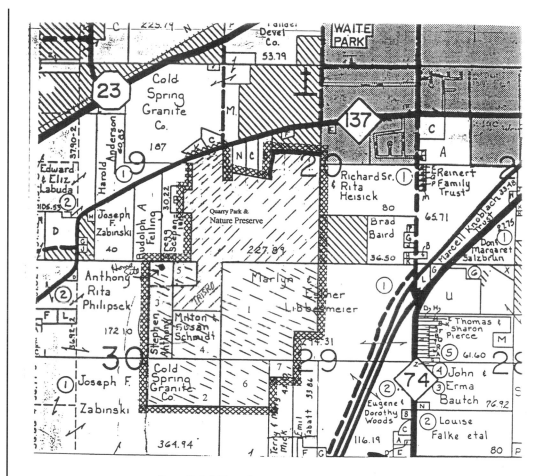

Quarry Park & Nature Preserve Expansion
Landowner List

Parcel No.	Owner	Acreage
1	Libbesmeier	130
2	Cold Spring Granite Co.	60
3	Antony	30
4	Schmidt	40
5	Lindquist	10
6	Mick, J.	30
7	Mick, T.	10
	Total	310

Presently owned property ▨

Proposed park expansion ▨

Note: This was a preliminary list of landowners with property in the potential park expansion zone. Ultimately, Stearns County also purchased a sixty-acre parcel from Joe and Marcella Zabinski and 39.5 acres from Greg and Carol Mick on the south end of the park. To date, the Lindquist parcel has not been purchased.

Chapter 6

Flora and Fauna and Their Statewide Significance

W HEN STATE REPRESENTATIVE Bernie Omann brought the good news in the spring of 1991 that Stearns County would have $250,000 in state dollars to spend on a park project, Chuck Wocken suggested three possible uses for the money. Those first dollars for Quarry Park were used for the purchase of Hundred Acres Quarry (actually 219 acres) from Cold Spring Granite Company. But what happened to Wocken's other two suggestions—a county geologic atlas and/or a biological survey?

As it turned out, the State of Minnesota paid for those important projects as well. The findings from those research projects led to a major expansion of Quarry Park and the establishment of a nature preserve with statewide significance, all within the boundaries of what was soon to be known as "Stearns County Quarry Park and Nature Preserve."

The State of Minnesota, under the direction of DNR botanist/plant ecologist Michael Lee, completed a biological survey for all of Stearns County. The Department of Natural Resources (DNR) was interested in identifying all the remnant natural communities in Stearns County, and they were willing to complete the study for "free!" Well, almost free. All the DNR asked was to have access to an old farmhouse purchased by Stearns County near the north (main) entrance to Quarry Park. The DNR simply wanted a staging area to

Swamp milkweed. (Author's Collection)

do their work and store their equipment. The house, along with a two-acre parcel, was purchased by Stearns County on April 16, 1996, from Mike and Lois Lehmeier (the agreement was finalized in July 1996). The purchase allowed the county a little "breathing room" at the entrance to the park at 1802 County Road 137. The house also served as park headquarters from 1999 to 2006. The old house was torn down on November 11, 2006, to make room for the Park Department's new offices and Central Park Maintenance Facility, completed in October 2006.

As for the DNR's request to use the house, Commissioner Rose Arnold initially convinced the board that the DNR request was fraught with problems. Too much liability and too many risks! Wocken brought the issue to the board, and he recalled that Commissioner Arnold's reasoning went something like this: "Oh, my gosh, we don't know what kind of things could happen out there. There could be wild beer parties. We don't have control. There's lots of liability in letting the State DNR use that house for this biological survey." Chair Arnold told Wocken, "No, we're not going to use the house for that."

Chuck and staff were obviously disappointed. After all, the county owned the house, and Chuck thought it was a great lever to get the state to agree to do a biological survey in Stearns County. The DNR had other places they could spend their energy. Use of the house by the DNR, right next to Quarry Park, could certainly sweeten the working relationship that already existed between Stearns County Parks and the Minnesota Department of Natural Resources.

After a number of months and a change of leadership on the County Board, Mike Lee, this time with his supervisor, County Biological Survey Director Carmen Converse, came back to the County Board. Carmen made a compelling pitch: "The study is valued at about $100,000, and we're not asking for anything except use of the house." Ms. Converse, then in her late forties, was dressed professionally but with a slightly nerdy, one might say "preppy" look, certainly not the beer-drinking party animal envisioned by

Commissioner Arnold. Carmen went on to say, "We just want to use that facility to house our staff while they're doing the survey." Commissioner Arnold (no longer chair), again said, "No, that's out of the question."

Commissioner Bob Gambrino was now the chair, and he said, "Sure, you can do that. Next issue."

Everyone snickered (expect Rose) and life went on!

The DNR had only one staff member, Mike Lee, who actually lived in the house for the duration of the study and because of the time he had available at Quarry Park, he found rare orchids—tubercled-rein orchids (*Platanthera flava*)—in the park! In fact, in the area south of the park, on Marlyn and Esther Libbesmeier's property, he found what was then the largest known concentration of this endangered orchid in the State of Minnesota! That was stunning news and certainly confirmation of the fact that areas south of the existing Quarry Park had state-wide significance, worthy of further exploration and probably protection. The County Board supported the idea of examining the areas south of Quarry Park, so long as staff asked permission to access private property. There had been plenty of advertising that biological survey work was going to take place, and, as it turned out, no neighbors objected.

Mike Lee credits a botanical survey, organized by Stephen Saupe, College of St. Benedict/St. John's University Biology Department, with the initial discovery of the rare orchids while completing a botanical survey of Quarry Park in 1994. Saupe explained the history of the early botanical work:

In spring 1993, then-Parks Director Chuck Wocken approached the Central Minnesota Audubon Society to conduct biological surveys in the proposed park. Little happened until the following spring when I gathered a group of local botanists and plant lovers together to participate in a botanical survey. The group called itself the 100 Acres Quarry Botanical Action Council (QBAC) and ultimately had a mailing list of about thirty individuals. A

data collection form was created, and the first major surveys began in summer 1994. For the most part, the surveyors did not collect plants but simply completed the data entry form to document the plants they encountered. Other individuals collected and prepared herbarium specimens and deposited them in a local herbarium such as ours (CSB/SJU Bailey Herbarium) and the one at St. Cloud State University.

Among the individuals who submitted datasheets or specimens were: Stephen Saupe (volunteer director of the QBAC Project), Meghan McKeon, Mark Terhaar, Jaclyn Inderrieden, Nick Zaczkowski, Deb Lentz, Barb Wilmesmeier, Troy Foede, Dominic Ackerman, Wayland Ezell, Brad Matuska, and Shannon Walsh. This group included a mix of local faculty from CSB/SJU and SCSU, as well as students (especially from CSB/SJU) and other interested individuals. The main contributors to the actual plant list were: Stephen Saupe, Meghan McKeon, Mark Terhaar, Jaclyn Inderrieden, Nick Zaczkowski, Troy Foede, and Dominic Ackerman.

In addition to those who actually collected specimens or turned in data sheets, the following individuals also participated in QBAC activities and work, including Don Peterson, Jane Bennett-Garver, Tom Clapp, Stephanie Digby, Jeff Evander, Mark Ahles, Tracy Daby, Bob Ellenbecker, Paul Jackson, Craig Lee, Ali Ulwelling, Eric Ribben, Beth Clysdale, Milt Blomberg, Jean Surma, George Shurr, Gary and Jesse Westrup, Joanie Robinson, Jim Davis, and Darian Westerlund.

Our final database included 395 entries representing 290 species in 189 genera and sixty-nine families.

The nomenclature (common names of plants) on the list of plants that appears in Chapter 7 of this book was updated by Olive Hogan-Stark (CSB student), based on the USDA Plants database, in 2015. The list of scientific plant names Hogan-Stark worked with was provided by Mike Lee for this publication. Mike Lee reminded me, "There is no such thing as an official common name, and that's why scientists use botanical names. Many plants have multiple common names, and these often vary by where you are in a plant's geographical range (Missouri folks call it something different than we do here, which is different from what they call it in Pennsylvania . . .). Even more confusing is that some common names are used for more than one species. However, each species has only one scientific (Latin) name (though many species also have older, no-longer used scientific names). That's why botanists use scientific names to refer to plants, to avoid any confusion as to what species they're talking about."

In 1997-1998, Mike Lee completed a detailed biological survey of remnant natural communities in Quarry Park. Finding the rare orchids alone justified bringing in the state botanist Welby Smith to take a closer look. Lee, Wocken, and Welby made quite a threesome as they first looked at aerial photographs and topographical maps. Then, as Chuck described, "They had a little procession down to the swamps on the edges of Marlyn Libbesmeier's property." They arrived at a spot where Mike Lee said, "Here it is." Welby Smith knelt down in the swamp and pulled out his monocle, looked close at the flower and the petals of this particular plant, and said, "Sure enough, this is a tubercled rein-orchid!" The main thing that made it a tubercled rein-orchid was a small bump (tubercle) on one of the petals. Wocken recalls, "I just thought okay, it's rare, that's all we need." Actually, the work had just begun.

After compiling all the biological survey data from around Stearns County, Quarry Park (and the immediate vicinity) was placed on a DNR list as one of eight places in Stearns County that should be preserved. Keep in mind at this point in time, Stearns County had some tubercled-rein orchids within the existing park boundaries, but the largest patches were south of the park. Mike Lee's biological field work influenced his recommendation to the

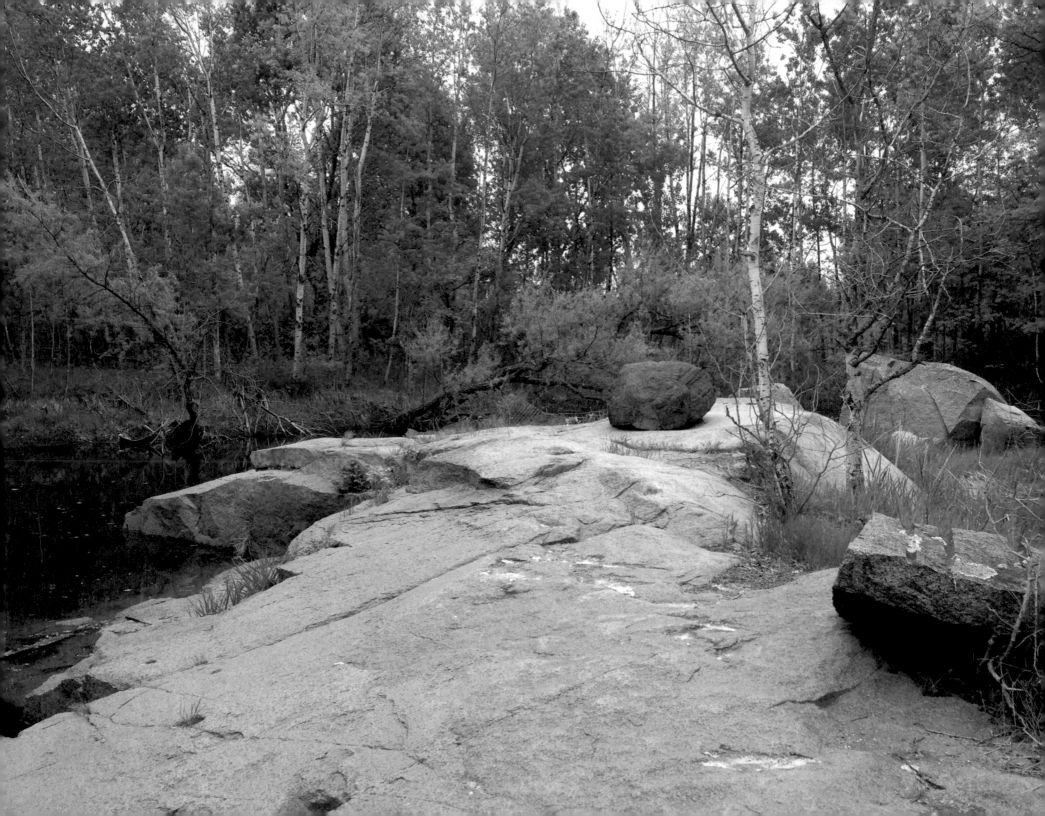

DNR Scientific and Natural Areas program that this area was of statewide significance and led the SNA program to come up with the state's share of the funding for the Libbesmeier land and Cold Spring Granite's southern sixty-acre parcel.

Brauer & Associates Ltd., contracted park planners out of the Twin Cities, were nearing the end of their work on the Park's master plan. With the help of such findings as the tubercled rein-orchid, and the biological/geological significance of the large unquarried outcrops, it was a lot easier to make the case that Quarry Park should grow considerably and ultimately encompass approximately 700 acres. The proposed purchase of the desired Libbesmeier acreage alone represented a 133-acre addition to Quarry Park!

The County Board, for its part, was supportive of expanding the park, but we had to find the money. One state source we considered was the Conservation Reserve Program (CRP). Other sources were discussed and grant writing at the Park Department launched into high gear!

Between 1999 and 2010, Stearns County purchased eight additional parcels, ranging from thirty acres to 133 acres in size, bringing the total area of Quarry Park and Nature Preserve to 685 acres! The important role of the Trust for Public Land in dealing and negotiating with land owners should not be minimized or forgotten. The Trust was critical in holding certain Quarry Park parcels until the county and state could come up with the dollars needed to make the private landowners and the Trust whole. The Trust for Public Land also played a key role in helping "shake the state money tree" to help come up with the dollars needed for the Libbesmeier parcel. It took a long time, but Stearns County eventually received a fifty-percent match in state bonding money in the amount of $554,250 to acquire the Libbesmeier parcel for $1,108,500. In other words, Stearns County was able to add an 133-acre addition to the park (more than half the acreage of the initial 219-acre purchase from Cold Spring Granite) thanks to the biological surveys that had been completed and the vision that was shared by so many who loved Quarry Park from its earliest days.

GOVERNOR CARLSON PAYS A VISIT TO THE PARK

QUARRY PARK'S STATEWIDE SIGNIFICANCE became more pronounced when Minnesota Governor Arne Carlson paid a visit to the park on August 23, 1995, and extolled the virtues of this unique jewel. The governor loved it. He called the park a piece of our childhood: "This is like Mark Twain all over again!"

Stearns County asked the governor for one million dollars in planning and start-up funding to develop a granite history interpretive center, with an additional five million dollars later to complete the project. Ken Speake, from KARE 11 News, reported, "The governor said two things. He said he would 'pitch the idea' to the state legislature but he also wanted to see Benton, Stearns, and Sherburne counties form a partnership and pitch in some of their own funding." Governor Carlson felt it was important for the three counties do more regional planning, especially on projects of regional significance such as Quarry Park. It should be noted that former State Representative Bernie Omann was serving as Governor Carlson's chief of staff at the time of the governor's 1995 visit to Quarry Park. Clearly, Bernie Omann's important work in finding state funding for the initial purchase of the Hundred Acres property continued to bear fruit for Quarry Park because of Bernie's new leadership role at the governor's office.

Unfortunately, the three-county proposal did not materialize. Ultimately, most of the dollars to develop Quarry Park came from the State of Minnesota and Stearns County. Some private contributions were also raised from local businesses, but not enough to build the much-anticipated granite interpretive center. As of the publishing of this book, the granite history center has not yet been built. The purchase of additional acreage, however, did occur, and that bodes well for a park with statewide significance and ever-growing usage.

Each parcel identified in the Park's "Phase II Expansion Master Plan" (and Stearns County's ability to come up with the dollars needed to

purchase those parcels) has a unique story. The sixty-acre site purchased from the Joseph and Marcella Zabinski family, for example, represented a unique and final addition to the Scientific and Natural Area on the southern edge of the park. A letter from Bob Djupstrom, supervisor for Scientific and Natural Areas at the Minnesota Department of Natural Resources, dated December 17, 2001, to then-County Board Chair Larry Haws, illustrates the complexities, timing, and creativity that were needed to complete the park. A request for board action regarding the Zabinski parcel was submitted by Park Director Chuck Wocken to the County Board on January 8, 2002. As requested, the County Board authorized signatures on the Agreement of Sale in the amount of $680,000, half of which was paid through a grant from the State of Minnesota and half from Stearns County taxpayers.

GOVERNOR VISITS QUARRY PARK

TIMES PHOTO BY KIMM ANDERSON

Gov. Arne Carlson answered questions Wednesday during a visit to the proposed Stearns County Quarry Park site. The children are (from left) Nick Curtis, 10, Lacy Keller, 9, Abby Young, 11, and Travis Curtis, 8, all of Waite Park. Abby Young's father, Al, said they heard the governor was coming, and the kids asked if they could go see what he looked like. Carlson said he was impressed with the site during the hour-long tour, and he may ask for $1 million in funding from the state for its development. Carlson said he believed the park deserves consideration for what it might have to offer area residents.

Governor visits Stearns County Quarry Park and Nature Preserve

Governor Arne Carlson visited the Stearns County Quarry Park and Nature Preserve August 23. The tour was designed to help Governor Carlson to become more familiar with the parks potential for future development.

In the early 1990's, Stearns County acquired a 220 acre tract outside St. Cloud to develop a regional park now know as the Quarry Park and Nature Preserve. The park offers a unique regional park that is rich in cultural history, a diverse natural resource base, and outdoor recreational facilities. The inherent qualities of the park lend themselves to enrichingthe quality of life in teh surrounding communities that goes beyond outdoor recreation, including: education from grade school through graduate school, cultural and natural interpretation, earth science and ecological research, and tourism. recreational acitivies at the park include: swimming, scuba diving, hiking, cross-country skiing, rock climbing, fishing, mountain biking, ice skating, concerts (in the outdoor amphitheater), and an interpretative center.

The park is considered to be one of the most unique geological features in Central Minnesota and contains dozens of pools of water along with numerous rock formations and many unusual biological features.

Governor Carlson and Stearns County Commissioner Mark Sakry at the Stearns County Quarry Park and Nature Preserve.

Article from the September 14, 1995, Association of Minnesota Counties newsletter. (Used with permission)

Above and at right: the governor's visit. (Author's collection)

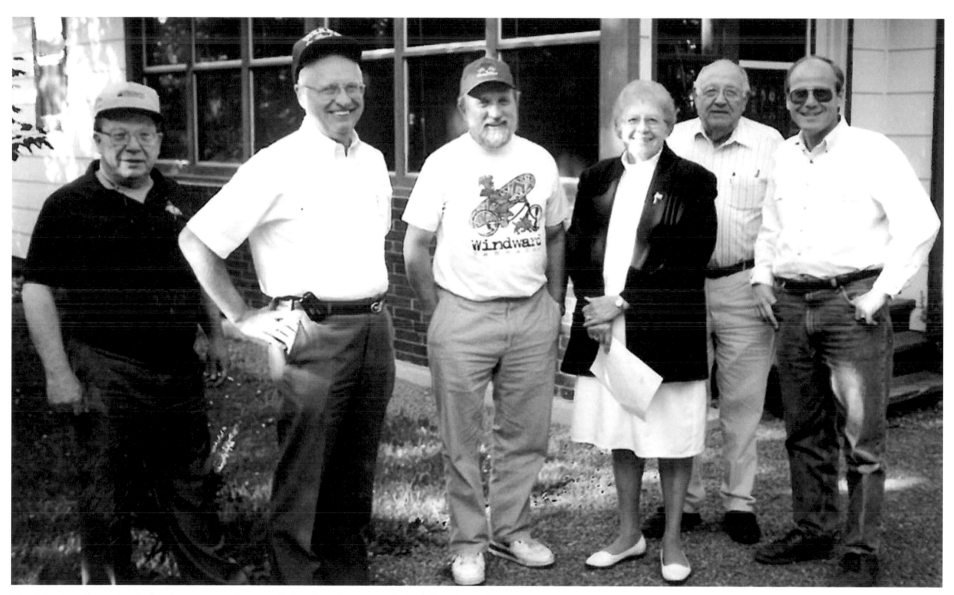

The July 1996 Quarry Park planning meeting at the park's headquarters (formerly the Lehmeier home) located near the entrance to Quarry Park. Left to right: Planning Commission's appointee to the Park Commission Dick Hall, District 3 Park Commission member Joe Chovan, District 5 Park Commission member Jim Boie, County Commissioner Rose Arnold, Bob Gambrino, and Mark Sakry. (Courtesy of Chuck Wocken and the Stearns County Park Department)

COUNTY OF STEARNS

Mark Sakry
County Commissioner - Second District

413 S. 10th Ave. • Waite Park, MN 56387 • (612) 252-5022

April 17, 1998

Mr. and Mrs. Marlyn Libbesmeier
1401 Graniteview Rd.
Waite Park, MN 56387

Dear Marlyn and Esther:

You may have heard that Stearns County's request to the State of Minnesota for bond money to expand Quarry Park and Nature Preserve was not approved in the 1998 Session of the Legislature. However, the good news is that Stearns County has been working with the Department of Natural Resources (DNR) to make funds available to expand Quarry Park and Nature Preserve southward from the existing park.

The DNR received $7 million through the recent legislative session for the Reinvest in Minnesota (RIM) Critical Habitat Match program. The DNR is earmarking some of these funds for Quarry Park expansion.

As you know Stearns County is interested in a portion of your property being preserved as a natural area for County park purposes. We hope your discussions with the Trust for Public Land are proceeding satisfactorily for you and your family. If you have any questions, please do not hesitate to call me or Chuck Wocken, Park Director (255-6172). We hope you will see this as an opportunity to leave a legacy for future generations. Thank you.

Sincerely,

Mark Sakry

Mark Sakry
District 2 Stearns County Commissioner
Member - Stearns County Park Commission
MS:mst

Enclosure

On the Land

A Natural Gem Near the "Nitty Gritty, Granite City"

Efforts are under way to expand the spectacular Quarry Park and Nature Preserve in central Minnesota into a regional treasure, protecting some of the area's best natural, scenic, cultural, and recreational resources.

Quarry Park was created to protect a significant natural area and to provide a wide variety of opportunities for recreation and for enjoying the area's exquisite beauty. According to Stearns County Park Director Chuck Woken, "The park is also a testament to central Minnesota's granite industry, which recently exported stone for the FDR memorial in Washington, D.C., the U.S. embassy in Singapore, and the interpretive center at Mount Rushmore."

The existing 252-acre Quarry Park lies close to the core of the St. Cloud metropolitan area. Once a small granite town and dubbed in 1913 the "Nitty Gritty, Granite City," St. Cloud is now the fastest-growing urban area in the state. The development associated with this growth means that remaining wildlands and rare plant and animal species face a precarious future. Without ambitious efforts to save remaining areas, many of Minnesota's diverse natural resources may be lost forever.

The geology, landforms, and ecosystems that have emerged

The yellow ladyslipper is one of many plants protected in Minnesota's Quarry Park and Nature Preserve.

through natural forces and cultural activities, mainly mining and agriculture, make Quarry Park and Nature Preserve a prime visitor destination, a playground for nature lovers, and a quality outdoor classroom for people of all ages. One unique aspect of the park is that it is a site for scuba diving. Some of the quarries feature clear water and good visibility as well as interesting rock formations and marine life. Scuba diving, currently allowed only under special permit, has been used there for biology experiments, park cleanup, underwater cultural and geologic video research, and training dives for people new to the sport. The park district hopes that these scuba sites will soon be open to the public.

To continue to protect Quarry Park's many resources, the Stearns County Board of Commissioners, at the recommendation of the park district, asked the Trust for Public Land to work with several landowners to coordinate a park expansion that would double the size of the park and nature preserve. Says TPL Project Manager Shaun Hamilton, "This effort by Stearns County is farsighted, given not only growth pressures on the existing park but also the limited window of opportunity to protect an undeveloped natural area of this size and quality."

To supplement the county's financial resources, TPL also lobbied the state legislature to secure additional project funding through the Reinvest in Minnesota program. This successful effort secured a commitment from the Department of Natural Resources to invest $1 million in matching money for park expansion in exchange for protective easements over the parkland secured with those funds. This state and county cooperation is essential to the protection effort.

In the face of rapid development and increased usage, the success of this project will allow Quarry Park and Nature Preserve to continue to provide Minnesota with a unique open space resource. Plans include offering interpretation and education related to the park's natural and cultural history, as well as recreation, including picnicking, fishing, trail walking, biking, cross-country skiing—and of course, Minnesota's own scuba diving. ❁

Visitors enjoy the unique landscape from one of the quarry's swimming platforms. TPL is working to expand the park to preserve its diverse natural and recreational resources.

4

Stearns County Quarry Park Acquisition Costs

Date of Recording	Date of Deed	Seller	Acres	County Costs	Grants Recived	Total Cost	Cost/Acre
1/4/1993	12/21/1992	Cold Spring Granite Company	218.65	$ -	$ 250,000.00	$ 250,000.00	$ 1,143.38
7/25/1996	6/8/1996	Lehmeier, Michael & Lois *	2.14	$ 75,000.00		$ 75,000.00	$ 35,046.73
8/29/1997	8/28/1997	Trisko, Robert & Helen	30.00	$ 145,000.00	$ 105,000.00	$ 250,000.00	$ 8,333.33
4/5/1999	3/29/1999	Trust for Public Land (TPL) - Prior deed from Libbesmeier, Marlyn as trustee of the Marlyn J. Libbesmeier Rev Trust & Libbesmeier, Esther C. as trustee of the Esther C. Libbesmeier Rev Trust	133.00	$ 554,250.00	$ 554,250.00	$ 1,108,500.00	$ 8,334.59
10/12/1999	10/6/1999	TPL - Prior deed from Mick, Terrance J. & Mary, trustees of the Mick Revocable Living Trust	30.88	$ 322,065.00	$ -	$ 322,500.00	$ 10,443.65
10/12/1999	10/7/1999	TPL - Prior deed from Mick, Gregory & Carol	40.00	$ 380,000.00	$ -	$ 380,000.00	$ 9,500.00
12/20/1999	12/15/1999	TPL - Prior deed from Schmidt, Milton & Susan L.	40.00	$ 150,000.00	$ 150,000.00	$ 300,000.00	$ 7,500.00
4/19/2000	4/10/2000	TPL - Prior deed from Cold Spring Granite Company	60.00	$ 225,000.00	$ 225,000.00	$ 450,000.00	$ 7,500.00
3/15/2001	3/5/2001	TPL - Prior deed from Anthony, Steven	30.00	$ 150,000.00	$ 150,000.00	$ 300,000.00	$ 10,000.00
1/28/2002	1/24/2002	TPL - Prior deed from Zabinski, Joseph F. Jr. & Wochnick, Marcella	60.00	$ 340,000.00	$ 340,000.00	$ 680,000.00	$ 11,333.33
4/22/2010	4/16/2010	Mick, Gregory & Carol	39.50	$ 350,500.00	$ 400,000.00	$ 750,500.00	$ 19,000.00
TPL = Trust for Public Land		**Total**	684.17	$ 2,691,815.00	$ 2,174,250.00	$ 4,866,500.00	$ 7,113.00

* price included 2 bedroom home

Quarry Park ga[~~]
40 acres in land

Stearns County to buy plot for $300,000

By Kirsti Marohn
TIMES STAFF WRITER

Quarry Park and Nature Preserve grew by 40 acres Tuesday when the Stearns County board agreed to sign a purchase agreement with landowners Milton and Susan Schmidt.

The county will pay $300,000 for the land, which is slightly less than the property's appraised value of $304,000. The closing date is set for Dec. 15.

Half of the cost will be paid with grant money from the Department of Natural Resources' Reinvest in Minnesota program. The county will pay the other half, using a portion of its $2.67 million park bond.

All lands purchased with RIM funds must be kept in their natural state, meaning none of the Schmidt property will be developed for recreational use. The Schmidt land is home to some rare species, including the endangered tubercled rein orchid.

Park users will be able to hike, cross-country ski and snowshoe on the land, but no new trails will

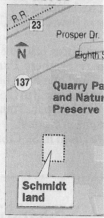

**Quarry Park g[~~]
40 acres**

Prosper Dr.
Eighth S[~~]
Quarry Pa[~~]
and Natu[~~]
Preserve

Schmidt land

TIMES MAP

The assessments [~~]
ered in the appraisa[~~]
Hamilton of the Tru[~~]
Land, the nonprofi[~~]
negotiated for the [~~]
county's behalf.

The land would [~~]
worth more than $[~~]
weren't for the a[~~]
Hamilton said.

The county is [~~]
appealing its asse[~~]
from Waite Park, [~~]
total $535,000 for th[~~]
expansion. The city [~~]
the drainage assessm[~~]
pay for road impro[~~]

The February 11, 2000, Board meeting. Opposite top: Board chair Mark Sakry signs the purchase agreement for an additional sixty acres from Cold Spring Granite to add to the Scientific and Natural Area portion of Quarry Park and Nature Preserve. Opposite bottom: Commissioners Rose Arnold and Larry Haws discuss plans for future acquisitions with Mark Sakry, in hopes of an ultimate build-out of nearly 700 acres. This page: Sakry, Arnold, and Haws with Minnesota map and blow up of Quarry Park area. (All three photos Author's Collection)

Park plan proceeds despite slim budget

By Kirsti Marohn
Times staff writer

The three-year expansion of Quarry Park and Nature Preserve is close to completion, as long as state funding isn't affected by the anticipated budget shortfall.

Stearns County commissioners voted this week to sign a purchase agreement for 60 acres from Joseph Zabinski for $680,000, or $11,333 an acre. The Trust for Public Land, a nonprofit conservation organization, negotiated the purchase.

The parcel will complete the park's Scientific and Natural Area, bought with matching grant money from the Department of Natural Resources.

Commissioners expressed some concern that because of the state budget shortfall, the DNR may not be able to provide 50

Quarry Park and Nature Preserve to grow by 60 acres

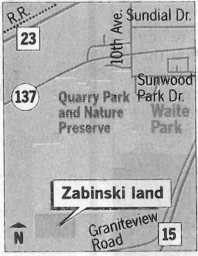

Times map

Quarry

percent of the price. The state recently froze all new

See **QUARRY, 4B** ▶

grant agreements until the shortfall can be addressed.

The county will ask the DNR for a written commitment for the funding, said Chuck Wocken, county parks director.

"Our county administrator doesn't want us to get caught in that trap," Wocken said. "We need to know that the funding really will be there."

If the DNR can't commit to providing the money, the county board will have to decide if it wants to delay the purchase, Wocken said.

Last summer, the DNR announced it had only $100,000 available this year for the purchase. The county board decided to move ahead with the purchase and cover the cost until the remainder is available, probably in 2003.

The 323-acre science and nature area is home to several rare plant and animal species and granite outcroppings. It is kept in its natural state, with only minimal use such as walking allowed.

The county will use money from its $2.67 million park bond approved in 1998 to pay for its share of the purchase.

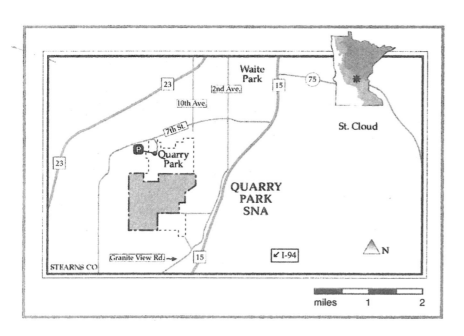

The Stearns County Parks was established in 1974. Quarry Park & Nature Preserve is the largest in the Stearns County Park system. Stearns County purchased the original 220 acres from Cold Spring Granite Company in 1992. Today the park contains 583 acres and 263 of that are Scientific and Natural Areas. For more information visit www.co.stearns.mn.us

Founded in 1972, the Trust for Public Land (TPL) specializes in conservation real estate, applying its expertise in negotiations, conservation finance, and law to protect land for public use and enjoyment. Working in partnership with Stearns County, the DNR and private landowners, TPL has been able to acquire and protect over 330 acres of land within Quarry Park and Nature Preserve. For more information visit www.tpl.org.

A Celebration Event

STEARNS COUNTY
QUARRY PARK
AND NATURE
PRESERVE

July 19, 2001, event. Courtesy of the Stearns County Park Department.

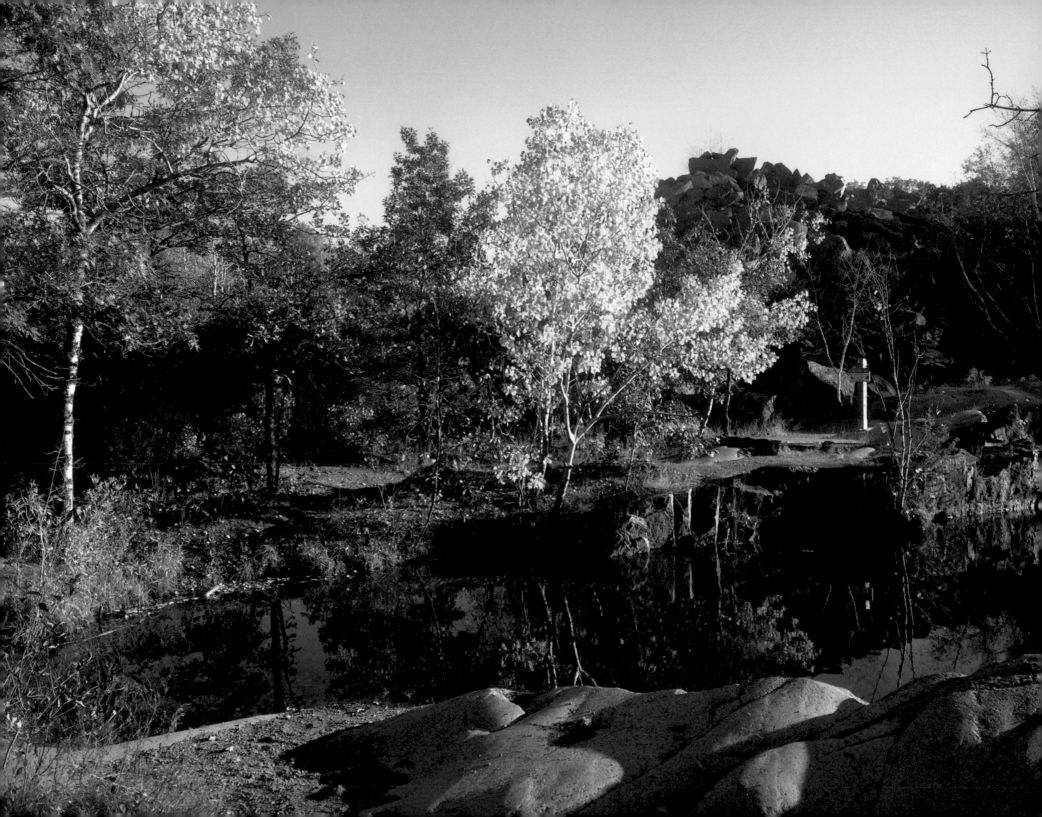

Granite sculpture, *Fata Morgana*, welcomes visitors to Quarry Park. The sculpture was created by Vermont artist George Kurjanowicz, using diamond pink granite quarried from the Rockville area. Chuck Wocken describes the piece as having grace and airiness even though it's carved out of stone. (Author's Collection)

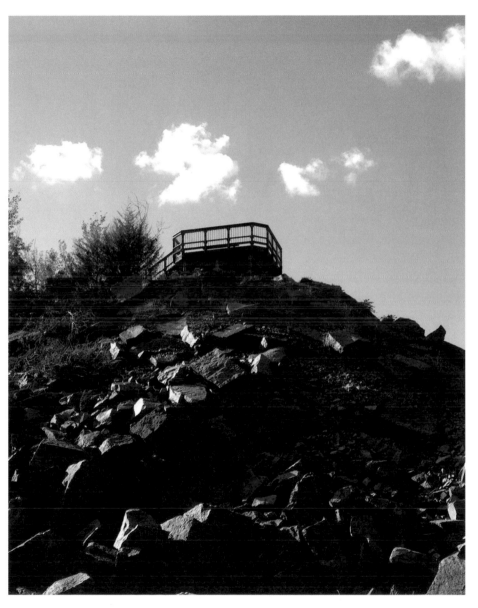

The observation deck, perched high on a grout pile just north of Quarry 8, offers visitors a fantastic bird's-eye view of the park, and it is just a short hike to the top. (Author's Collection)

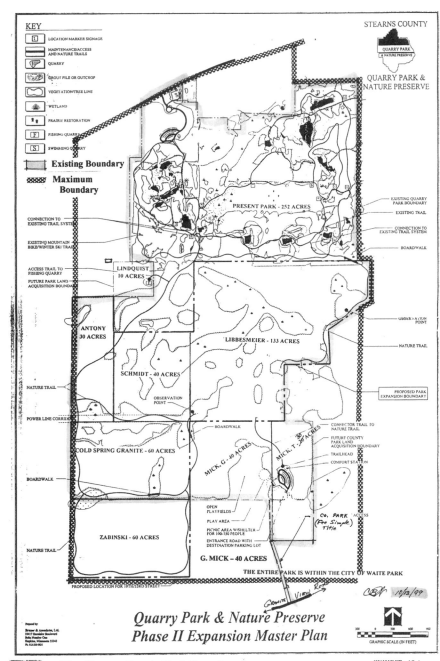

KEY

- 1 — LOCATION MARKER SIGNAGE
- MAINTENANCE/ACCESS AND NATURE TRAILS
- QUARRY
- GROUT PILE OR OUTCROP
- VEGETATION/TREE LINE
- WETLAND
- PRAIRIE RESTORATION
- F — FISHING QUARRY
- S — SWIMMING QUARRY

Existing Boundary

Maximum Boundary

STEARNS COUNTY

QUARRY PARK & NATURE PRESERVE

PRESENT PARK - 252 ACRES

CONNECTION TO EXISTING TRAIL SYSTEM

EXISTING MOUNTAIN BIKE/WINTER SKI TRAIL

ACCESS TRAIL TO FISHING QUARRY

LINDQUIST 10 ACRES

FUTURE PARK LAND ACQUISITION BOUNDARY

ANTONY 30 ACRES

LIBBESMEIER - 133 ACRES

NATURE TRAIL

SCHMIDT - 40 ACRES

OBSERVATION POINT

POWER LINE CORRIDOR

BOARDWALK

COLD SPRING GRANITE - 60 ACRES

MICK. G - 40 ACRES

MICK. T - 20 ACRES

BOARDWALK

ZABINSKI - 60 ACRES

NATURE TRAIL

G. MICK – 40 ACRES

EXISTING QUARRY PARK BOUNDARY

EXISTING TRAIL

CONNECTION TO EXISTING TRAIL SYSTEM

BOARDWALK

OBSERVATION POINT

NATURE TRAIL

PROPOSED PARK EXPANSION BOUNDARY

CONNECTOR TRAIL TO NATURE TRAIL

FUTURE COUNTY PARK LAND ACQUISITION BOUNDARY

TRAILHEAD

COMFORT STATION

OPEN PLAYFIELDS

PLAY AREA

PICNIC AREA W/SHELTER FOR 100-150 PEOPLE

ENTRANCE ROAD WITH DESTINATION PARKING LOT

CO. PARK ACCESS (Fee Simple) Title

THE ENTIRE PARK IS WITHIN THE CITY OF WAITE PARK

PROPOSED LOCATION FOR 19TH/33RD STREET

GRANITE VIEW ROAD

Quarry Park & Nature Preserve
Phase II Expansion Master Plan

GRAPHIC SCALE (IN FEET)

EXHIBIT 18-A

Courtesy of the Stearns County Park Department.

STATE OF MINNESOTA DEPARTMENT OF NATURAL RESOURCES

Minnesota Department of Natural Resources

500 Lafayette Road
St. Paul, Minnesota 55155-40__

Mr. Larry Haws, Chair 17 December 2001
Stearns County Board
c/o Chuck Wocken
1802 Co. Road 137
Waite Park, MN 56387

Dear Chairman Haws:

This letter is alert you to the fact that the $100,000, which the SNA Program set aside (as noted in our letter 20 July, 2001) for the acquisition of a conservation easement from Stearns County on the Joseph Zabinski parcel has been frozen, even though these funds by law (MN Statutes 92.69, Subdivision 1) must be spent on scientific and natural areas.

The Department of Natural Resources, Scientific and Natural Areas (SNA) Program remains committed to assisting Stearns County in the completion of the acquisition of the last remaining parcel at the Stearns County Quarry Park and SNA site. As we have been doing, the SNA Program of the Minnesota Department of Natural Resources fully intends to cost share for 50% on this parcel through the acquisition of a conservation easement.

The balance of the funds necessary to acquire the conservation easement ($240,000) is contingent on appropriations for the Reinvest in Minnesota (RIM) Program this coming legislative session. This is the funding source that we have used to date to acquire conservation easements on the first four land parcels at Quarry Park as an SNA. The SNA Program is confident that the Stearns County parcel will be a top internal priority for RIM funds since the SNA Program has two major internal loans of over $750,000 for past RIM projects outstanding. Funds appropriated for RIM (including this $240,000) would become available for expenditure in July of 2002.

The SNA Program is sorry for any problems the "funding freeze" may cause, however, we could not anticipate the funding freeze when we made the commitment to finish the acquisition at Quarry Park with Stearns County. However, we remain confident that the project will be completed this coming year and look forward to our continued work with Stearns County on the completion of this important SNA.

Sincerely,

Bob Djupstrom, Supervisor
Scientific and Natural Areas

Author's Collection.

Chapter 7

The Plants and Wildlife of Quarry Park

ICHAEL LEE, DNR PLANT ecologist/botanist, graciously provided the following Quarry Park rare natural features "at a glance," along with selected pages from the Minnesota County Biological Survey Project Evaluation, which follows. Mike's fine work identifying rare flora and fauna throughout the Quarry Park and Nature Preserve played a major role in acquiring state and county funding that made the park possible.

"Quarry Park and Natural Area is home to the largest concentration of bedrock outcrops in Central Minnesota. Rising up to forty feet above the surrounding level terrain, these granitic outcrops support a diverse native plant community characterized by scattered gnarly, open-grown (savanna-like) oaks with patches of prairie grasses and wildflowers in shallow soil pockets between the rock exposures. Specialized drought-tolerant plants such as brittle prickly-pear cactus (*Opuntia fragilis*) and small-flowered fame flower (*Talinum parviflorum*) occur with lichens and mosses in the dry cracks of the granite itself. A variety of lichens cover the exposed rock surfaces. Several uncommon species of blackberry (*Rubus spp.*) occur on these ancient granite exposures as well.

"Oak woodlands surround the outcrops and provide habitat for many birds, including uncommon red-shouldered hawks (*Buteo lineatus*) and Acadian flycatchers (*Empidonax virescens*).

"Scattered sedge meadows are interlaced among the woodlands and outcrops. One of the state's largest populations of the rare tubercled rein-orchid (*Platanthera flava*) is found along the margins of these wetlands.

"The 684-acre County Park and State Scientific and Natural Area is a very important block of natural habitat in an increasingly urban part of the state. This mix of woodland, wetland, outcrop, and restored prairie is home to at least sixty-three summer resident bird species and over 300 plant species."

Date of Evaluation: 18 November 1998
Author: Michael Lee

MINNESOTA COUNTY BIOLOGICAL SURVEY PROJECT EVALUATION

NAME OF PROJECT: Quarry Park South
COUNTY: Stearns

ECS REGION: Minnesota & NE Iowa Morainal Section; Anoka Sand Plain Subsection

DNR QUAD CODE: P13c

LEGAL DESCRIPTION: T124N R28W NW1/4 sec. 29, NE1/4 sec. 30, SE1/4 sec. 30

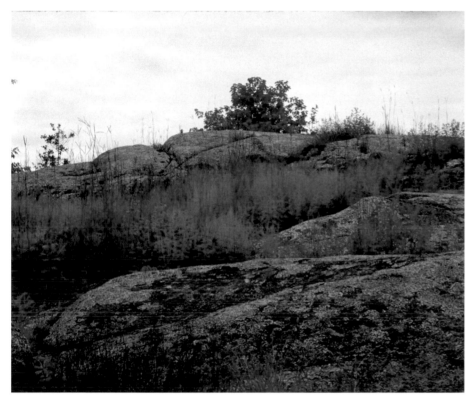

DNR state botanist Welby Smith (left) and Michael Lee, DNR plant ecologist/botanist, near the top of one of the larger outcrop complexes, examining a shallow soil pocket between bedrock exposures in July of 1997. Granite outcrops such as this provide park visitors an opportunity to witness a diversity of prairie plants, including prairie dropseed (*Sporobolus heterolepis*), big bluestem (*Andropogon gerardii*), leadplant (*Amorpha canescens*), arrow-leaved violet (*Viola* *sagittata*), prairie wild onion (*Allium stellatum*), the uncommon open-field sedge (*Carex conoidea*), as well as outcrop specialists such as rusty woodsia (*Woodsia ilvenis*), rock spike-moss (*Selaginello rupestris*), small-flowered flameflower (*Talinum parviflorum*), brittle prickly pear cactus (*Opuntia fragilis*), several uncommon kinds of blackberry (*Rubus spp.*), and several kinds of reindeer lichens (*Cladina spp.*)

CURRENT PROTECTION STATUS: County Park (in part), all is proposed park expansion area.

RECOMMENDED PROTECTION STATUS: Acquisition by Stearns County and designated as a State Scientific & Natural Area.

PROXIMATE ACREAGE: 400

OWNERSHIP: Five private owners, Stearns County Parks

ADMINISTRATIVE ACTION: Approved by Commissioner's Advisory Committee - 2 December 1998

ECOLOGICAL SIGNIFICANCE OF PROJECT AREA

QUARRY PARK SOUTH CONSISTS of the best Central Minnesota examples of a granite bedrock outcrop community in a large, natural, woodland and wetland landscape setting. Along with numerous expressions of rock outcrop vegetation, the site contains high-quality wet meadow, wet prairie, oak woodland, and oak forest (Table 1). The largest population in the state of the endangered tubercled rein-orchid *(Platanthera flava* var. *herbiola)* occurs along the margins of wet meadows throughout the site. The woodland and forest support a breeding population of red-shouldered hawks *(Buteo lineatus)*. A singing male Acadian flycatcher *(Empidonax virescens)* was reported there in 1997.

The project area occurs in the Mississippi Valley Outwash Geomorphic Region near the border of the St. Croix Moraine Complex Geomorphic Region. In the DNR's Ecological Classification System (ECS), the boundary between these two landforms separates the Anoka Sand Plain Subsection from the Hardwood Hills Subsection. Granitic bedrock outcrops with similar species composition occur in both of these subsections. The land is level to gently sloping, with frequent shallow depressions. One third of the area is composed of bedrock exposures and associated shallow, loamy soils where bedrock is less than twenty inches from the surface. These areas of shallow soil and exposed bedrock support matrices of prairie/savanna and bedrock outcrop vegetation. The rest of the area has sandy loam soils varying from moderately well drained (supporting woodland and forest), to very poorly drained in the wetlands.

In this part of Minnesota, exposures of granite occur most frequently within a roughly seven-square-mile area in the city of Waite Park and on the southwest side of St. Cloud. In this relatively level area, bedrock is present either at or within fifty feet of the surface. Located in the city limits of Waite Park, Quarry Park South encompasses nearly twenty percent of the center of this largest regional outcrop concentration. Elsewhere in the region, granite exposures occur sporadically along the Sauk River upstream to Cold Spring (fifteen miles to the southwest). Additional outcrops are found to the northwest of Sartell (nine miles to the north), and along the east side of the Mississippi River from north of Sartell at Peace Rock (twelve miles to the northeast) to the southeast side of St. Cloud (five miles to the east). Most of the larger of these outcrops harbor the scars of past quarrying activity. The only protected examples of this bedrock community exist among the scars of extensive past quarrying operations in the adjacent Stearns County Park land to the north.

In Quarry Park South, rock outcrop areas rise to heights of thirty feet above the surrounding landscape. The vegetation of the these areas consists of two types: rock outcrop and dry prairie. Rock outcrop vegetation consists of lichens and mosses, which occur on the surface of bare rock, as well as vascular plants, which occur in crevices or in slight soil accumulations in depressions on the rock surface. Within the site, rock outcrop vegetation has a variety of expressions but falls in two main categories: moist, shady areas and dry, exposed areas. Moist, shady areas are frequent and usually occur on small outcrops under woodland canopy. Vegetative cover is largely mosses with some lichens as well as herbs from the surrounding woodland. Dry, exposed situations provide habitat for numerous lichens on the sunny, bare rock, while mosses and vascular plants exist in crevices and depressions in the rock. Common specialists of rock crevices and shallow depressions include: prairie fame-flower *(Talinum parviflorum)*, brittle prickly-pear *(Opuntia fragilis)*, pale corydalis *(Corydalis sempervirens)*, rusty woodsia *(Woodsia ilvensis)*, and bulbostylis *(Bulbostylis capillaris)*. Especially noteworthy plants here include dwarf bilberry *(Vaccinium cespitosum)* at the southern edge of its range, and bearberry *(Arctostaphylos uva-ursi)*, which occurs on county park land.

Rock outcrops in this part of Minnesota differ in species composition considerably from those of the forested northeast. However, northern species such as pale corydalis reach their southern range limit in Minnesota

on Stearns County outcrops. Though many differences exist, species composition here more closely resembles that of prairie outcrops in the southwestern part of the state. Likewise, several prairie outcrop species reach the northern limit of their range on the outcrops around St. Cloud.

In the shallow, loamy soils amongst rock exposures, prairie or savanna vegetation predominates. Scattered, short, gnarly bur oak *(Quercus macrocarpa)* and northern pin oak *(Quercus ellipsoidalis)* stand amongst prairie grasses and forbs. Occasional copses of shrubs and small trees occur along the rock/soil interface. The prairie ranges from dry to dry-mesic and is dominated by big bluestem *(Andropogon gerardii),* with frequent Indian grass *(Sorghastrum nutans)* and prairie dropseed *(Sporobolus heterolepis).* Other common species include arrow-leaved violet *(Viola sagittata),* purple milkwort *(Polygala sanguinea),* prairie onion *(Allium stellatum),* and leadplant *(Amorpha canescens).* The uncommon sedge *Carex conoidea* (normally restricted to wet prairie and meadows) occurs in some of the moister areas where the underlying bedrock is shaped to retain water. Typically, dry prairie and rock outcrop vegetation occur in a mosaic throughout an outcrop complex. For this reason, these areas are mapped as one rock outcrop entity. The largest of these outcrop complexes approach ten acres.

In contrast to most outcrops in Central Minnesota, past quarrying operations have had minimal impact here. However, several small old quarries do exist in the project area. Associated with these are waste stockpiles (grout piles), which rise as much as seventy feet above the surrounding landscape. The quarries themselves contain groundwater at the level of the local water table. The water table varies greatly in the area. Water levels in the heavily quarried county park land immediately to the north vary as much as twenty feet in elevation between quarries only 600 feet apart.

Nearly one quarter of the project area is covered by wetlands. The majority of this acreage consists of two connected narrow wet meadow drainages each about a half-mile long. These high-quality communities are variously dominated by the sedges *(Carex lacustris* and *Carex stricta),* with occasional bluejoint *(Calamagrostis canadensis)* and small patches of cattail *(Typha latifolia)* depending on moisture level. Forb diversity is moderate to high, with spotted Joe-pye weed *(Eupatorium maculatum)* common. Exotics, including reed canary grass *(Phalaris arundinacea),* are rare. These wet meadows are nearly free of shrubs due to a history of fall haying during dry years and is a releve from this same wet meadow system on the county-owned land immediately to the north.

Several acres of wet prairie exist on the margin of one of the wet meadow strips. Much more diverse than the wet meadow, this community is composed of prairie grasses and forbs as well as wetland sedges. It also supports the state endangered plant, tubercled rein-orchid *(Platanthera flava* var. *herbiola).* Before the suppression of wildfires over 100 years ago, wet prairie existed along the margin of wet meadows throughout the site. Today, nearly all of the wet meadow margin has been invaded by thick stands of young quaking aspen *(Populus tremuloides)* and gray dogwood *(Cornus racemosa).* However, in small openings in this brush, as well as under the brush itself, the largest population of tubercled rein-orchid in Minnesota exists. Over 1,000 plants occur in the project area, with an additional 300 plants in the county park to the north. The uncommon sedge *(Carex conoidea)* occurs sporadically.

A small alder swamp dominated by *Alnus incana* and *Carex lacustris* occurs in the extreme southwest part of the project area.

Over half the project area is wooded, most of which is oak woodland-brushland. Again, with suppression of pre-settlement wildfires, a rather closed-canopy woodland has succeeded from a much more open woodland or savanna situation. The woodland is somewhat evenly aged in appearance; the majority of the oaks originating less than eighty years ago. Northern pin oak is the dominant tree, but bur oak and red oak *(Quercus rubra)* are frequent. Both forest-grown and open-grown trees are common. Patches of quaking aspen are frequent. There is little sub-canopy development, but the

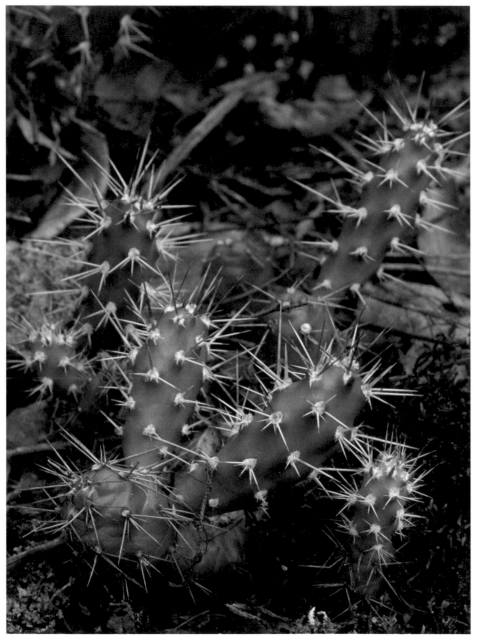

Bedrock outcrops (above) in Quarry Park create an ideal environment for speciallized drought-tolerant plants such as the prickly pear cactus (*Opuntia fragilis*) (on the left) to thrive. (Both photos courtesy of Mike Lee, DNR botanist/plant ecologist)

shrub layer is often dense and fairly diverse. The first confirmed location of the hawthorn (*Crataegus macrosperma*) in the state was collected here in 1997. (Several erroneous locations are represented in *Vascular Plants of Minnesota*, Ownbey & Morley, 1991). The exotic buckthorn (*Rhamnus cathartica*) occurs occasionally. Herb layer diversity is moderate with typical dry-mesic species predominating. Prairie species are uncommon.

Around fifty acres of mature oak forest occurs in the southern part of the project area. The trees are taller here and are all forest grown with straight boles. Some oaks are between 100 and 120 years old. Red oak and northern pin oak are co-dominant in the canopy. White oak (*Quercus alba*) is occasional. Red maple (*Acer rubrum*) is common in the canopy and understory. Large snags are occasional, and the shrub layer is patchy and less dense than it is in the oak woodland. Herb layer diversity is slightly higher as well.

The forest and woodland support the State Special Concern bird red-shouldered hawk (*Buteo lineatus*). One confirmed nest location exists in oak forest in the southern part of the site. Also, a red-shouldered hawk responded to a playback on the northern edge of the project area. The State Special Concern bird Acadian flycatcher (*Empidonax virescens*) was documented in the woodland on county park land to the north. Being a large, nearly contiguous canopy, this site supports breeding populations of many interior forest birds. This is becoming increasingly important, as forest fragmentation due to residential development is reducing this type of habitat at an alarming rate in this part of the state.

The largest tract (Libbesmeier) of this site, approximately 160 acres, is part of a 264-acre tract that has been in the same ownership for over seventy-five years. Part of a dairy and crop farm, this part of the project area was a lightly used pasture for a small dairy herd. The long, narrow wet meadows on the property were hayed during the falls of drier years. This part of the project area, which no longer receives any grazing pressure, is in very good condition. The sixty-acre Cold Spring Granite property, which

has been undisturbed for at least thirty years (including no past quarrying), is also in very good shape, as is the adjacent forty-acre Schmidt tract. The other small properties show slightly higher disturbance levels, mostly due to past grazing, but remain quite intact. Buffer areas include agricultural fields and more disturbed oak forest.

THREATS and OPPORTUNITIES

THE PROJECT AREA IS BOUNDED on the north by the existing Stearns County Hundred Acres Quarry Park. This 250-acre tract is being managed as cultural/historical park depicting the granite industry as well as a natural

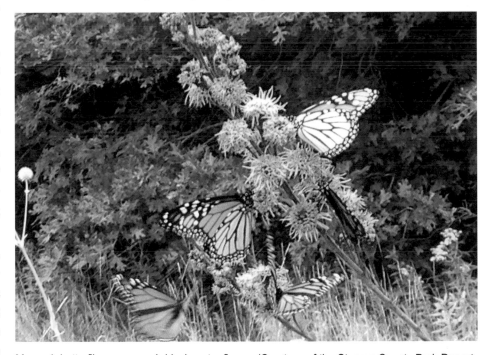

Monarch butterflies on a rough blazing star flower. (Courtesy of the Stearns County Park Department)

Quarry Park offers beauty to Waite Park

Why city isn't jumping at the chance to expand acreage is confusing because residential development will benefit

Waite Park has a rare diamond in its midst with Quarry Park. Yet some officials act as if it's a lump of coal.

The city is stalling approval of the land sale that would add to the 252-acre park. Delaying buying has consequences, potentially affecting purchase agreements with deadlines or driving up land prices.

Officials have expressed concern that expanding the park may not benefit the city. A former mayor even believes an expanded park would "gut the heart out of the city of Waite Park's most attractive potential residential housing sites."

They're mistaken.

The creation and expansion of Quarry Park is the best thing that's happened in Waite Park in years. A city that was defined by apartment buildings, a "smiley face" water tower and Burlington Northern repair yards now has a scenic attraction at its center.

The city reaps the benefits of having a unique natural and historical resource for hiking, biking, rock-climbing, cross-country skiing, scuba diving and study without the cost. Stearns County pays for land acquisition, park maintenance and law enforcement.

The park also increases the value of surrounding land for the city and draws tourism-related business. Far from "gutting the heart" of potential residential development, it makes Waite Park a much more desirable site for housing development.

The proposed expansion area is bedrock and wetlands anyway, both of which pose development problems. Ideally, Waite Park would begin envisioning residential development with an expanded Quarry Park at the center.

This would mean rethinking, just a little, the roads of the future. Waite Park imagines, for example, a major east-west road crossing Minnesota Highway 15 (requiring an interstate-style interchange) to connect with St. Cloud's 33rd Street South. An expanded Quarry Park would force the city to move that road a quarter mile south. No big deal.

It also may require rethinking a proposed road improvement project for Second Avenue South this summer. The road is a mile from the park, but the city wants property owners in a 700-acre drainage basin to pay for storm water improvements. It says it won't approve sale of the land for the park unless the county promises to pay $637,000 in assessments.

If the county didn't buy the land, presumably the owners of farmland — even though their land doesn't abut the road to be improved — would be whacked with a bill for several hundred thousand dollars. Something is wrong with this picture.

It's not the people of Waite Park demanding that the city hold up park expansion. Waite Park City Council member Paul Ringsmuth notes that he's not had a single resident or nonresident tell him that the proposed park land should be developed for homes. "I get a lot of positive feedback on preserving that land."

Waite Park officials should realize the gem they have in Quarry Park and move forward as quickly as possible. Approve the sale of land parcels, without strings attached, so Stearns County can get on with park expansion.

resource area with recreational trails, quarry swimming, and fishing holes. Quarry Park South lies within the boundaries of the proposed park addition. Much of the park expansion area is encompassed by the project area. County plans for this expansion area call for light use while maintaining the area in its natural state. The thirty-acre tract of county land (formerly Trisko property) in the northwest part of the project area was recently purchased as part of this expansion. To the east of the project area are agricultural fields and pasture. To the southeast are heavily-grazed woodland and several new houses. Woods that were heavily grazed in the past and cropland exist to the south and west.

Quarry Park South is part of a large portion of the former St. Cloud Township that was recently annexed into the City of Waite Park. The city is currently undergoing a planning process to determine the fate of its newly annexed lands. Most of the planning scenarios for the project area involve either residential or commercial development. Pressure to develop the area is high. Transportation and utility corridors are additional immediate threats. The county is, however, strongly pursuing the area as parkland.

RECOMMENDATION

QUARRY PARK SOUTH REPRESENTS the most significant remaining example of rock outcrop (Central Section) in Central Minnesota and is the only opportunity to protect an intact, landscape-scale portion of this community. The high-quality wetlands with their large tubercled rein-orchid population are reason in and of themselves for protection. The fact that these

communities and rare species occur in a large, natural woodland setting makes this one of the most important sites in this part of the state.

Management should include periodic prescribed fire to reduce brush along Wet Meadow margins and to restore areas of woodland to a more open state. Tubercled rein-orchid populations respond vigorously to burns. Fire would also help to maintain the open prairie present around the outcrops and improve areas of degraded prairie. Trails should be kept to a bare minimum, and public use of the outcrops, especially by mountain bikes, should be prohibited. Recreational uses such as picnic and camp sites should be kept out of the project area.

The Minnesota County Biological Survey and Natural Heritage and Nongame Research Program recommend this site be designated as a State Scientific & Natural Area.

SOURCES

Michael Lee, Plant Ecologist, Steve Stucker and Robin Maercklein, Ornithologists, & Gerald Wheeler, Botanist, Minnesota County Biological Survey 1997, 98; Welby Smith, Botanist, Natural Heritage Program 1997, 98; Chuck Wocken, Stearns County Park Director 1997; Jeff Latzka, Consultant, Bird Surveys 1993; Steve Saupe, Botanist, St. John's University 1994; Soil Survey of Stearns County, USDA-SCS-Univ. of MN Ag. Experiment Station 1985; Stearns County Geologic Atlas, Minnesota Geologic Survey-Univ. of MN 1995; Minnesota Soil Atlas: St. Cloud Sheet 1975; The Geology of Quarry Park and Nature Reserve, George W. Shurr & Garry G. Anderson, St. Cloud State University 1995; Gerald Ownbey & Thomas Morley, in Vascular Plants of Minnesota, 1991.

Birds of Quarry Park Area
Excerpt (Table 8) from Mike Lee's 1998 DNR Project Evaluation

Common Name	Scientific Name
Acadian Flycatcher	*Empidonax virescens*
American Goldfinch	*Carduelis tristis*
American Crow	*Corvus brachyrhynchos*
American Kestrel	*Falco sparverius*
American Redstart	*Setophaga ruticilla*
American Robin	*Turdus migratorius*
Black-billed Cuckoo	*Coccyzus erythropthalmus*
Black-capped Chickadee	*Parus atricapillus*
Blue Jay	*Cyanocitta cristata*
Blue-gray Gnatcatcher	*Polioptila caerulea*
Blue-winged Teal	*Anas discors*
Broad-winged Hawk	*Buteo platypterus*
Brown-headed Cowbird	*Molothrus ater*
Canada Goose	*Branta canadensis*
Catbird	*Dumetella carolinensis*
Cedar Waxwing	*Bombycilla cedrorum*
Chestnut-sided Warbler	*Dendroica petechia*
Chimney Swift	*Chaetura pelagica*
Chipping Sparrow	*Spizella passerina*
Common Grackle	*Quiscalus quiscula*
Common Snipe	*Capella gallinago*
Common Yellowthroat	*Geothlypis trichas*
Cooper's Hawk	*Accipiter cooperii*
Downy Woodpecker	*Picoides pubescens*
Eastern Kingbird	*Tyrannus tyrannus*
Eastern Phoebe	*Sayornis phoebe*

Common Name	Scientific Name	Common Name	Scientific Name
Eastern Wood-Pewee	*Contopus virens*	Northern Oriole	*Icterus galbula*
Field Sparrow	*Spizella pusilla*	N. Rough-winged Swallow	*Stelgidopteryx serripennis*
Golden-winged Warbler	*Vermivora chysoptera*	Ovenbird	*Seiurus aurocapillus*
Gray Catbird	*Dumetella carolinensis*	Pileated Woodpecker	*Dryocopus pileatus*
Great Crested Flycatcher	*Myiarchus crinitus*	Purple Martin	*Progne subis*
Great Horned Owl	*Bubo virginianus*	Red Crossbill	*Loxia curvirostra*
Green Heron	*Butorides virescens*	Red-bellied Woodpecker	*Melanerpes carolinus*
Hairy Woodpecker	*Picoides villosus*	Red-eyed Vireo	*Vireo olivaceus*
House Wren	*Troglodytes aedon*	Red-shouldered Hawk	*Buteo lineatus*
Indigo Bunting	*Passerina cyanea*	Red-tailed Hawk	*Buteo jamaicensis*
Killdeer	*Charadrius vociferus*	Red-winged Blackbird	*Agelaius phoeniceus*
Kingfisher	*Megaceryle alcyon*	Rose-breasted Grosbeak	*Pheucticus ludovicianus*
Least Flycatcher	*Empidonax minimus*	Ruby-throated Hummingbird	*Archilochus colubris*
Mallard	*Anas platyrhynchos*	Ruffed Grouse	*Bonasa umbellus*
		Sandhill Crane	*Grus canadensis*

The great crested flycatcher (left) and indigo bunting (above).

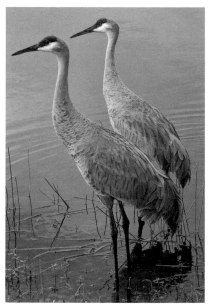

The rose-breasted grosbeak (above) and a pair of sandhill cranes (at right).

Common Name	Scientific Name
Saw-whet Owl	*Aegolius acadicus*
Scarlet Tanager	*Piranga olivacea*
Sedge Wren	*Cistothorus platensis*
Sharp-shinned Hawk	*Accipiter striatus*
Song Sparrow	*Melospiza melodia*
Swamp Sparrow	*Melospiza georgiana*
Tree Swallow	*Iroprocne bicolor*
Turkey Vulture	*Cathartes aurea*
Veery	*Catharus fuscescens*
Warbling Vireo	*Vireo gilvus*
White-breasted Nuthatch	*Sitta carolinensis*
Wood Duck	*Aix sponsa*
Wood Thrush	*Hylocichla mustelina*
Yellow-throated Vireo	*Vireo flavifrons*

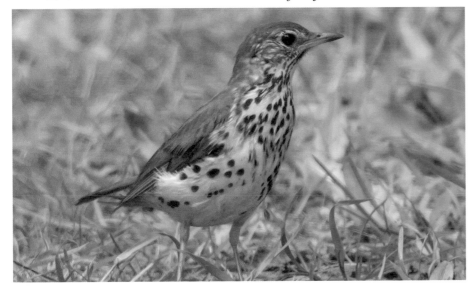

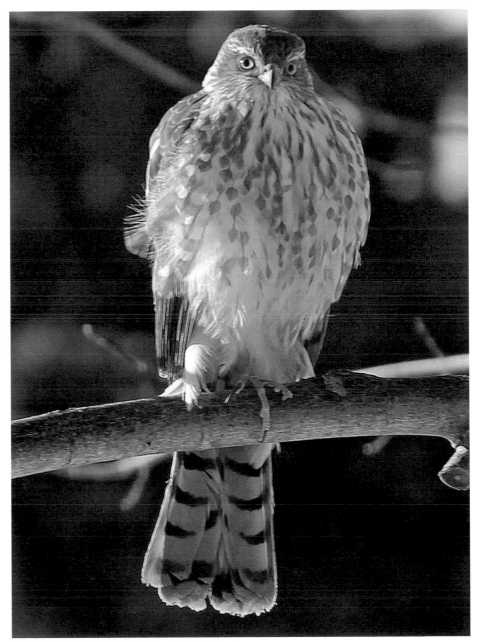

The wood thrush (above) and the sharp-shinned hawkl (at right). (Hawk photo courtesy of Rudy Frank)

Plants of Quarry Park Area

This plant list resulted from a combination of two botanical investigations at Quarry Park. The first was the 1994 field surveys of Stephen G. Saupe, Ph.D., professor of biology, and his group of community volunteers, including SJU/CSB and SCSU students. They called themselves the "Hundred Acres Quarry Botanical Action Council" (QBAC). The second was the DNR's County Biological Survey field work (1997-1998). This list of over 300 plants in the Quarry Park and Nature Preserve area was provided by Mike Lee, DNR botanist/plant ecologist, with common names researched and added by Olive Hogan-Stark (College of St. Benedict student), based on the USDA plants database. Special thanks to the joint Biology Department of the College of St. Benedict/St. John's University. Date: February 2015.

Common Name	Scientific Name
absinthe wormwood	*Artemisia absinthium*
Allegheny blackberry	*Rubus allegheniensis*
alumroot	*Heuchera richardsonii*
American burnweed	*Erechtites hieracifolius*
American elm	*Ulmus americana*
American hazelnut	*Corylus americana*
American hemp	*Apocynum cannabinum*
American vetch	*Vicia americana*
American willow herb	*Epilobium ciliatum*
arrow-leaved tearthumb	*Persicaria sagittata*
arrow-leaved violet	*Viola sagittata*
awl-fruited sedge	*Carex stipata*
awned umbrella sedge	*Cyperus squarrosus*
base-branched three-awn	*Aristida basiramea*
basswood	*Tilia americana*
bastard toadflax	*Comandra umbellata*
bearberry	*Arctostaphylos uva-ursi*
bearded birdfoot violet	*Viola pedatifida*
Bebb's willow	*Salix bebbiana*
Bicknell's sedge	*Carex bicknellii*
big bluestem	*Andropogon gerardii*
bigfruit hawthorn	*Crataegus macrosperma*
big-toothed aspen	*Populus grandidentata*
bird's foot coreopsis	*Coreopsis palmata*
bird's foot trefoil	*Lotus corniculatus*
black ash	*Fraxinus nigra*
blackberry	*Rubus spp.*

Common Name	Scientific Name
black bindweed	*Fallopia convolvulus*
black cherry	*Prunus serotina*
black medick	*Medicago lupulina*
blood milkwort	*Polygala sanguinea*
blue giant hyssop	*Agastache foeniculum*
blue monkey flower	*Mimulus ringens*
blue vervain	*Verbena hastata*
bluejoint	*Calamagrostis canadensis*
bluets	*Hedyotis longifolia*
bog aster	*Symphyotrichum boreale*
bog birch	*Betula pumila*
bottle gentian	*Gentiana andrewsii*
box elder	*Acer negundo*
bracken	*Pteridium aquilinum*
bracted spiderwort	*Tradescantia bracteata*
brittle prickly pear	*Opuntia fragilis*
broad-leaved cattail	*Typha latifolia*
bulb-bearing water hemlock	*Cicuta bulbifera*
bull thistle	*Cirsium vulgare*
bunchberry	*Cornus canadensis*
bur clover dodder	*Cuscuta pentagona*
bur oak	*Quercus macrocarpa*
bush honeysuckle	*Diervilla lonicera*
butter-and-eggs	*Linaria vulgaris*
Buxbaum's sedge	*Carex buxbaumii*
Canada bluegrass	*Poa compressa*
Canada goldenrod	*Solidago canadensis*

Common Name	Scientific Name
Canada mayflower	*Maianthemum canadense*
Canada tick trefoil	*Desmodium canadense*
Canada wild lettuce	*Lactuca canadensis*
catnip	*Nepeta cataria*
chokecherry	*Prunus virginiana*
climbing bittersweet	*Celastrus scandens*
columbine	*Aquilegia canadensis*
common boneset	*Eupatorium perfoliatum*
common buckthorn	*Rhamnus cathartica*
common burdock	*Arctium minus*
common dandelion	*Taraxacum officinale*
common enchanter's nightshade	*Circaea lutetiana*
common evening primrose	*Oenothera biennis*
common false Solomon's seal	*Maianthemum racemosum*
common marsh marigold	*Caltha palustris*
common mint	*Mentha arvensis*
common mullein	*Verbascum thapsus*
common polypody	*Polypodium virginianum*
common ragweed	*Ambrosia artemisiifolia*
common sheep sorrel	*Rumex acetosella*
common St. John's-wort	*Hypericum perforatum*
common strawberry	*Fragaria virginiana*
common yarrow	*Achillea millefolium*
crested fern	*Dryopteris cristata*
Culver's root	*Veronicastrum virginicum*
cut-leaved bugleweed	*Lycopus americanus*
densetuft hairsedge	*Bulbostylis capillaris*

Common Name	Scientific Name	Common Name	Scientific Name	Common Name	Scientific Name
downy arrowwood	*Viburnum rafinesquianum*	hoary frostweed	*Helianthemum bicknellii*	meadow-rue	*Thalictrum dioicum*eastern
dwarf alder	*Rhamnus alnifolia*	hoary vervain	*Verbena stricta*	Mead's sedge	*Carex meadii*
dwarf bilberry	*Vaccinium caespitosum*	hog peanut	*Amphicarpaea bracteata*	Michigan lily	*Lilium michiganense*
dwarf raspberry	*Rubus pubescens*early	hooked crowfoot	*Ranunculus recurvatus*	mock pennyroyal	*Hedeoma hispida*
elliptic shinleaf	*Pyrola elliptica*	horseweed	*Conyza canadensis*	mountain blue-eyed grass	*Sisyrinchium montanum var. montanum*
false pennyroyal	*Isanthus brachiatus*	hybrid cattail	*Typha glauca*	moutain rice grass	*Oryzopsis asperifolia*
fen wiregrass sedge	*Carex lasiocarpa subsp. americana*	Indian grass	*Sorghastrum nutans*	nannyberry	*Viburnum lentago*
field chickweed	*Cerastium arvense*	Indian paintbrush	*Castilleja coccinea*	narrowleaf willow	*Salix exigua*
field horsetail	*Equisetum arvense*	Indian pipe	*Monotropa uniflora*	narrow-leaved cattail	*Typha angustifolia*
field pussytoes	*Antennaria neglecta*	interior sedge	*Carex interior*	New England aster	*Symphyotrichum novae-angliae*
field sedge	*Carex conoidea*	intermediate juneberry	*Amelanchier ×intermedia*	New Jersey tea	*Ceanothus americanus*
field thistle	*Cirsium discolor*	interrupted fern	*Osmunda claytoniana*	nodding bur marigold	*Bidens cernua*
fireberry hawthorn	*Crataegus chrysocarpa*	ironwood	*Ostrya virginiana*	nodding trillium	*Trillium cernuum*
flat-topped aster	*Doellingeria umbellata var. umbellata*	Jack-in-the-pulpit	*Arisaema triphyllum*	northern bedstraw	*Galium boreale*
fleshy hawthorn	*Crataegus succulenta*	junegrass	*Koeleria macrantha*	northern blue flag	*Iris versicolor*
fowl bluegrass	*Poa palustris*	Kalm's hawkweed	*Hieracium kalmii*	northern bugleweed	*Lycopus uniflorus*
fringed brome	*Bromus ciliatus*	Kentucky bluegrass	*Poa pratensis*	northern green orchid	*Platanthera aquilonis*
fringed loosestrife	*Lysimachia ciliata*	Kinnickinnick dewberry	*Rubus multifer*	northern marsh fern	*Thelypteris palustris*
giant goldenrod	*Solidago gigantea*	lady fern	*Athyrium angustum*	northern panic grass	*Dichanthelium boreale*
giant Solomon's seal	*Polygonatum biflorum*	lake sedge	*Carex lacustris*	northern pin oak	*Quercus ellipsoidalis*
golden alexanders	*Zizia aurea*	lance-leaved figwort	*Scrophularia lanceolata*	northern red oak	*Quercus rubra*
golden ragwort	*Packera aurea*	large-thorned hawthorn	*Crataegus macracantha*	oldfield cinquefoil	*Potentilla simplex*
graceful sedge	*Carex gracillima*	leadplant	*Amorpha canescens*	oxy-eye daisy	*Leucanthemum vulgare*
grass-leaved goldenrod	*Euthamia graminifolia*	leathery grapefern	*Botrychium multifidum*	pale bellwort	*Uvularia sessilifolia*
gray dogwood	*Cornus racemosa*	Leiberg's panic grass	*Dichanthelium leibergii*	pale corydalis	*Corydalis sempervirens*
gray goldenrod	*Solidago nemoralis*	Leonard's skullcap	*Scutellaria leonardii*	pale vetchling	*Lathyrus ochroleucus*
greater water dock	*Rumex orbiculatus*	Lindley's aster	*Symphyotrichum ciliolatum*	paper birch	*Betula papyrifera*
green foxtail	*Setaria viridis*	little bluestem	*Schizachyrium scoparium*	Pennsylvania sedge	*Carex pensylvanica*
green-flowered peppergrass	*Lepidium densiflorum*	Loesel's twayblade	*Liparis loeselii*	Pennsylvania smartweed	*Persicaria pensylvanicum*
hackberry	*Celtis occidentalis*	long-leaved chickweed	*Stellaria longifolia*	Philadelphia fleabane	*Erigeron philadelphicus*
hairy goldenrod	*Solidago hispida*	lopseed	*Phryma leptostachya*	pink shinleaf	*Pyrola asarifolia*
hairy panic grass	*Dichanthelium acuminatum subsp. fasciculatum*	lowbush blueberry	*Vaccinium angustifolium*	pointed-leaved tick trefoil	*Desmodium glutinosum*
harebell	*Campanula rotundifolia*	many-flowered woodrush	*Luzula multiflora*	poke milkweed	*Asclepias exaltata*
Hayden's sedge	*Carex haydenii*	marsh bellflower	*Campanula aparinoides*	poverty grass	*Danthonia spicata*
heal-all	*Prunella vulgaris*	marsh skullcap	*Scutellaria galericulata*	prairie blazing star/gayfeather	*Liatris pycnostachya*
heart-leaved aster	*Symphyotrichum cordifolium*	marsh straw sedge	*Carex tenera*	prairie cordgrass	*Spartina pectinata*
heart-leaved willow	*Salix eriocephala*	marsh vetchling	*Lathyrus palustris*	prairie dropseed	*Sporobolus heterolepis*
hoary alyssum	*Berteroa incana*	maryland black snakeroot	*Sanicula marilandica*	prairie pinweed	*Lechea stricta*

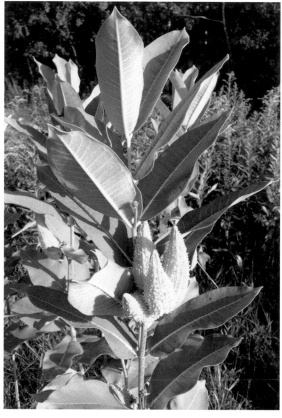

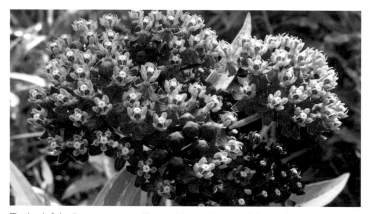

To the left is the common milkweed in pod stage. A lack of pesticides and the limited use of herbicides at Quarry Park resulted in an abundance of milkweek plants, which add to the number of monarch butterflies in the park. Milkweed is one of the common host plants for the larval stage (caterpillar) of the monarch. In the lower left corner is Indian paintbrush. Below is the yellow lady's slipper (courtesy of the Stearns County Park Department). In the lower right corner is an example of wild bergamot. To the right is the rare tubercled rein-orchid found in Quarry Park (courtesy of the Stearns County Park Department). Above is swamp milkweed. (All photos Author's Collection, except those of the orchids)

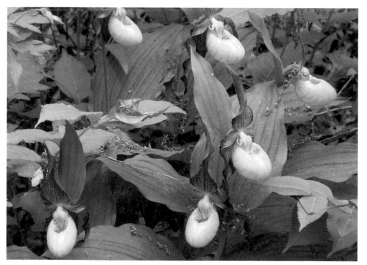

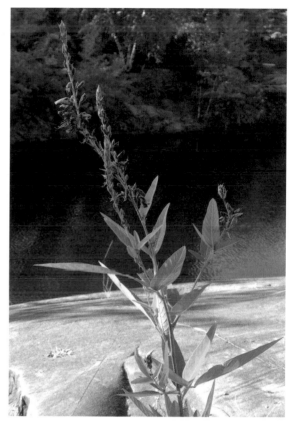

In the lower left corner is the ox-eye daisy. Below is the wild geranium. In the lower right corner is an example of the bird's foot trefoil. To the right is the showy tick-trefoil at Quarry 13. To the left is gayfeather, also known as the prairie blazing star. Above is yellow coneflower. (all Author's Collection)

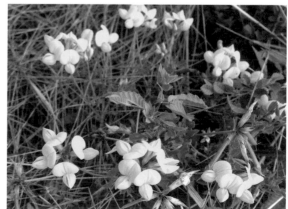

Common Name	Scientific Name
prairie ragwort	*Packera plattensis*
prairie sedge	*Carex prairea*
prairie wild onion	*Allium stellatum*
prairie willow	*Salix humilis*
pretty honeysuckle	*Lonicera bella*
prickly ash	*Zanthoxylum americanum*
prickly gooseberry	*Ribes cynosbati*
prostrate hairy spurge	*Euphorbia maculata*
purple prairie clover	*Dalea purpurea*
purslane	*Portulaca oleracea*
pussytoes	*Antennaria sp.*
pussy willow	*Salix discolor*
quackgrass	*Elymus repens*
quaking aspen	*Populus tremuloides*
rattlesnake fern	*Botrychium virginianum*
rattlesnake master	*Eryngium yuccifolium*
red cedar	*Juniperus virginiana*
red clover	*Trifolium pratense*
red elm	*Ulmus rubra*
red maple	*Acer rubrum*
red raspberry	*Rubus idaeus*
red-berried elder	*Sambucus pubens*
red-osier dogwood	*Cornus sericea*
red-stemmed aster	*Symphyotrichum puniceum*
red-stemmed aster	*Symphyotrichum p. var. puniceum*
reed canary grass	*Phalaris arundinacea*
rigid sedge	*Carex tetanica*
roadside agrimony	*Agrimonia striata*
rock spikemoss	*Selaginella rupestris*
rough bentgrass	*Agrostis scabra*
rough blazing star	*Liatris aspera*
rough cinquefoil	*Potentilla norvegica*
rough-fruited cinquefoil	*Potentilla recta*
round-headed bush clover	*Lespedeza capitata*
rue anemone	*Thalictrum thalictroides*
Rugel's plantain	*Plantago rugelii*
rusty woodsia	*Woodsia ilvensis*
sage-leaved willow	*Salix candida*

Common Name	Scientific Name
sand cherry	*Prunus pumila*
sensitive fern	*Onoclea sensibilis*
short sedge	*Carex brevior*
showy tick-trefoil	*Desmodium canadense*
Siberian elm	*Ulmus pumila*
side-flowering sandwort	*Moehringia lateriflora*
silvery cinquefoil	*Potentilla argentea*
skyblue aster	*Symphyotrichum oolentangiense*
slender knotweed	*Polygonum tenue*
small purple fringed orchid	*Platanthera psycodes*
small-flowered fameflower	*Phemeranthus parviflorus*
smooth brome	*Bromus inermis*
smooth hedge nettle	*Stachys hispida*
smooth sumac	*Rhus glabra*
speckled alder	*Alnus incana subsp. rugosa*
spotted Joe pye weed	*Eutrochium maculatum*
spotted touch-me-not	*Impatiens capensis*
spotted water hemlock	*Cicuta maculata*
spreading bentgrass	*Agrostis stolonifera*
spreading dogbane	*Apocynum androsaemifolium*
Spreadingpod rockcress	*Arabis × divaricarpa [drummondii × holboellii]*
starflower	*Trientalis borealis*
starry sedge	*Carex rosea*
stiff goldenrod	*Solidago rigida*
swamp buttercup	*Ranunculus fascicularis*
swamp lousewort	*Pedicularis lanceolata*
swamp milkweed	*Asclepias incarnata*
swamp saxifrage	*Micranthes pensylvanica*
swamp thistle	*Cirsium muticum*
sweet everlasting	*Pseudognaphalium obtusifolium*
sweetgrass	*Hierochloe odorata*
sweet-scented bedstraw	*Galium triflorum*
tall cinquefoil	*Potentilla arguta*
tall coneflower	*Rudbeckia laciniata*
tall meadow-rue	*Thalictrum dasycarpum*
tartarian honeysuckle	*Lonicera tatarica*
timothy	*Phleum pratense*

Common Name	Scientific Name
tubercled rein-orchid	*Platanthera flava var. herbiola*
tussock sedge	*Carex stricta*
umbel sedge	*Carex umbellata*
Virginia creeper	*Parthenocissus quinquefolia*
Virginia mountain mint	*Pycnanthemum virginianum*
water horsetail	*Equisetum fluviatile*
water parsnip	*Sium suave*
western androsace	*Androsace occidentalis*
western poison ivy	*Toxicodendron rydbergii*
white avens	*Geum canadense*
white clover	*Trifolium repens*
white meadowsweet	*Spiraea alba*
white oak	*Quercus alba*
white rattlesnakeroot	*Prenanthes alba*
white sage	*Artemisia ludoviciana*
white snakeroot	*Ageratina altissima*
white sweet clover	*Melilotus alba*
white turtlehead	*Chelone glabra*
white wild indigo	*Baptisia alba*
wild bergamot	*Monarda fistulosa*
wild black currant	*Ribes americanum*
wild geranium	*Geranium maculatum*
wild grape	*Vitis riparia*
wild honeysuckle	*Lonicera dioica var. glaucescens*
wild plum	*Prunus americana*
wild rose	*Rosa spp.*
wild sarsaparilla	*Aralia nudicaulis*
winter bentgrass	*Agrostis hyemalis*
wood anemone	*Anemone quinquefolia*
wood betony	*Pedicularis canadensis*
woodland sunflower	*Helianthus strumosus*
woundwort	*Stachys palustris*
yellow/gray-headed coneflower	*Ratibida pinnata*
yellow goat's beard	*Tragopogon dubius*
yellow hawk's beard	*Crepis tectorum*
yellow star-grass	*Hypoxis hirsuta*
yellow wood sorrel	*Oxalis stricta*
zigzag goldenrod	*Solidago flexicaulis*

Native prairie planting sign. (Author's Collection) Rattlesnake master (above) is a native species quite uncommon in Central Minnesota, though they only occur naturally further south in the state. (Courtesy of the Stearns County Park Department) However, it is often included in seed mixes for prairie restoration projects, which is likely the reason it shows up in Quarry Park.

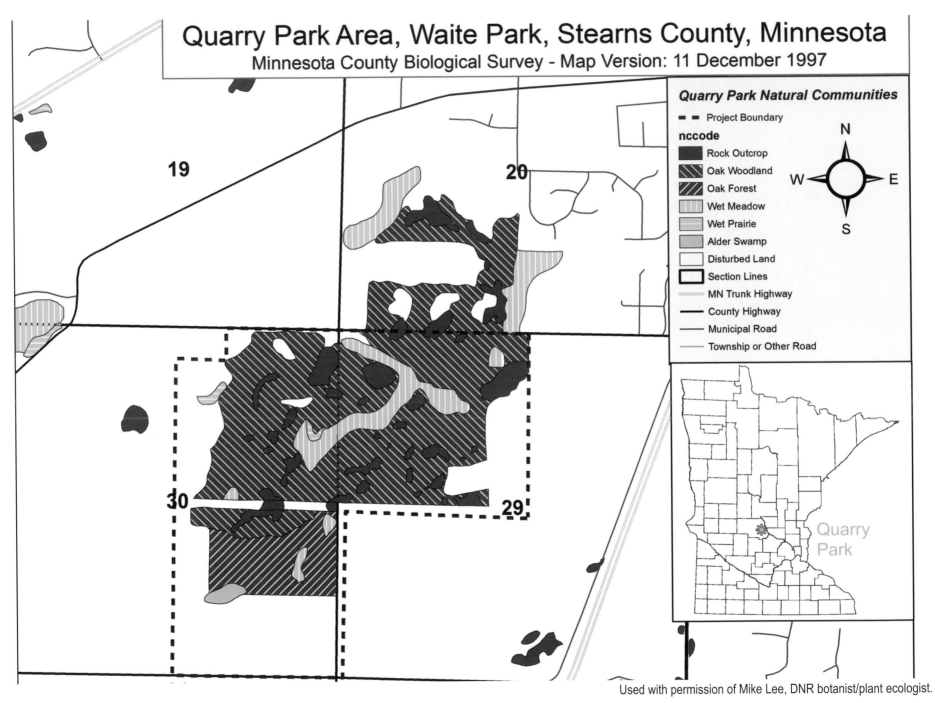

Quarry Park Area, Waite Park, Stearns County, Minnesota
Minnesota County Biological Survey - Map Version: 11 December 1997

Quarry Park Natural Communities

- ▪ ▪ Project Boundary

nccode

- Rock Outcrop
- Oak Woodland
- Oak Forest
- Wet Meadow
- Wet Prairie
- Alder Swamp
- Disturbed Land
- Section Lines
- MN Trunk Highway
- County Highway
- Municipal Road
- Township or Other Road

19

20

30

29

Quarry Park

Used with permission of Mike Lee, DNR botanist/plant ecologist.

[108]

Native Plant Communities of Quarry Park Area

Minnesota County Biological Survey - Map Version: 13 April 1999

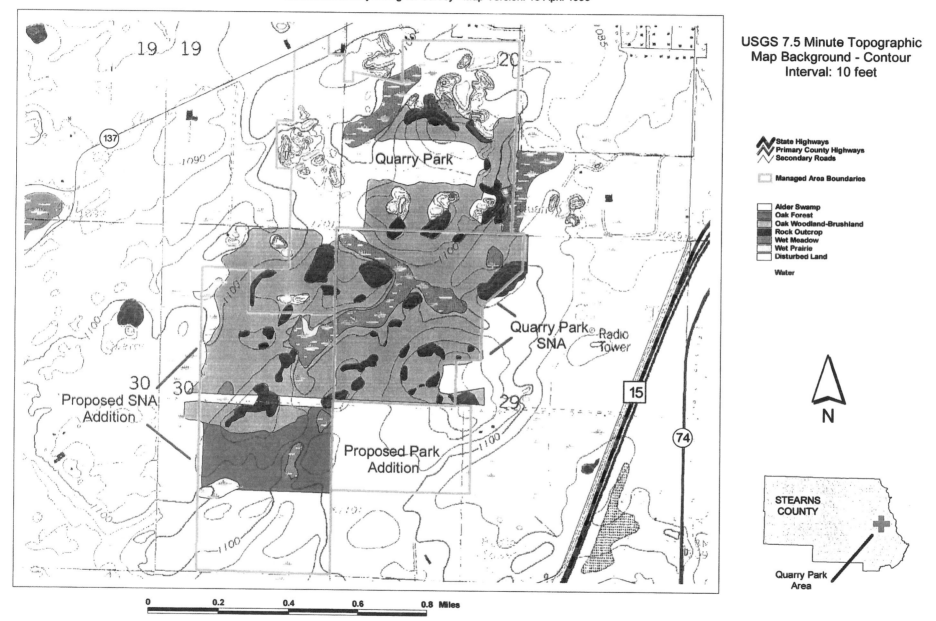

USGS 7.5 Minute Topographic
Map Background - Contour
Interval: 10 feet

State Highways
Primary County Highways
Secondary Roads

Managed Area Boundaries

Alder Swamp
Oak Forest
Oak Woodland-Brushland
Rock Outcrop
Wet Meadow
Wet Prairie
Disturbed Land

Water

N

STEARNS
COUNTY

Quarry Park
Area

0 0.2 0.4 0.6 0.8 Miles

Used with permission of Mike Lee, DNR botanist/plant ecologist.

CITIES OF ST. CLOUD AND WAITE PARK

T.124N. - R.28W.

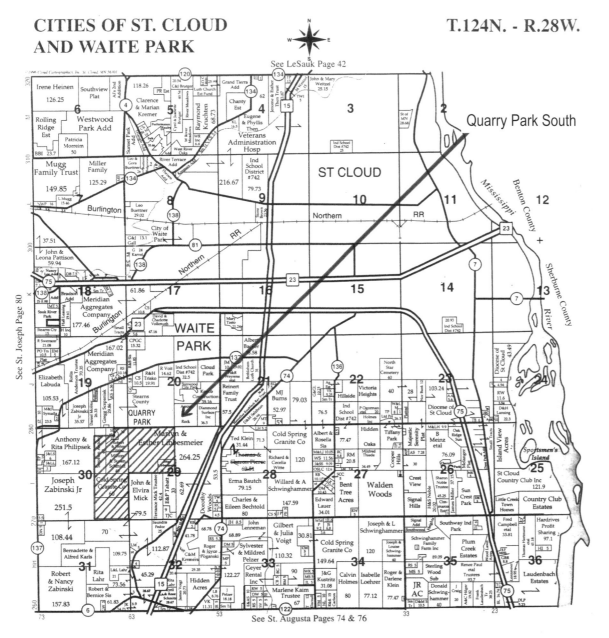

Quarry Park South

Wild turkeys (top) (courtesy of the Park Department) and a mallard mom and her ducklings (bottom) (courtesy of Rudy Frank).

Note the arrow pointing to Quarry Park South. (Used with permission of Mike Lee, DNR botanist/plant ecologis)

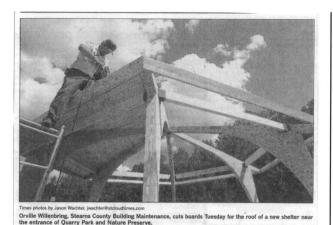

Orville Willenbring, Stearns County Building Maintenance, cuts boards Tuesday for the roof of a new shelter near the entrance of Quarry Park and Nature Preserve.

Picnic shelter marks 1st building in park

$12,000 structure is 1 of 3 to be built in Quarry Park as part of upgrades

By Kirsti Marohn
kmarohn@stcloudtimes.com

WAITE PARK — Visitors to Quarry Park and Nature Preserve will have a place to get some relief from sun or rain.

Stearns County employees are building a picnic shelter, the first structure to be built within the park boundaries, near the park entrance.

The open-air shelter is one of several improvements at the county's most-visited park, which opened in 1998.

The 25-foot octagonal shelter will include two picnic tables available on a first-come, first-serve basis.

"It's just meant for people stopping at the park who want to have an impromptu picnic," parks director Chuck Wocken said.

The county is using $12,000 from its capital improvement bond to pay for the materials and its own employees to build the structure, Wocken said. It should be completed in about a week.

Park caretaker Christy Flugga expects the shelter to be popular with park users for birthday parties and other gatherings. It's one of several steps planned for the next several years to improve the

Quarry Park visitors can use the shelter and its two picnic tables on a first-come, first-serve basis for picnics or to get out of the elements.

> The more we can do, the happier the public is.
>
> **Christy Flugga**
> Quarry Park caretaker

park, she said.

"The more we can do, the happier the public is," Flugga said.

Eventually, another shelter probably will be added to the park near a scenic backdrop such as a granite rock pile, Wocken said.

A third shelter available for large groups is planned for the park's southern portion.

Art-print auction to raise cash for park

The park department is planning to auction a loon print by Rep. Leslie Schumacher, DFL-Santiago, as a fund-raiser for Quarry Park.

The print and latest bids can be viewed at the county's park office at Quarry Park or on the county's Web site at www.co.stearns.mn.us/departments/parks/events.htm#news.

Bids can be placed at the county park office or e-mailed to parkinfo@co.stearns.mn.us.

The minimum bid is $50. The bidding ends Sept. 30.

Park workers recently restored a prairie area near the entrance by planting native grasses, including colorful wildflowers, Wocken said.

It will take about three years for the prairie to reach maturity.

"We want it to be real showy in the area," he said.

Boy Scouts also are clearing a milelong pedestrian trail for winter use to avoid conflict between cross-country skiers and walkers.

They're also clearing a trail through the park's Scientific and Natural Area, which is kept in its natural state with limited use.

Quarry Park rocks show the power of water and cold

ROBERT WICHMAN
GEOLOGY

This winter has been a cold one, at least for those of short memory.

Cold enough to crack the stones around us, some might say. But that's an exaggeration.

It is true that boulders and ledges split by gaping cracks are found all over the North Country, but it takes more than cold to open cracks like that.

Most things shrink when they cool (freezing water is the chief exception), but very few things shrink a lot. And rocks are generally large, strong, slow to heat or cool, and buried in snow for the winter. So it's hard for winter to cool a rock far enough to break it open.

Nevertheless, the rocks do break. A nice example can be seen in Quarry Park & Nature Preserve.

There, on a corner in the west wall of Quarry 17, two vertical fissures are splitting a large block out of the quarry face. They are perfectly natural — they show no sign of human drilling, cutting, or blasting — and they are large, ranging in breadth from several inches to a double hand-span.

If you go looking in the summer, you also can see where they run off into the bedrock beyond, but there they are just faint, thin lines etched into the granite surface. They only open right along the edges of the block itself.

What forced those cracks open?

It wasn't just the cold. While dropping temperatures can make a crack (slightly) wider as both sides shrink back, they should swell right back again come summer with no net movement.

It wasn't plant roots either. There are no trees, bushes, grass, or soil anywhere near those cracks.

The most likely answer is frost wedging, which uses the power of both water and cold to pry things apart. If water drips into a crack and then freezes, the expanding ice pushes on both sides of the crack, just like a wedge. Indeed, that is how early stoneworkers used to split rock, by pounding soft iron into a line of holes until the expansion broke the rock between.

Before the quarry was dug, however, such wedging wouldn't do much. There was just too much granite around the crack for the ice to get any leverage. With the quarry open, however, that has changed.

Now, with nothing in the quarry to push back, every time the ice freezes it pushes the block just a little farther out over the edge.

Of course, because frost wedging needs both liquid water and freezing temperatures, this winter hasn't moved that block much.

A dry, cold winter doesn't give many freeze-thaw cycles. A warmer, wetter winter with many thaws and storms is much more effective at prying things apart.

Still, even average winters add up, and that quarry is less than 100 years old. Given the present size of those cracks, that block may not be there for more than a few more centuries.

This is the opinion of Robert Wichman, a geologist and professor who has explored many of Minnesota's state parks with a particular interest in their rocks. He can be reached at newsroom@stcloudtimes.com.

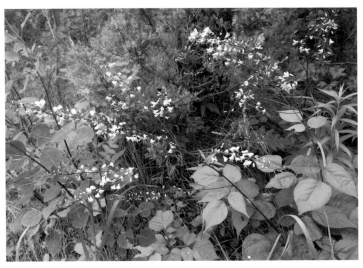

In the lower left corner is blue vervain. (Courtesy of Rudy Frank) Below is the ghostly Indian pipe. (Courtesy of the Park Department) In the lower right corner is an example of lichen. (Author's Collection) To the right is wild white indigo, another plant that probaby came to Quarry Park in prairie planting mixes. (Author's Collection) To the left are aspens and pin oaks in their fall colors, and above is pointed-leaved tick trefoil. (both Author's Collection)

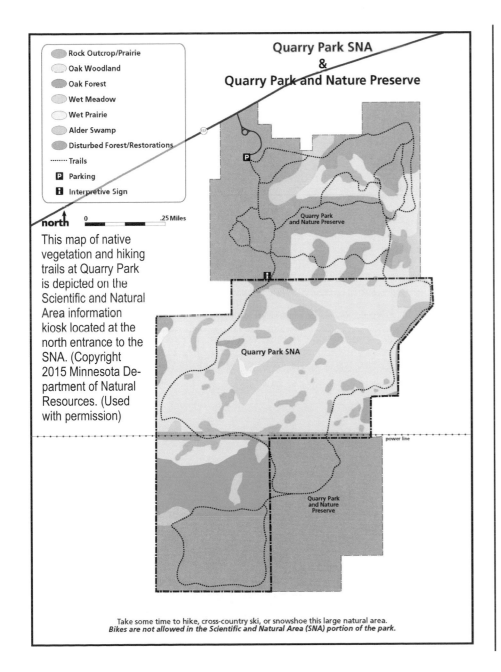

Quarry Park SNA
&
Quarry Park and Nature Preserve

- Rock Outcrop/Prairie
- Oak Woodland
- Oak Forest
- Wet Meadow
- Wet Prairie
- Alder Swamp
- Disturbed Forest/Restorations
- Trails
- **P** Parking
- **i** Interpretive Sign

north 0 _____ .25 Miles

This map of native vegetation and hiking trails at Quarry Park is depicted on the Scientific and Natural Area information kiosk located at the north entrance to the SNA. (Copyright 2015 Minnesota Department of Natural Resources. (Used with permission)

Quarry Park and Nature Preserve

Quarry Park SNA

power line

Quarry Park and Nature Preserve

Take some time to hike, cross-country ski, or snowshoe this large natural area.
Bikes are not allowed in the Scientific and Natural Area (SNA) portion of the park.

Beautiful flower makes a comeback

Indian Paintbrush blooms at area park

Times photos by Paul Middlestaedt, pmiddlestaedt@stcloudtimes.com
Stearns County Parks Officer Danielle Coffield inspects a small grassy area dotted with Indian Paintbrush flowers Tuesday in Quarry Park and Nature Preserve.

Times staff report

WAITE PARK — Brilliant Indian Paintbrush plants are producing a summer show at Quarry Park and Nature Preserve.

The flashy native plant is making a comeback at the park off Stearns County Road 137 after being almost crowded out of the park's central prairie by other plants.

A controlled burn last year reduced the competition for the hardy wildflower.

The red, red-orange, or occasionally yellow flowers are actually bracts surrounding almost-inconspicuous yellow-green flowers at the top of the spike, according to the Department of Natural Resources.

Those who walk the trails at Quarry Park also will find ladyslippers and prickly pear cactus at the park.

Visitors will find the best fields of Indian Paintbrush flowers in the south and east portions of the prairie in Quarry Park, the largest park in the Stearns County park system.

Because of construction along County Road 137 in Waite Park, park visitors will find the easiest route to the park is to take Minnesota Highway 23 west to Bel Clare Drive, take a left, continue on to County Road 137 and take another left.

Vehicle permits cost $4 a day and $14 a year. They are available at the entrance. Annual permits are available online at www.co.stearns.mn.us.

Used with permission of the *St. Cloud Times.*

Chapter 8

Remnants of a Quarrying Past

The Park Department brought in experts and volunteers to restore the Liberty Derrick, which was taken off the Sis family property, located just east of the parks maintenance facility near the entrance to Quarry Park. The derrick was reconstructed on a site where there was an active derrick in 1946. Through a lot of ingenuity and tremendous generosity on the part of Dale Gruber Construction and others, the derrick is now at a point where the operation can be fired up and lift a four-ton stone out of a quarry and place it on the loading dock, just like they used to do in 1880.

READING STONES

Signs of tools, techniques used years ago remain at Quarry Park

By Ann Wessel
awessel@stcloudtimes.com

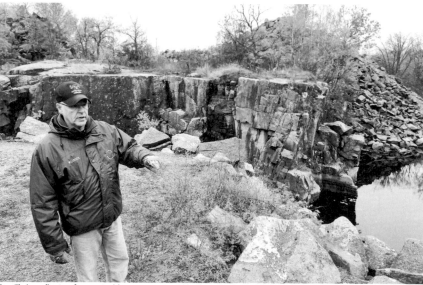

Gary Theisen, director of corporate risk management at Coldspring, talks about quarrying features at a quarry in Quarry Park & Nature Preserve. DAVE SCHWARZ, DSCHWARZ@STCLOUDTIMES.COM

WAITE PARK — You don't have to wait for the next derrick demonstration to extract insight from the granite quarries and grout piles at Quarry Park & Nature Preserve. The grooves, holes and striations on some of the stones provide hints to the methods used in an evolving industry that defined St. Cloud and built buildings around the world.

By 1963, 10 quarries operated within 10 miles of St. Cloud, which by that time was the No. 2 granite-producing area in the U.S., according to the park's master plan. While granite companies still owned the St. Cloud Township property that decades later would become the park, by the mid-1950s, quarry operations at the site had stopped. Exactly when is unclear.

The first owner, Plymouth Rock Granite Co., bought land in 1903. The last quarry owner, Coldspring (known then as Cold Spring Granite Co.), bought the land in 1959 but never operated there. (While companies today buy sites to meet customer demand for matching stone, at that time the appeal likely was proximity to existing operations.) In the years between, major advances were made in the methods used to remove, shape and ship stone. Some of the succession reveals itself in what was left behind.

Gary Theisen, director of corporate risk management at Coldspring, provided a bit of contrast with current operations during a recent stop at the park. Al Hockart, who worked for Cold Spring Granite Company from 1937 until he retired as quarry manager in 1984, explained how some of the tools and machinery worked. He gleaned some knowledge from his father, John, who ran a steam hoist and tended the boilers at a quarry. Stearns History Museum records and displays filled in some of the gaps.

"The big aim always was to get the block out and get it out free of cracks and seams and flaws," Hockart said.

Here are some explanations for what you'll see in the granite at Quarry Park:

See QUARRY, Page 15B

MORE ONLINE

Wondering what else you might spot in Quarry Park & Nature Preserve at different times of the year? Check out a gallery of items found there, as well as a video explaining quarrying operations at **www.sctimes.com/woodswaters**.

Quarry

From Page 16B

EYE-BOLT ANCHORS

The oval holes, a bit wider than a hoagie bun, found atop cut stones at Quarry 18, likely are the product of demonstrations at the park. In a working quarry, they would have held eye bolts through which a cable was threaded, allowing a derrick to lift the blocks.

DOG HOLES

The pairs of holes, about 2 inches wide, appear opposite each other near the top of a stone. The hooks that fit into the holes were wedged in place when the derrick pulled the connecting cable taut.

Gary Theisen, director of corporate risk management at Coldspring, points out features of Quarry 18 within Quarry Park. Pairs of holes placed opposite each other held hooks, connecting by cable to the derrick that would lift them out of the quarry. These likely were made for demonstration purposes.

EARLY DRILLING

Drilling and blasting freed the rock that later would be extracted and finished. Workers read the rock and determined where natural faults in the ledge lay. The channels they made were of varying depths.

"The varying depth of the holes(as seen in "Blasting holes' photo above, right) was probably just common sense to how much you had to use to blast," Hockart said.

In the earliest days — the first quarry to operate in Stearns County was Breen and Young at the St. Cloud Reformatory — work was done with hammers and a series of chisels of various lengths. Hockart said blacksmith shops operated on site. Steam may have been used briefly, but by the 1910s, pneumatic tools powered by compressed air were used. Hydraulic power followed.

OUTCROPS

The bare, rounded outcrops of granite, their surface sometimes broken by tufts of grass that resemble bits of hair clinging to a balding noggin, were the first thing scouts sought.

Hikers today can stand on remnants of those outcrops, even at Quarry 18, and imagine the unbroken dome that existed before quarrying took place.

"Decades ago, people would travel the country and ask, 'Do you have any land that you can't use?' " Theisen said. They'd be looking for granite outcroppings, land impossible to farm. They'd sample the stone before buying.

In the early days, Hockart said scouts sought out places where the faults, which generally run at 90-degree angles, were fairly close together.

"In those days they would look for ledges that had more faults because it would be easier to break it loose," Hockart said.

BLASTING HOLES

After holes were drilled, pieces were blasted loose with dynamite. Smaller pieces were freed with jackhammers or drills. The shallowest channels, spaced about 4 inches apart, were likely made by a plug drill, which was used to trim the excess from a usable block. Finally, wedges and feathers were driven into the holes with a hammer to make more precise trims. The wedge fit in the groove between the feathers — two tapered pieces of steel rounded on the outside and flat on the inside.

At one time, Hockart said the holes were filled with water in the winter. The expanding ice would split the rock.

Granite blocks on a grout pile at Quarry Park & Nature Preserve could show evidence of plug-drill use.

GROUT PILES

In a modern quarry operation, you wouldn't see such mountainous mounds of discarded materials. Early quarrying was a loud and dangerous business that required workers to blast the rock loose and then split up the bigger pieces.

"This goes back to a point in time where we did do the blasting to get big chunks," Theisen said.

In the early days, blasting would have produced 10-ton pieces measuring about 10 by 10 feet.

Today's operations use wire saws — diamond-wire saws at Coldspring since 2005 — that cut the granite from quarry walls like a slice of bread. In a more controlled process, Theisen said blasting powder is tucked underneath to break the slab loose horizontally. The resulting loaf (large slab of granite) can produce a 30- to 50-ton piece measuring up to 30 feet wide, 80 feet long and 20 feet high.

"It doesn't fracture the granite as much," Theisen said. The grout that remains today is basketball size or smaller. By 2020, Coldspring aims to eliminate waste rock altogether.

In the early days, Theisen said, it wasn't uncommon for a quarry's net yield to run 3 to 6 percent. Advances in technology boosted net yield to 9 to 16 percent. Cracks, fissures and blemishes are among the features that make stone unusable.

CHANNELING MARKS

The closely and evenly spaced channels extending to a uniform depth could have been made with the aid of a drifter drill. Mounted on an 8- to 10-foot bar, the drill — using bits of increasing length — made holes 1⅜ to 2 inches in diameter, according to The Architectural, Structural and Monumental Stones of Minnesota, a 1935 University of Minnesota Press publication by Carl E. Dutton. The connecting rock was then broken, creating a channel.

In some places, a broaching tool — a drill-powered flat chisel — cut the remaining web between channels. Elsewhere, interlocking channels were drilled. (Today, the channel may be made with a wire saw.) The slab was freed using black powder put into perpendicular holes drilled at the base.

Slabs then could be cut into smaller pieces with a saw.

Channeling likely didn't take place at the Quarry Park site, although Hockart said it was used elsewhere in the county, likely in the late 1930s or early 1940s. The examples may be the product of a demonstration or may have been brought in for display purposes.

STAPLE ANCHOR

The anchors held guy wires, which stabilized the derrick. They appear throughout Quarry Park. Hockart said their predecessors, called dead men, consisted of a steel bar parallel to the ground, anchored in two stacks of stones. The cable length could be adjusted.

Several anchors like this appear throughout Quarry Park & Nature Preserve. They held the cables that stabilized the derrick. DAVE SCHWARZ, DSCHWARZ@STCLOUDTIMES.COM

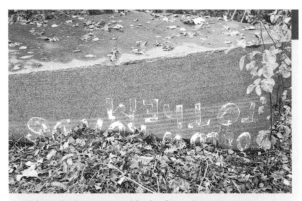

Writing is shown on a block of granite at Quarry Park & Nature Preserve. The striations on the rock show that it was cut with a saw, although that likely did not happen on the site of the present-day park. Instead, the piece probably was brought in.

SAW MARKS

Striations indicate that a saw cut or trimmed a piece of granite. Saws likely were not used at the operations that worked in today's Quarry Park. Like pieces from the old public library and St. Cloud Times buildings, the saw-cut slab that rests along the trail opposite Quarry 18 likely was brought in.

Wire saws operated between two towers, one of them placed in a column drilled about 40 feet back from the granite ledge. The column was made by a toothed steel drum that cut a 1-inch circle around a core 5 feet in diameter.

"The aim was to get a hole in the granite ledge that was 5 feet in diameter and 21, 22 feet deep," Hockart said.

The second tower was placed out from the ledge. Between them, the saw cut quarter-inch-wide slots. The process was repeated 50 feet over, producing vertical slabs of granite that workers on scaffolding could break up into block size.

STAGING AREA

Piles of smaller granite pieces along the main hiking path to Quarry 18 likely marked a staging area where quarried stone was finished by hand. Park records don't specify exactly what took place there. Possibilities include monuments. Before saws and polishers changed the process, headstones had a rougher surface — pitching tools were used to remove the marks from the plug drills that worked down the stone's surface.

In a 1918 U.S. Geological Survey report, quarries including Empire Quarry and Frick & Borwick Granite Co., which operated in the sections of today's Quarry Park, mention transporting granite by horse and wagon or railroad.

Used with permission of the *St. Cloud Times*.

Granite exhibit to feature Stearns' antique derrick

By Kate Kompas and
Lawrence Schumacher
kkompas@stcloudtimes.com,
lschumacher@stcloudtimes.com

WAITE PARK — Workers started removing a 64-foot antique derrick Tuesday from land near Quarry Park and Nature Preserve.

The wooden derrick eventually will be put in Quarry Park as part of Stearns County's efforts to showcase the granite industry.

The park's master plan calls for an exhibit of an early 20th century granite quarry as well as a $4 million granite-educational center.

Granite facts/4B

The granite exhibition will be by Quarry Park's parking lot and near the area where there eventually will be rock climbing, said Chuck Wocken, Stearns County parks director. County officials don't know when they will install the derrick at its new location.

"The quarrying and granite industry through the last century was a driving economic force in Central Minnesota and certainly drove the land forms that we have," Wocken said.

Until state money becomes available, the granite-educational center won't be built, and the derrick will be the most obvious part of the granite exhibit at Quarry Park.

"The important part is to give people a chance to figure out how they got this

See DERRICK, 4B ▶

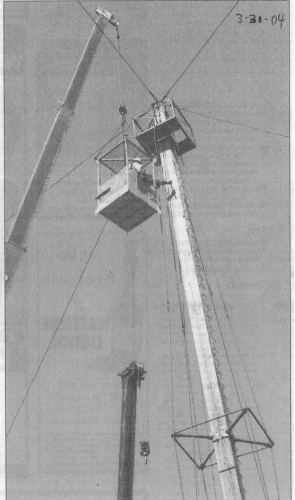

Times photo by Kimm Anderson, kanderson@stcloudtimes.com

Workers from Landwehr Construction, St. Cloud, ride a cage to the top of a 64-foot-tall antique wooden granite industry derrick being taken down Tuesday adjacent to Quarry Park & Nature Preserve. The derrick is going into storage temporarily with the thought that it will become part of a granite industry exhibit at Quarry Park.

Used with permission of the *St. Cloud Times*.

From Page 1B
Derrick

rock severed from this earth, picked it up, transported it and made it into this beautiful stone," Wocken said.

The derrick, which Stearns County historians believe was built between 1910 and 1930, was used to hoist heavy blocks of granite onto carts and trailers for processing, according to information provided by the parks department.

Officials believe Liberty Granite built the derrick. The company operated in Central Minnesota between 1924 and 1959.

The derrick used to belong to Bob Sis, who lives near Quarry Park. Wocken said the county had a long-standing deal with Sis for him to turn over the derrick. Landwehr Construction Inc. is not charging the county for its removal, Wocken said.

Sis bought the property in 1960 and the derrick had already been there for decades, he estimated. He said he had used the derrick a couple of times to haul loads of granite for his own use, but he doesn't need it anymore.

"I have a Bobcat that does as much as the derrick does," he said.

Granite facts

- The St. Cloud Area Convention and Visitors Bureau has launched a theme tying this area with its most famous natural resource. It's "St. Cloud and Central Minnesota: The Granite Cities of the World."
- The first granite quarry in this area opened in 1868 at what is now the state prison site in southeast St. Cloud.
- More than 70 businesses in Stearns, Benton and Sherburne counties use "Granite," "Granite City" or "Greystone" in their names, according to the St. Cloud Area Convention and Visitors Bureau.
- Granite from Central Minnesota is in the Minnesota State Capitol, the Franklin D. Roosevelt monument in Washington and in the facing of the Mount Rushmore interpretive center.
- Cold Spring Granite Company is the largest granite quarrier in the world.

Source: Times archives, Stearns County.

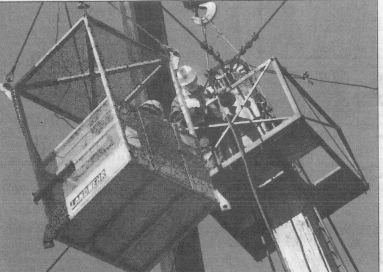

Times photo by Kimm Anderson, kanderson@stcloudtimes.com

A crew attaches cables to stabilize the derrick as guy wires holding the structure vertical are removed.

September 19, 2008, ribbon cutting for the new "derrick house," generously donated by Dale Gruber Construction. The $40,000 building protects the machinery needed to operate the derrick. Left to right: State Representative Steve Gottwalt, Commissioner Leigh Lenzmeier, Commissioner Vince Schaefer, Commissioner Mark Sakry, and Dale Gruber. (Author's Collection)

Sunday, Aug. 19, 2012

Granite tells story of our past

ROBERT WICHMAN
GEOLOGY

Any gifted outdoorsman can read stories from the world around them. The tracks on a beach, the scars on a tree's bark, a drift of pinecone scales beside a stump, each has its own tale to tell.

In a similar way, geologists see stories written in the rocks around us. Ancient stories, perhaps, far predating any human deed, often with missing or vague details, but still revealing how the land was formed and why it has the shape we see.

Several pages of this history are seen in the ledges and quarries near St. Cloud, with a particularly good collection on display in Stearns County's Quarry Park & Nature Preserve.

Here, there are two types of granite:

The older is the Reformatory Gray, a medium-grained gray rock found mostly in the middle of the park, as well as in ledges and quarries across St. Cloud. Similar rocks are found in Rockville and Richmond.

The other is the St. Cloud Red. This is larger-grained and ranges in color from grayish pink to red. It is found more on the east and west sides of the park (where most of the quarries are) and can be seen in several places wedging into the Reformatory Gray. Like the Gray, it is found elsewhere in St. Cloud and Sauk Rapids, and it seems related to a very large intrusion reaching from Foley almost to Mille Lacs.

Cutting through both of these granites are bands of fine-grained diabase a few centimeters to more than 10 feet across. These are similar to basalt in chemistry, but not texture, and weather to a dark greenish-gray. If one looks closely, they may see interesting details, such as chill margins where the magma quenched against the cooler granites, matching features wedged apart by the diabase, or even small bits of granite that got picked up and carried along inside the later magmas.

So what story do these outcrops tell?

First, granites form deep underground. Based on details of mineral chemistry, it looks as if these granites formed at a depth of about 13 miles, while the diabase seems to have come in at depths of 8-10 miles. Second, all these rocks are old. Isotopic dating shows the Gray granite to be about 1.8 billion years old, with the Red forming about 40 million years later.

Dates for the diabase are less reliable, ranging from about 1.2 billion to more than 1.5 billion years. As I have personally seen a dike showing interaction with a still-soft granite, I favor the older dates.

Putting the clues together, we find that when these granites formed, St. Cloud (or at least its rocks) lay far below a major mountain range. Two pulses of heating, possibly related to plate tectonics, then melted the crust below those mountains. Shortly afterward, the roots of those mountains rose and spread, but only for a few hundred million years.

Since about 1.2 billion years ago, all that has happened here has been erosion. Enough erosion to remove a mountain range.



ABOUT ROBERT WICHMAN

Professor and geologist Robert Wichman will write about Minnesota's ancient history for Our Woods & Waters, specifically the unseen history preserved in the rocks and landforms in the state. This column describes what can be learned from the granites of St Cloud, and future pieces will address topics such as the rocks near Pipestone, sandstones and fossils from the bluffs of the Mississippi, ancient volcanic rocks along the North Shore and the banded iron formations mined by the taconite industry. He has taught geology and astronomy for several colleges in the St. Cloud area and formerly offered a continuing ed class on the Rocks of Quarry Park. He also has explored many of Minnesota's state parks, with a particular interest in the rocks that can be seen in them.

Geologists see stories written in the rocks around us. Ancient stories, perhaps, far predating any human deed, often with missing or vague details, but still revealing how the land was formed and why it has the shape we see.

Courtesy of Robert Wichman and the *St. Cloud Times.*

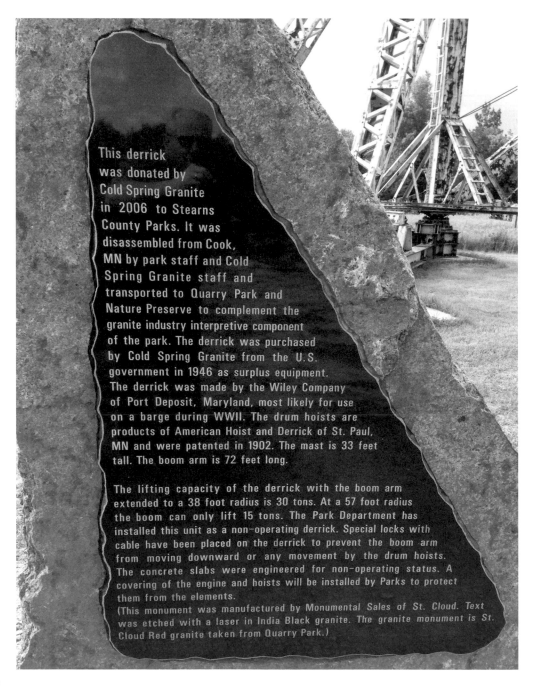

This derrick was donated by Cold Spring Granite in 2006 to Stearns County Parks. It was disassembled from Cook, MN by park staff and Cold Spring Granite staff and transported to Quarry Park and Nature Preserve to complement the granite industry interpretive component of the park. The derrick was purchased by Cold Spring Granite from the U.S. government in 1946 as surplus equipment. The derrick was made by the Wiley Company of Port Deposit, Maryland, most likely for use on a barge during WWII. The drum hoists are products of American Hoist and Derrick of St. Paul, MN and were patented in 1902. The mast is 33 feet tall. The boom arm is 72 feet long.

The lifting capacity of the derrick with the boom arm extended to a 38 foot radius is 30 tons. At a 57 foot radius the boom can only lift 15 tons. The Park Department has installed this unit as a non-operating derrick. Special locks with cable have been placed on the derrick to prevent the boom arm from moving downward or any movement by the drum hoists. The concrete slabs were engineered for non-operating status. A covering of the engine and hoists will be installed by Parks to protect them from the elements.
(This monument was manufactured by Monumental Sales of St. Cloud. Text was etched with a laser in India Black granite. The granite monument is St. Cloud Red granite taken from Quarry Park.)



"How many people can say they've done something like this?"

UNCOVERING HISTORY
AT QUARRY PARK

Support lines for the reconstructed derrick at Quarry Park are held by anchors.

By Ben Katzner
bkatzner@stcloudtimes.com

WAITE PARK — The thought of looking for a needle in a haystack doesn't normally conjure up pleasant thoughts.

But at Quarry Park and Nature Preserve, Charles Wocken and other members of the Stearns County Parks Department have been doing it — successfully — for the past three months.

Wocken and park maintenance workers Joseph Kulzer and Brent McMullen took advantage of unseasonably warm winter weather to embark on a reconnaissance mission that could eventually lead to a better understanding of the history of Quarry Park — and Central Minnesota's granite foundations.

"The parks department is trying to reconstruct the industrial use of what's now Quarry Park and Nature Preserve," Wocken said. "... Quarry Park was actually quarried by probably 15 different ma-and-pa-type operations and over the years there were different businesses that operated within the quarries. And there is no record of who did what and where except for the names on the quarries."

While some derrick sites in the park are well known, others have laid undiscovered for decades, hidden by deep winter snow or thick summer underbrush. Wocken, the county parks director, said this year's abnormal winter offered a rare opportunity to take a closer look for clues to the park's history.

Staples search

When spare time presented itself this winter, Wocken and a handful of other members of the

Joe Kulzer (left) and Brent McMullen locate the former site of a derrick anchor at Quarry Park recently. The lack of snow cover and warm temperatures have allowed surveying and marking of the anchors this year. TIMES PHOTOS BY DAVE SCHWARZ, DSCHWARZ@STCLOUDTIMES.COM

WHAT IS QUARRY PARK AND NATURE PRESERVE?

Park features include:
» 30 granite quarries, most filled with water now.
» A swimming hole that is 112 feet deep.
» Hiking and ski trails.
» Mountain bike paths.
» Trout fishing.
Learn more at http://www.co.stearns.mn.us/Recreation/CountyParks

parks department trekked through Quarry Park looking for signs of the long-gone derricks used for quarrying the granite that made the area famous.

The biggest tell about where a derrick stood are steel staples protruding from the ground. The staples, or sometimes just a heap of rock, were used to anchor the derricks that pulled the granite from the earth. The staples can come in groups of six to eight and are set up at various points around the derrick.

While searching for a needle in

See QUARRY, Page 9A

KNOWN DERRICK LOCATIONS

Quarry Park and Nature Preserve

WAITE PARK

Graniteview Road

ST. CLOUD

0 1/2 mile

SOURCE: Stearns County

TIMES GRAPHIC BY LISA MUELLER, LMUELLER@STCLOUDTIMES.COM

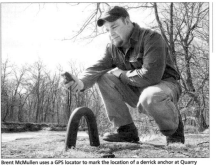

Brent McMullen uses a GPS locator to mark the location of a derrick anchor at Quarry Park. TIMES PHOTO BY DAVE SCHWARZ, DSCHWARZ@STCLOUDTIMES.COM

Quarry
From Page 1A

a haystack doesn't sound enjoyable, searching for a staple in a rock pile has its issues as well. Wocken said some of the sites had multiple sets of staples, which raised more questions — was the site quarried by multiple companies? Was there a mistake? Did they forget where the anchors were and decide to create new ones? All are questions the group hopes to answer eventually.

"It's about determining the history of the quarry by these little steel staples sticking in rocks," Kulzer said.

Wocken and the others discovered 54 staples.

"We wanted to know what was all out there," Kulzer said. "We located them all and we ribboned them and after that we GPS-ed them. There were regular staples, (rock) piles that were anchors and some of them even had a double staple."

The group also took note of the angles of each staple — staples belonging to the same derrick should all be set at the same angle, Kulzer said — to help determine which derrick a group of staples belongs to.

"Once we get that figured out, we should be able to figure out how many derricks were operating in the park," Kulzer said. "How many people can say they've done something like this? Not many. I'm into this."

Building history

Kulzer isn't the only one excited by the findings and what they could mean for Quarry Park. John Decker of the Stearns History Museum said the information could have a ripple effect on what's known about the area's history.

"It's exciting because that's a real quarried site, so they have a lot to determine ... I think it's very exciting for them and it's exciting for us because we'll probably get some knowledge from that as well," Decker said. "That's part of our history and it's a

very important part. If they can get a chronology on this, that will be amazing."

Decker said that when the time is right he hopes the Stearns History Museum and parks department can pool their resources to patch any gaps in the history of Quarry Park. Wocken said there is information about some of the companies that quarried the grounds, but most records were destroyed in a fire at Melrose Granite, which owned the land before Cold Spring Granite Co. The land was sold to the county in 1992.

Wocken said he would like to eventually compile a list of all the material quarried from the park and where it ended up — a daunting task.

"Our goal is also to be able to say where did the rock go from this park, (but) you'd have to find someone certifiably insane, probably, to search through records," he said.

Decker stressed that while a tall task, that sort of cataloging could mean a lot to area historians.

"Granite has been such a big part of the area. (The industry has) been here since after the Civil War. It's just another piece in the chronology that's needed," Decker said.

With the raw data collected, Wocken said the next and perhaps most difficult step in the process is to organize the information and see what

they can learn. Wocken stressed that despite the amount of information they've already collected, this excursion into archaeological geocaching isn't an exact science. First there's the matter of the accuracy of the GPS map they've created.

"The GPS has a 12-meter error possibility, so that could throw us off if we can't get the stuff right on ... There could be some discrepancies in that and that could be a bit frustrating," Wocken said. "If you've got a certain amount of discrepancy, you still have to kind of go groping through the grass, looking for the treasure."

Even with the new data, it's understood that other information could easily be missing. Wocken and Kulzer said there could still be buried or obscured staples to discover, meaning there could have been more derricks than previously thought.

Dissecting the information will take time. Wocken said that over the next year the group hopes to make sense of the data it's collected. But he's hoping all the work will lead to a deeper understanding of Quarry Park.

"The more you can put flesh on the skeleton of this type of activity, the more fascinating it is, I think, to the visitor," Wocken said. "We look at it as refining the product that we have available for our customer.

Used with permission of the *St. Cloud Times*.

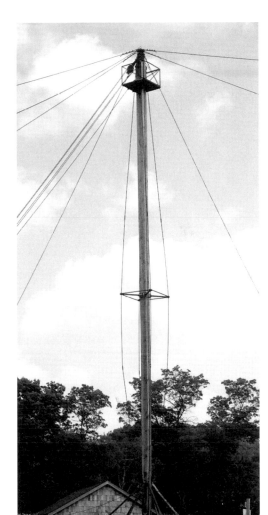

Derrick (right). (Author's Collection)

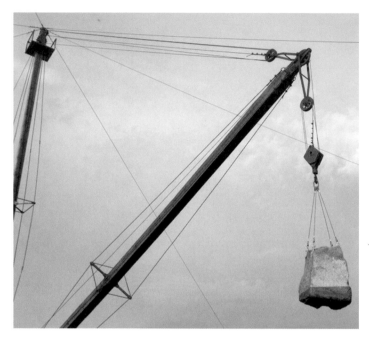

Four tons of red granite suspended from the derrick boom arm delight the many observers gathered for the derrick's "maiden voyage" and at a Chamber Connections event held at Quarry Park on September 19, 2008. Years of work, generous donors, and many skilled craftsmen made this historic display of the granite industry possible. Plans for the future include a granite country interpretive center near the entrance to the park. (Photos courtesy of the Stearns County Park Department)

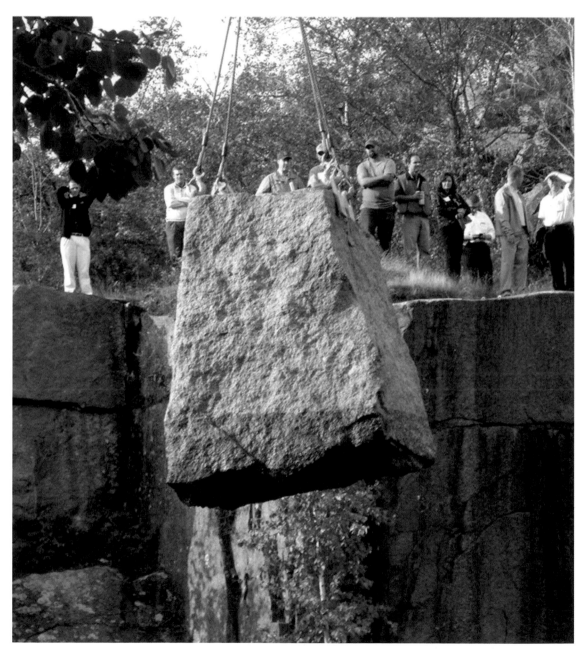

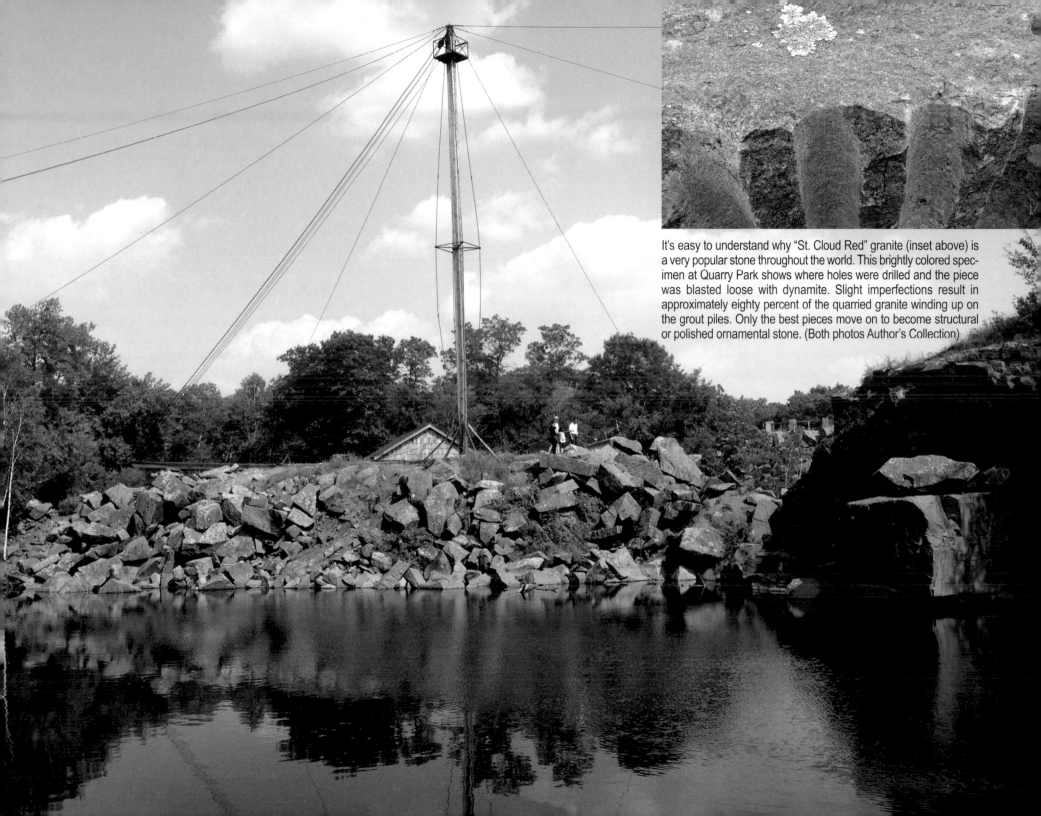

It's easy to understand why "St. Cloud Red" granite (inset above) is a very popular stone throughout the world. This brightly colored specimen at Quarry Park shows where holes were drilled and the piece was blasted loose with dynamite. Slight imperfections result in approximately eighty percent of the quarried granite winding up on the grout piles. Only the best pieces move on to become structural or polished ornamental stone. (Both photos Author's Collection)

Chapter 9

Through His Eyes

In the words of Amy Bowen, in the Saturday, October 27, 2012, edition of the *St. Cloud Times*, "Don Kempf, a photographer, and his pal, Emma, a spunky Australian shepherd, walk every morning through Quarry Park & Nature Preserve in Waite Park."

Bowen continued. "The ninety-two-year-old from St. Cloud and his four-legged friend pass through woods, follow trails and marvel at the many swimming holes.

"Kempf and Emma explored the natural beauty of the area for years.

"He snaps pictures along the way. He captures snowfalls, changing leaves, spring dew, and the serenity of hot summer days.

"Now, his work is gaining a following. He has sold his photos at craft sales. His work will be displayed at two locations in coming months.

"And his photographs will now be used in an upcoming book about the quarry."

Photos

From Page 1C

"I'm like a hunter," Kempf said. "I see what I want and I shoot it."

Eagle eye

Kempf is in good health for his age. He suffered an injury to his hearing during World War II, so he must concentrate on every word uttered by others. He keeps notes about his life for easy access.

But his eyesight is excellent. And he has been behind the camera for decades.

He attended the Minneapolis Institute of Arts before the war. Back then, it took a full day to develop a color photograph, he said.

"I enjoy the art part," Kempf said. "I have the time to walk around. My

Don Kempf, 92, St. Cloud, lifts his camera to his eye Oct. 18 in Quarry Park & Nature Preserve in Waite Park. TIMES PHOTO BY KIMM ANDERSON, KANDERSON@STCLOUDTIMES.COM

eyes are good. I can see things."

Kempf became a commercial photographer after the war. He had a studio in Minneapolis and employed two photographers. He maintained the business for three or four years before selling it.

"It's something I feel well qualified to do,"

Kempf said of taking photos. "So much what I did was in sections."

During Kempf's 90-plus years, he also has dabbled in sales and reality.

Good friends

Kempf spent most of his life in Edina before moving to St. Cloud about

10 years ago. He moved here to finish a friend's home.

Kempf befriended Helen and Robert Trisko of Waite Park after moving to the area. He and Helen Trisko connected when he was looking for volunteer work. Eventually, he started walking the couple's dog every morning.

After hearing about his past, the Triskos bought him a digital camera one Christmas. His daily routine of walking Emma and snapping photos was born.

He now has a digital camera. He had an old-fashioned box camera when he started in the industry. He loved the new technology.

"How times have changed," Helen Trisko said.

The Triskos thought Kempf had something special with his views of the Quarry. He and the

Triskos assembled a team to help him market his artwork.

He was hesitant at first. Kempf never thought of selling his photos. He just loved the scenery and the process of taking photos.

But now, his views of the Quarry are gaining a following.

Artwork

Paula Conrad of Cold Spring is selling and showing Kempf's artwork. The two have been friends for a couple of years.

She has sold his work at the Lemonade Concert & Arts Fair and a craft sale at Lake George. The response has been impressive, she said.

"It's just downright gorgeous," Conrad said. "People are just amazed at what he captures. Don is very special."

Conrad helped Kempf

book two upcoming art shows. His photos will be displayed at the Paramount Theatre and at the Whitney Senior Center in St. Cloud.

Kempf's photos also will be used in the upcoming book, "Quarry Quest: A History of Stearns County Quarry Park and Nature Preserve," by Mark Sakry of Waite Park. The book will hopefully be published by the fall of 2013.

The book will explore the granite industry's history and how the Quarry Park was developed.

Kempf captures the Quarry's natural beauty, Sakry said. He plans on using between 15 to 20 of Kempf's photos.

"Isn't it great?" Sakry asked. "Isn't it a testimony to healthy living and getting out into the community? I hope it inspires others to get out into Quarry Park."

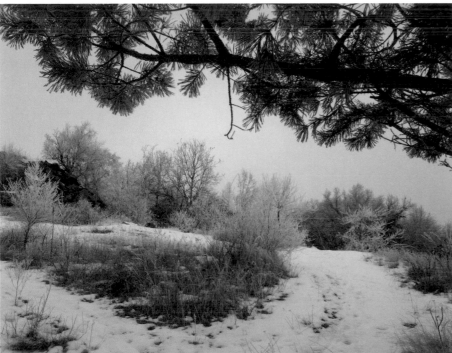

Chapter 10

The Final Forty Acres

The recreational site plan for the final forty acres purchased on April 16, 2010 (the Greg and Carol Mick property), includes plans for a picnic shelter, a children's playground, an open play area and parking for forty to fifty vehicles. This new southern entrance to the park will offer more traditional *city* park amenities, such as picnic tables and shelter rentals to celebrate birthdays, anniversaries, family reunions, and other events.

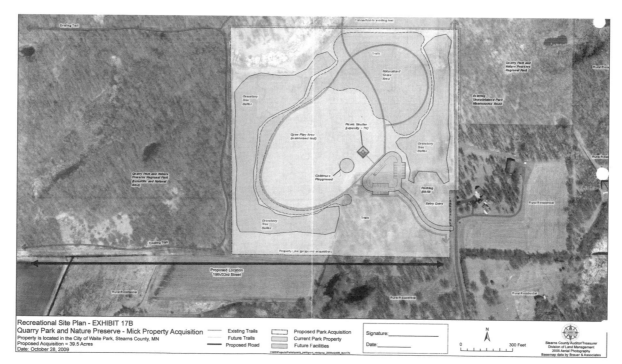

Courtesy of the Stearns County Park Department.

THE FINAL PIECE

The Quarry Park & Nature Preserve adds 39.5 acres

By Kirsti Marohn
kmarohn@stcloudtimes.com

WAITE PARK — It's taken nearly 20 years, millions of dollars and much public and private negotiation, but Quarry Park & Nature Preserve is finally complete.

Stearns County signed a purchase agreement Friday with owners Greg and Carol Mick for 39.5 acres on the park's southern edge. It's the final piece in the county's master plan for the park.

The purchase brings Quarry Park's total size to 683 acres, vastly larger than any other park in the St. Cloud area and rivaling many state parks.

> **The purchase brings Quarry Park's total size to 683 acres**

There have been bumps along the way, including rising land prices and concerns about the safety risk posed by the rocky terrain.

But Stearns County board Chairman Mark Sakry said the park has turned out exactly as officials envisioned two decades ago.

"We knew it would take some time to ultimately purchase those various parcels," he said.

Sakry was chairman of the board in 1992, when the county bought the first 220 acres for the park. He plans to retire from the board at the end of the year, and calls Quarry Park the most important accomplishment of his tenure.

The county met its goal of making sure "that the wonders of going to swim in a quarry could preserved for everybody," Sakry said.

See **QUARRY PARK, 5A** ▶

Times photo by Kimm Anderson, kanderson@stcloudtimes.com

Will Mayes, Sauk Rapids, reflects Sunday on a perfect day for sunshine and fishing in Quarry Park & Nature Preserve.

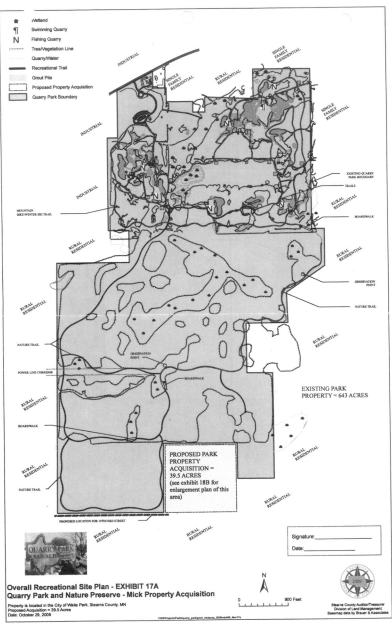

Overall Recreational Site Plan - EXHIBIT 17A
Quarry Park and Nature Preserve - Mick Property Acquisition

Property is located in the City of Waite Park, Stearns County, MN
Proposed Acquisition = 39.5 Acres
Date: October 29, 2009

Stearns County Auditor/Treasurer
Division of Land Management
Basemap data by Brauer & Associates

Used with permission of the Stearns County Park Department.

FROM PAGE 1A

Quarry Park

'Unique'

Stearns County's website calls Quarry Park "the unique county park in the United States."

The site was once a hotbed of mining by several companies seeking the famed St. Cloud red granite. Quarrying operations ceased there in the mid-1950s, but the land remained in private ownership, gradually reverting to a more natural state.

In 1992, Stearns County bought the first parcel from Cold Spring Granite Company for about $1,100 an acre. The park opened to the public in 1998.

Since then, the county has continued to acquire property to expand the park, including 323 acres of habitat for rare orchids and hawks that became the park's Scientific and Natural Area.

Over the years, the park has become popular for swimming, hiking, mountain biking, rock climbing, scuba diving and cross-country skiing. It has more than 100,000 visitors every summer.

Active area

Since the park's inception, county officials have eyed the Mick property as a natural addition. It will provide a southern entrance and a buffer for the rest of the park, said Chuck Wocken, county parks director.

"The important part is we prevented it from turning

NEWLY PURCHASED LAND

QUARRY PARK & NATURE PRESERVE

0 1/2 mile

SOURCE: Stearns County
Times graphic by Lisa Mueller,
lmueller@stcloudtimes.com

into residential," he said.

The addition includes about 29 acres of former cropland, 5 acres of oak forest and 5 acres of wetland, Wocken said.

Wocken envisions the property as a more active-use area, with a picnic shelter, playground and maybe a ball field. Trails from the northern part of the park will be rerouted down into the new part, he said.

Wocken also would like to see a large enclosed shelter that could accommodate wedding receptions or other large gatherings.

"I'd like to see a shelter in there that could really handle a crowd," he said.

The property likely won't be open to the public for several years, Wocken said. The county first needs to revise its master plan for the park, then find funding.

Rising prices

The Micks have been will-

ing to sell the property to the county for six years, but finding the money during difficult budget times has been no easy task.

Land prices have risen considerably since the park's creation. The county paid $750,000 for the Mick property — almost $19,000 an acre.

The breakthrough came when Stearns received a $400,000 grant from the Clean Water, Land and Legacy Amendment, the sales tax increase voters approved in 2008 to pay for the outdoors and the arts.

The county will use money from a capital improvement bond it had set aside several years ago to pay the remainder, Wocken said.

The county's ability to buy land for parks is diminished due to the tough financial times, Sakry said. Still, he said most people recognize the wisdom of seizing opportunities to buy choice proper-

ties.

"These unique places should be preserved," Sakry said.

Expansion complete

Aside from a few acres here or there offered by willing sellers, this will be the last major land purchase for Quarry Park, Wocken said.

He still hopes the county will one day fulfill the goal of building an interpretive center to educate visitors about the importance of the granite industry.

Other future improvements could include opening another quarry for swimming and building an observation deck atop a rock pile that's accessible to people with disabilities, he said.

Wocken said he anticipates continued public support for the park.

"Quarry Park has been built into the culture of the St. Cloud metro area for generations," he said.

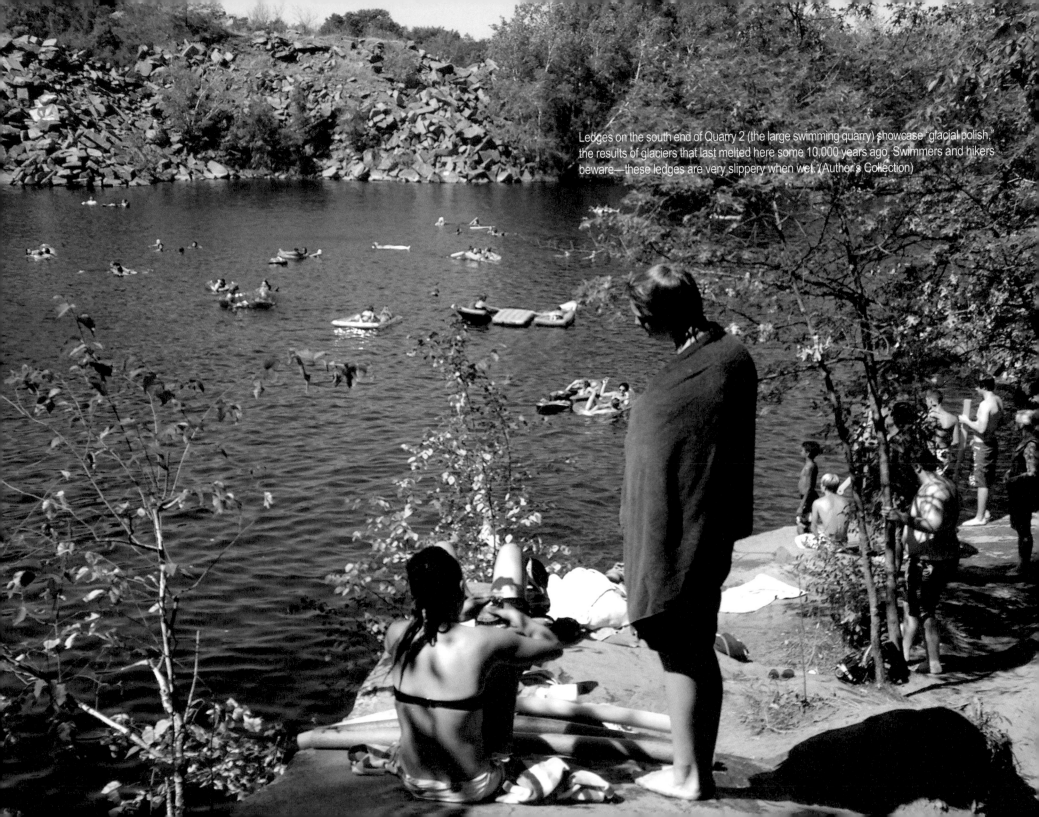

Ledges on the south end of Quarry 2 (the large swimming quarry) showcase "glacial polish," the results of glaciers that last melted here some 10,000 years ago. Swimmers and hikers beware—these ledges are very slippery when wet. (Author's Collection)

Chapter 11

Something for Everyone at Quarry Park and Nature Preserve

Swimming has certainly been the number one attraction for the majority of visitors to Quarry Park, but the park offers a variety of activities for all ages and interests. Several quarries are regularly stocked with rainbow trout, making the park a popular place for fishing. Scuba diving, geocaching, rock climbing, mountain biking and cross-country skiing have also grown in popularity.

Rainbow trout thrive in the cool waters of deep quarries. The quarry holes in the park range in depth from rather shallow to as much as 116 feet deep. "Melrose Deep 7," the large swimming quarry, is the deepest quarry in the park. Since 1999, a total of 700 fish were stocked each year in seven different quarries. Signs indicate which quarries have been stocked with trout and are available and approved for fishing.

At left, scuba divers enjoy swimming among the rainbow trout at Quarry Park. Bringing a little "trout chow" along enhances the feeding frenzy. Above, a beautiful specimen of a rainbow trout. (Both photos courtesy of Roger Peterson)

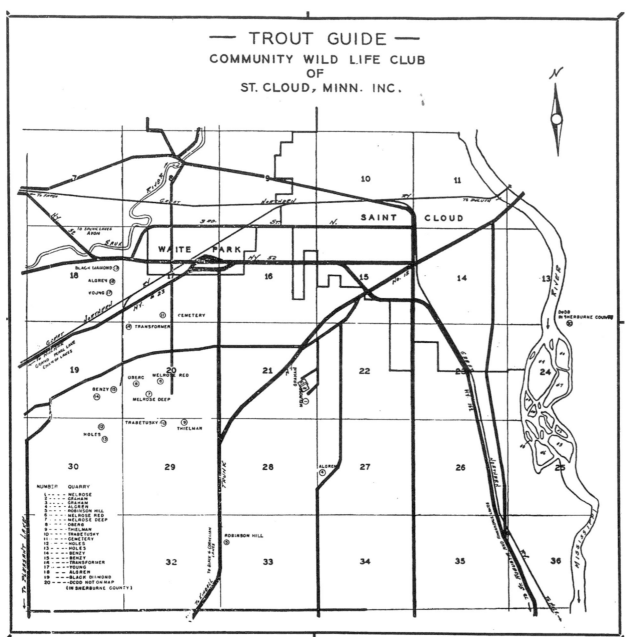

Trout fishing rules. (Author's Collection)

This "Trout Guide" (circa 1935) shows that local quarries were already popular destinations for trout fishing enthusiasts more than seventy years ago. (Courtesy of the Stearns County Park Department)

Quarry Park develops geocaching challenge

By Kirsti Marohn
kmarohn@stcloudtimes.com

WAITE PARK — Most of the thousands of people who visit Quarry Park & Nature Preserve each year probably hurry past rare natural features and plants. They hustle on their way to the swimming quarry without stopping to appreciate them.

That's led park officials to create two new ways for the public, with the help of technology, to get a closer look at and appreciation for the park's treasures.

A new Eco-Walk highlights some of the park's special features, including a scenic overlook, a fault line, rocks polished by a glacier and a cluster of prickly pear cactus.

The 2.6-mile self-guided walk features a dozen sites that can be found using a traditional map or a global positioning system, or GPS.

Stearns County created the park in 1998 in part to protect some of the rare features spotlighted on the tour, but many park users aren't aware of them, said Sean Leary, a county park intern who helped create the Eco-Walk.

ON THE NET

- For a map and information about the new Eco-Walk at Quarry Park: www.co.stearns.mn.us/documents/QP_EcoWalk.pdf.
- For more about geocaching: www.geocaching.com.

"People were walking around, but they didn't really know what they were seeing," said Leary, a 2006 graduate of St. John's University.

Geocaching site

Quarry Park also will become the newest local spot for fans of geocaching. It's a relatively new pastime whose participants use GPS to find certain points, similar to a treasure hunt.

Geocachers are given longitude and latitude coordinates, usually via Web sites devoted to the pastime, to find a hidden "cache" or container that might have trinkets and a log book to sign.

Times photo by Kimm Anderson, kanderson@stcloudtimes.com

Stearns County Park Department marketing intern Sean Leary carries the cache to its hiding place Thursday inside Quarry Park & Nature Preserve.

FROM PAGE 1B

Geocache

They're also are asked to leave something in return.

One cache was hidden last week at the park as a test run, and more could be added in the future, Leary said. Quarry Park's cache contains pieces of St. Cloud red granite for geocachers to take as souvenirs.

Geocaching has been gaining popularity since 2000 when then-President Clinton signed a bill that paved the way for ordinary citizens to use GPS, which was developed for the military and uses satellites to pinpoint the exact coordinates of every spot on the planet. The devices can determine your location within a range of 6 to 20 feet.

There are 317,128 active caches in 222 countries, according to geocaching.com's Web site. Some are placed by organizations; most are hidden by other geocachers.

Local interest

Last week, the Minnesota Department of Natural Resources reversed its policy and began allowing geocaching at state parks.

The sport also is attracting more devotees in the St. Cloud area, said Tony Ebnet, gift bar manager at Sportsmen's Warehouse, which sells GPS units ranging in price from $80 to $500. Last June, St. Cloud sponsored a geocaching training seminar and challenge as part of the city's 150th birthday celebration.

"I believe it is getting more popular as time goes on," Ebnet said. GPS units are getting easier to operate and more accurate, he said. There also are more Web sites where people can find hidden caches in their area.

Quarry Park's cache is hidden in the park's central grassland, which will give geocachers a glimpse of a lesser-used part of the park.

Both the Eco-Walk and geocaching could be considered part of the so-called ecotourism movement attracting more enthusiasts worldwide to activities such as wildlife-spotting in Costa Rica and vista-seeking in Alaska.

Ecotourism is an $18 billion industry in the United States and $500 billion worldwide, Leary said. There are other benefits as well, including helping people realizing the value of nature and wanting to protect it, he said.

"Having an environmentally literate society is something that is a goal of mine, and I think the park as well," Leary said.

Eco-Walks at Quarry Park

Eco-Walks are self-guided walking tours that explore the natural history of Quarry Park, the largest public park in the Stearns County Parks System. Quarry Park & Nature Preserve is an exceptional location to explore and discover natural and human history, together evolving before your eyes. A quick survey of the park reveals scenic woodlands, open prairie, diverse wetlands, and both quarried and un-quarried granite bedrock. A deeper look tells a story of how Central Minnesota became one of the largest producers of granite in the country.

The Eco-Walk tour has twelve sites which exhibit the park's unique natural features. At a relaxing pace the tour takes about two hours from beginning to end. You will cover 2.6 miles. This walk is designed to be done with a GPS unit and traverses rough terrain.

A county vehicle-parking permit is required at Quarry Park and Nature preserve. Revenues generated from the fees are used for park facility maintenance. For more info on Quarry Park and Nature Preserve or to purchase an annual permit online go to

www.co.stearns.mn.us

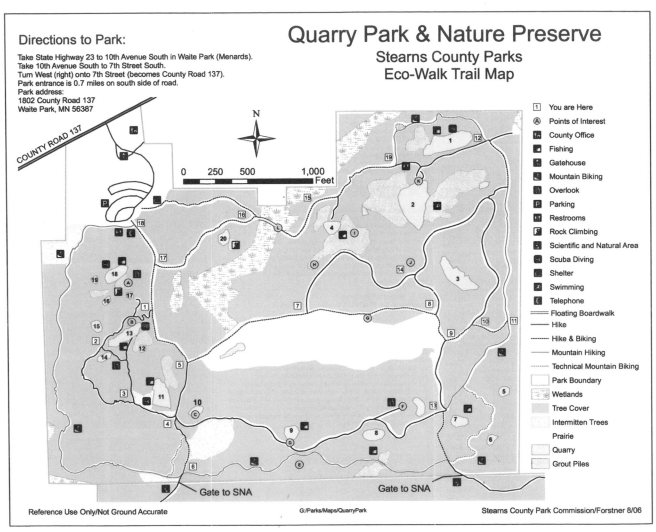

Directions to Park:

Take State Highway 23 to 10th Avenue South in Waite Park (Menards).
Take 10th Avenue South to 7th Street South.
Turn West (right) onto 7th Street (becomes County Road 137).
Park entrance is 0.7 miles on south side of road.
Park address:
1802 County Road 137
Waite Park, MN 56387

Quarry Park & Nature Preserve
Stearns County Parks
Eco-Walk Trail Map

1	You are Here
Ⓐ	Points of Interest
	County Office
	Fishing
	Gatehouse
	Mountain Biking
	Overlook
P	Parking
	Restrooms
	Rock Climbing
	Scientific and Natural Area
	Scuba Diving
	Shelter
	Swimming
	Telephone
	Floating Boardwalk
	Hike
	Hike & Biking
	Mountain Hiking
	Technical Mountain Biking
	Park Boundary
	Wetlands
	Tree Cover
	Intermitten Trees
	Prairie
	Quarry
	Grout Piles

Gate to SNA Gate to SNA

Reference Use Only/Not Ground Accurate G:/Parks/Maps/QuarryPark Stearns County Park Commission/Forstner 8/06

Courtesy of the Stearns County Park Department.

Site A: Historic Quarry Derrick
Coordinates: Lat. 45.53422713 Long. -94.24156168

This 1913 derrick, known as the Liberty Derrick was imported from the former Liberty Granite Company site, just north of Quarry Park. The derrick was used by Liberty Granite for unloading granite to the processor plant. It was erected on this site in August of 2006. It will be in an operational status by the fall of 2007. This derrick was fabricated by American Hoist and Derrick out of St. Paul and is the typical model used in the early 20th century. This model has been refurbished with two 4,000 lb. timbers which replaced the mast and boom of the derrick. Before the derrick is fully operational further maintenance is needed on the gear house. When the restoration is completed the derrick will be able to lift a 40 ton granite stone from the pit, which is roughly the size of a midsize car. Also on this site is an 11.5 ft. diameter saw blade that was used for cutting granite in the processing plants. This blade would have had diamond tipped teeth welded on and was capable of cutting massive stone blocks into thin usable sheets. Another artifact on the site is the original drum hoist that controlled this derrick.

Site B: Quarry 13 Basalt Dikes
Coordinates: Lat. 45.53338688 Long.. -94.24148065

Quarry 13 is a long narrow quarry that runs roughly northeast to southwest. The deepest point in this quarry is 39 feet. This quarry is an excellent place to witness the predominant rock in the park St. Cloud Red Granite, which is pink to red in color, interacting with the dark black basalt. Walking up the trail just a short distance to the right and you can witness several basalt dikes with glacial striations. The basalt dikes were formed by molten basalt magma oozing up through fractures in the red granite. Glacial Striations are the result of large rocks imbedded in the moving glacial ice moving over the bedrock under extremely high pressure carving scratches in the bedrock. Also smaller particles of silt and sand polish some rocks as the ice moves across the rock. This phenomenon is known as glacial polish. The degree to which the rocks are polished is more extreme in the granite than the basalt because the granite is physically harder and less easily weathered away than the basalt, which crumbles and scratches more easily.

Site C: Quarry 10 Snails and Glacial Polish
Coordinates: Lat. 45.531398 Long. -94.23958393

Quarry 10 is one of the smallest and shallower of all the quarries in the park with a maximum depth of 20 feet. This quarry may have been the location of the most recent quarrying within the park, occurring several decades ago. On the edge of the submerged bedrock there are hundreds of snails. Snails belong to an ancient group of animals called mollusks. These snails, which belong to the class Gastropoda, move by secreting a film of mucous that they use to glide over with their muscular arm. The coiled shell that you see is a living part of the animal and provides protection from the outside environment and predators alike. Snails are herbivores and eat by scraping plant matter into their mouthparts with antennae. Snails are among the oldest and most abundant species, with over 80,000 species and dating back 500 million years. This site is also another excellent place to view glacial polish.

Site D: Quarry 9 Reverse Fault
Coordinates: Lat. 45.53077344 Long. -94.23674151

The most noteworthy rock feature that can be seen at quarry nine is a fault located on the west wall. The best place to observe this feature is from the east side. The fault runs almost horizontally through the west wall of the quarry, and has a slight curvature to the crack. Often times the crack is leaking groundwater, which explains the richness of vegetation growing out of the fracture. On the top side of the fracture is Reformatory grey granite and below the St. Cloud Red Granite. This fault is unique to the park because it runs north to south, which is why it is known as a reverse fault.

Site E: Prickly Pear Cactus Outcrop
Coordinates: Lat. 45.53029895 Long. -94.23646737

This site is home to one of the most unique plants that can be found in the park. The brittle Prickly Pear Cactus (Opuntia fragilis) grows abundantly here. The soil on this outcrop is very thin. Accordingly, plants must evolve specialized features in order to survive the arid environment. The brittle prickly pear cactus is perfectly suited for such an environment. It has a shallow root system and succulent waxy stems which help to conserve water and tolerate drastic temperature fluctuations. A comparable perennial plant Fameflower can also be found on the outcrop. Fameflower's succulent tubular leaves and short taproot help it tolerate such a dry environment. Both plants perform a process known as Crassulacean acid metabolism (CAM). This process is a specialized form of photosynthesis in which plants reverse the order of opening their pores. CAM plants open their pores for gas exchange at night in order to keep water losses at a minimum. These plants are unusual in the area and represent the northernmost edge of their range.

Site F: Quarry 8 Overlook
Coordinates: Lat. 45.531505 Long. -94.233268

This lookout is the highest point in the park and offers a great panoramic view of the park. Looking north you can view the large central grassland. Just at the foot of the overlook on the north, east, and south side you can view a wetland. Duckweed, a floating aquatic plant, is abundant in this manmade wetland. This plant produces the smallest flowers in the plant kingdom. At the edges of the prairie are quaking aspen trees which are invaders into the prairie. There movement into the prairie is kept in check by fire suppression. North of the aspens is the oak savanna, which includes northern pin oak, northern red oak, and bur oak.

Site G: Central Grassland
Coordinates: Lat. 45.53339307 Long. -94.23430262

Here in the central prairie you will find a wide variety of plant species. In the summer colorful species such as purple prairie clover, yellow coneflower, brown-eyed Susan, and Indian paintbrush, are plentiful. Introduced weedy grasses such as Smooth brome grass, Kentucky bluegrass, and Quack grass may be indicators of low prairie quality, however, native species, such as Big blue stem and Indian grass can also be found in the grassland. These are just a few of the many plant species that thrive in the prairie. There are also many other varieties such as Aster, Blackberry, Blue vervain, Bush clover, Dogbane, Goldenrod, Evening primrose, Lousewort, Wild strawberry, and Yarrow. This prairie is burned every few years to simulate natural disturbance. It was last burned in 2005.

Site H: Wild Raspberry and Lead Plant
Coordinates: Lat. 45.53455915 Long. -94.23589875

Here on this rocky outcrop you will find wild raspberries. This site is not the only location in the park where the raspberries grow but they are very abundant here. Take a while to walk around the outcrop. It is quite large and well worth exploring. Lead plant (Amorpha canescens) which is a nitrogen fixer and member of the legume family can be found here as well. Lead plant has delicate gray-green or (lead) colored leaves which are highly nutritious. It has adapted a deep root system that helps it survive in such dry conditions, as well as a symbiotic relationship with a nitrogen fixing bacteria. This bacterium allows leadplant to change atmospheric nitrogen into organic nitrogen which fertilizers the plant in nitrogen poor environments. Leadplant is also an indicator for an undisturbed prairie because it declines rapidly under grazing.

Site I: Bearberry
Coordinates: Lat. 45.53521777 Long. -94.23465777

Bearberry (Arctostaphylos uva-ursi), which gets its name from the edible fruit claimed to be a favorite of bears, grows here on the largest of the rock outcrops in the park. It is an evergreen shrub which is more commonly found in northern evergreen conifer forests. Native Americans referred to this plant as kinnickinic and used it for tea as well as a treatment for urinary disorders. However this is not advisable because the plant contains the toxic chemical arbutin.

Site J: Fault
Coordinates: Lat. 45.53456983 Long. -94.23294879

Located just south of quarry two, the fault on this site is known as a strike-slip fault. At one time two massive bedrock shelves collided here. Molten basalt seeped up into a lateral facture in the shelves and created the basalt dike that is now visible. Notice the displacement in the basalt dike; this is the location of the fault. The two granite shelves that collided here shifted horizontally. The basalt dike and the granite bedrock which it is imbedded in slid several inches. This slippage can be measured using both the basalt dike and the glacial striations in the bedrock.

Site K: Swimming Quarry
Coordinates: Lat. 45.53631149 Long. -94.23266513

This Quarry named Melrose Deep Seven was mined exclusively for St. Cloud Red Granite. It is the deepest and largest of all the quarries with a maximum depth of 116 ft. On the southeastern side of the quarry you can see where red granite was mined until rock removal halted where the thick black basalt dike intrudes into the red granite. Birch trees are common at the edges of this quarry. This tree which prefers cool moist environments suggests the presence of springs which feed this quarry. On the western edge of the quarry there are several native prairie species, including big blue stem, Indian grass, and alumroot. Feel free to take a dip in this quarry.

Site L: Wetland and Boardwalk
Coordinates: Lat. 45.53535923 Long. -94.23696831

The wetland that this floating boardwalk traverses stretches from the northern edge of the western part of the prairie all the way through northern boundary of the park. The wetland has a strongly linear shape from north-east to southwest and remains flooded because of the presence of rich clay soils which work like a bowl to hold in water and prevent it from intruding through the underlying bedrock. This wetland is home to several species of Orchids, including the beautiful purple fringed orchid and the rare tubercled rein orchid. The tubercled rein orchid is uncommon, however under appropriate conditions it grows near the margins of the wetland. In this wetland are examples of six of the eight possible wetland types. These wetland types range from only seasonally wet to yearly submerged, to wetland shrub swamps. On the north side of the boardwalk you can observe several shrub species predominantly willow and red-osier dogwood.

ALL COORDINATES ARE IN WGS 84 REFERENCE SYSTSTEM

Prepared by: Sean Leary, Intern 9/06

SITE A Quarry Derrick

SITE G Prairie Overlook

SITE B Basalt Dike

SITE G Purple Prairie Clover

SITE C Snails

SITE H Leadplant

SITE C Glacial Polish

SITE I Bearberry

SITE D Reverse Fault

SITE K Swimming Quarry

SITE E Prickly Pear Cactus

SITE L Wetland Boardwalk

Courtesy of the Stearns County Park Department.

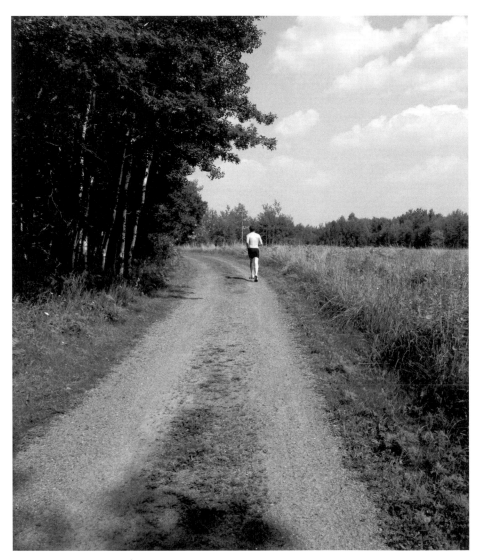

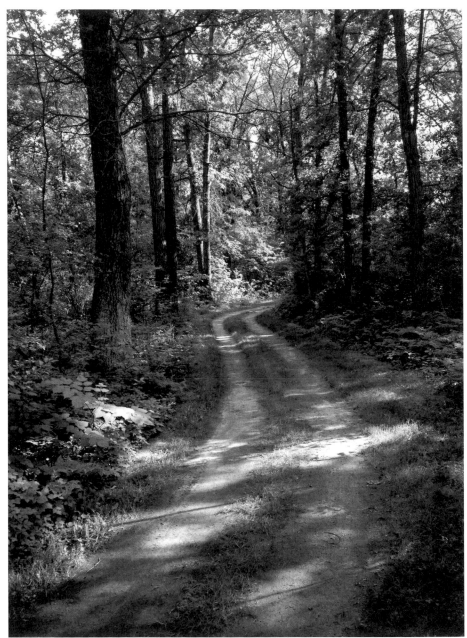

Above and at right: Hikers and joggers of all ages enjoy the trails and boardwalks of Quarry Park. (Both photos Author's Collection) Oppostie page: Plastic flotation tanks were used in the construction of the boardwalk on the north end of the park. In a wet year, hikers headed for the swim quarry will feel the effect and slight movement of a real floating bridge (Used with permission of the *St. Cloud Times*)

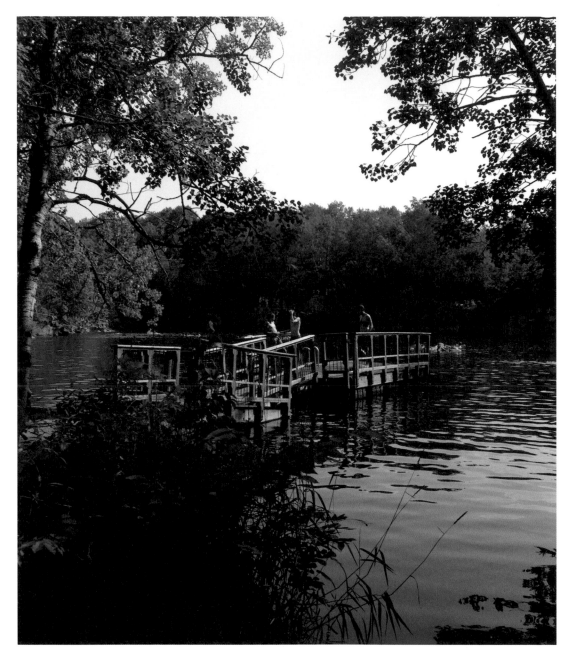

The well-maintained swimming areas, including this dock (on left) and the natural beauty of the wildflowers (above) also draw countless visitors to Quarry Park every year. (Both photos Author's Collection)

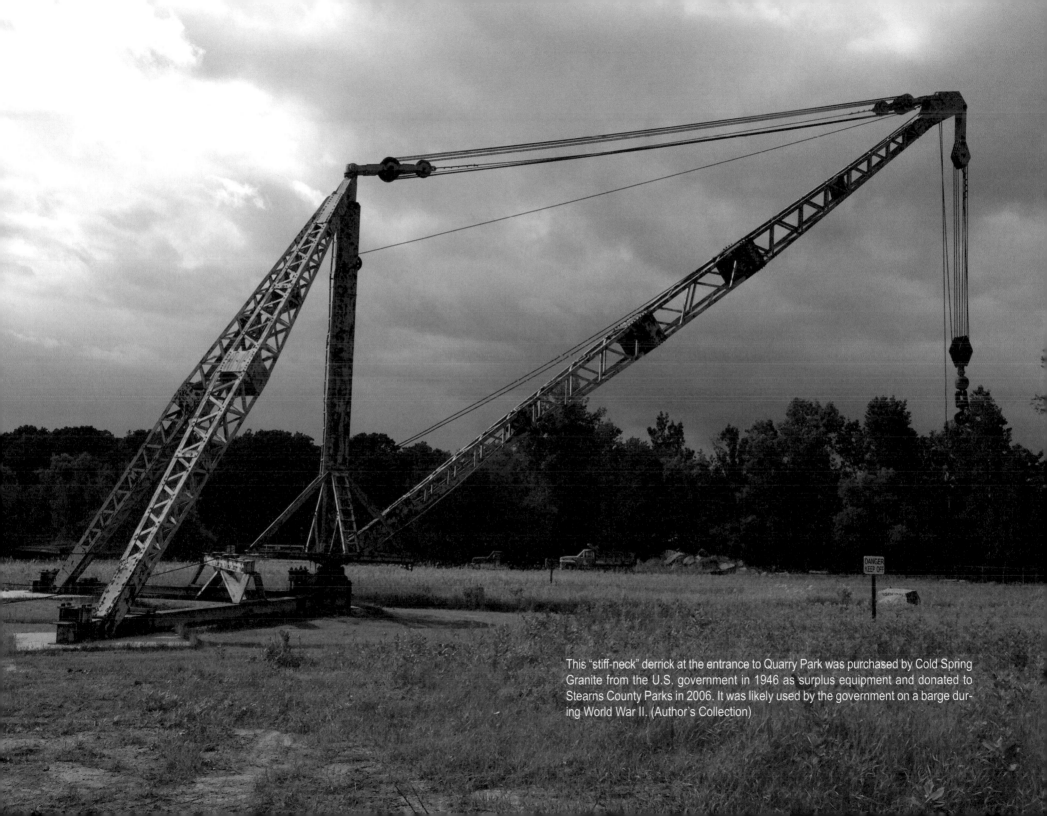

This "stiff-neck" derrick at the entrance to Quarry Park was purchased by Cold Spring Granite from the U.S. government in 1946 as surplus equipment and donated to Stearns County Parks in 2006. It was likely used by the government on a barge during World War II. (Author's Collection)

Skiing 4.2 miles of lighted cross-country trails is the park's most popular winter activity. Some say the soft lights are like candles guiding visitors and skiers through the park, while still allowing them to look up and view the stars. (Photos courtesy of the Stearns County Park Department)

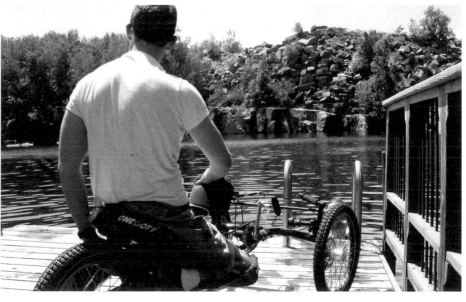

Mountain bikers (above, right) of all ages love the dramatic views and miles of scenic trails at Quarry Park. Granite outcrops provide techical zones that challenge even the most advanced cyclists. Park Department intern Sean Leary (above and at right) pays a visit to "Melrose Deep 7" (Quarry 2) in September 2006 to gather information for a detailed visitor's guide *Eco Walks at Quarry Park* (*see* pages 134 and 135) to assist park visitors in locating many of the unique geological and biological treasures at Quarry Park and Nature Preserve. Free copies of the guide are available at the park office and at the gate house entry to Quarry Park. (Photos courtesy of the Stearns County Park Department)

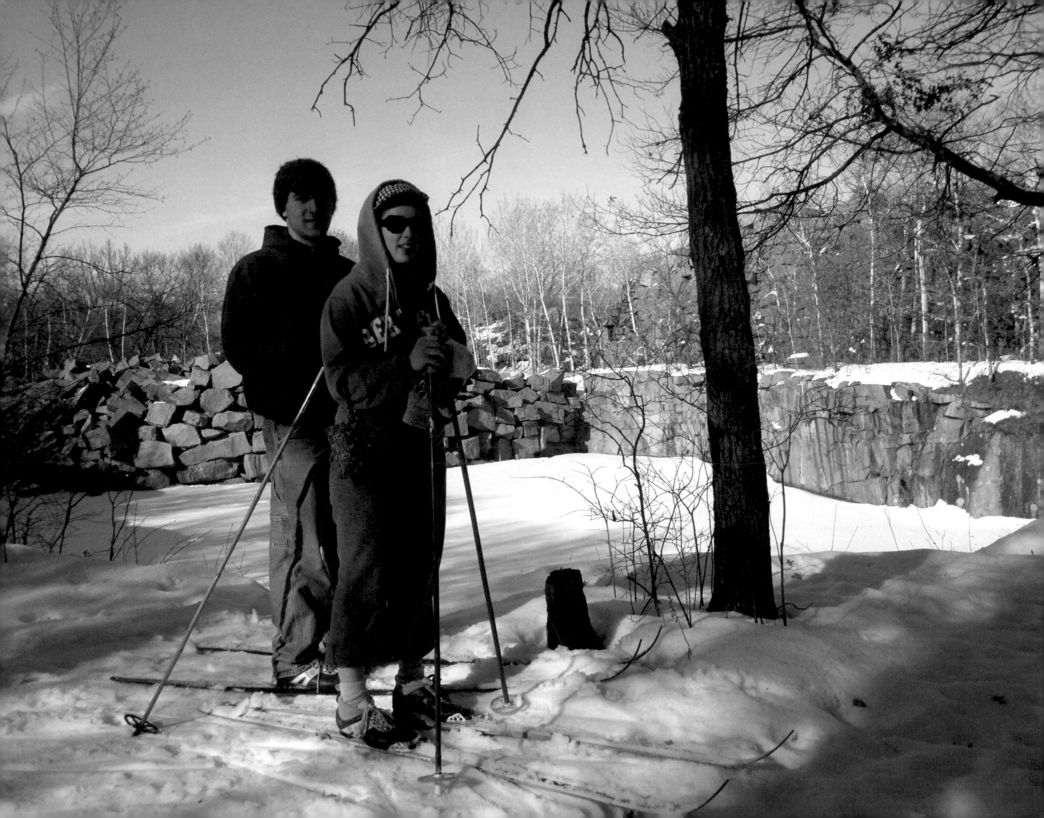

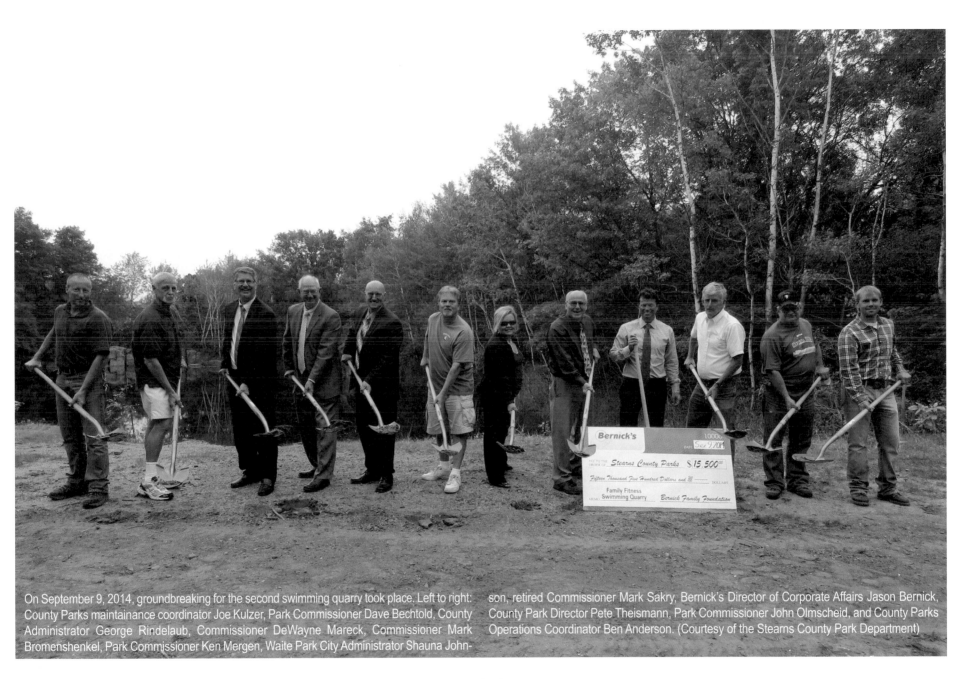

On September 9, 2014, groundbreaking for the second swimming quarry took place. Left to right: County Parks maintainance coordinator Joe Kulzer, Park Commissioner Dave Bechtold, County Administrator George Rindelaub, Commissioner DeWayne Mareck, Commissioner Mark Bromenshenkel, Park Commissioner Ken Mergen, Waite Park City Administrator Shauna Johnson, retired Commissioner Mark Sakry, Bernick's Director of Corporate Affairs Jason Bernick, County Park Director Pete Theismann, Park Commissioner John Olmscheid, and County Parks Operations Coordinator Ben Anderson. (Courtesy of the Stearns County Park Department)

Chapter 12

What Will the Future Bring?

With the dramatic success and popularity of Quarry Park throughout its first twenty years of being open to the public, it's fun to imagine what the future will bring. Will a granite interpretive center, so long on the drawing board, become a reality? Will an outdoor amphitheater, featuring concerts and educational programs, come to fruition? In fifty years or more, when Martin Marietta finishes quarrying in Waite Park, will their reclamation plans (like Meridian before them) include two lakes totaling hundreds of acres of surface water and nearly 400-foot depths? Parkland and trails around "Lake Meridian" might expand Quarry Park to the north of its present location, much like Meridian Aggregate's original reclamation concept drawings in 1992. The planning for that reclamation should begin now! Quarrying operations can and should plan ahead, leaving shallow rock ledges for future swimming beaches. A bike/hike trail, several miles long around the entire perimeter of the future "Lake Meridian" or "Lake Marietta," could serve future generations, much like Lake Calhoun in Minneapolis does today.

Meanwhile, new improvements to Quarry Park included the development of a second swimming quarry, which officially opened on Tuesday, June 23, 2015, at a 1:30 p.m. ribbon-cutting ceremony. A groundbreaking ceremony and check presentation from Bernick's Pepsi took place on September 9, 2014, at Quarry 11.

Quarry 11 has been drawing large numbers of swimmers and picnickers since the first day it opened to the public. Other quarries in

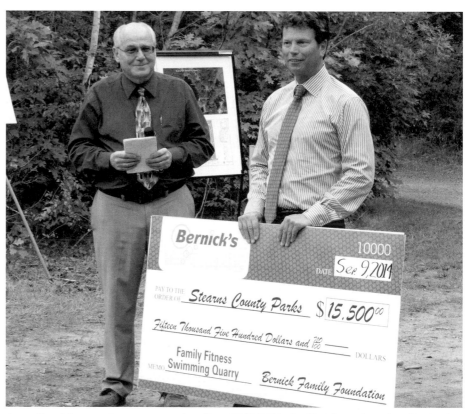

Jason Bernick presents a generous donation of $15,500 to the Park Department on September 9, 2014, to assist in costs associated with converting "Quarry 11" into a swimming area. Quarry 11 was designed to provide more of a family atmosphere than Deep 7, the park's largest and deepest swimming hole (Quarry 2), which tends to attract large numbers of college students and young people. (Author's Collection)

Students collect data for potential swimming hole

St. John's University seniors Ethan Evenson (left) and Aaron Remer fill sample bottles with water and use a special net to collect zooplankton, respectively, during a study at Quarry Park & Nature Preserve's Quarry No. 11.
TIMES PHOTOS BY KIMM ANDERSON, KANDERSON@STCLOUDTIMES.COM

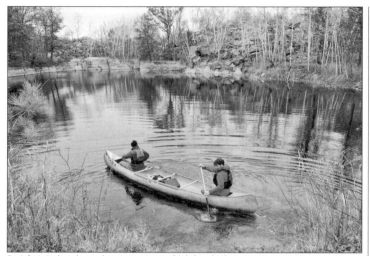

St. John's University seniors Aaron Remer (right) and Ethan Evenson paddle out to the location in Quarry No. 11 where they plan to collect samples of water and take measurements of water temperature, oxygen content, and zooplankton populations on Oct. 29. TIMES PHOTO BY KIMM ANDERSON, KANDERSON@STCLOUDTIMES.COM

Quarry Park's human impact

By Ann Wessel
awessel@stcloudtimes.com

Pull the net in too fast and it creates a cone of water. Too slow, and it resembles a big fish in pursuit.

Capturing the zooplankton samples that await identification in formaldehyde-filled jars somewhere in a St. John's University lab refrigerator required a bit of practice.

Aaron Remer flushed the contents of the net into a metal cylinder, which he then sprayed with tap water. The zooplankton sample emptied into a small glass jar. Some were visible to the naked eye; others would reveal themselves more clearly under a microscope. From the boulders

MORE ONLINE

View a gallery of photographs and a video of Aaron Remer and Ethan Evenson's workday on Quarry No. 11 online at www.sctimes.com

overlooking the smooth, black surface of Quarry No. 11, the contraption looked like a mechanical squid.

Remer, a senior environmental studies major from Sauk Rapids, is collecting data this fall as part of his internship at Quarry Park & Nature Preserve. His work could help staff track what — if any — effect converting the pool to a swimming hole has on zooplankton, phytoplankton, water clarity, oxygen levels and water temperature.

Remer and friend Ethan Evenson, a biology major from Mounds View, previously collected samples from Quarry No.

Aaron Remer rinses a zooplankton sample from the collection device Oct. 29 at Quarry Park & Nature Preserve's Quarry No. 11.

See QUARRY, Page 4A

Quarry

From Page 1A

18, which is a similar size and depth.

"The goal is to have some baseline data of these two quarries, and mostly for the swimming quarry because right now it's just a regular quarry for swimming and scuba diving," said Chuck Wocken, Stearns County parks director.

The earliest No. 11 could become a swimming hole is summer 2014. The parks department requested $136,400 from the Parks and Trails Legacy Grant Program and secured a $15,500 match from the Bernick Family Foundation. Wocken said he expected grant recipients to be notified by the end of the year.

Plans for the additional

swimming spot — which would be considerably closer to the parking lot than Melrose Deep 7 — call for a platform, nearby picnic area and vault toilet. It would aim to provide more of a family atmosphere than the existing swimming hole, which tends to attract hordes of college students.

"It's really nice when it's just you and a few friends out there, but on those hot summer days it'll get really busy," Remer said of the existing swimming hole.

Late last month Remer and Evenson had No. 11 nearly to themselves as they paddled a canoe to the deepest part of the quarry — 50 feet deep — to begin taking samples. The anchored canoe occasionally made an arc, sending ripples across the water rimmed in mostly

leafless trees. Midway through their 45-minute excursion, a man wandered by with his dog.

While Remer's unpaid internship will produce field and lab experience — plus an exercise in scientific writing — Bill Lamberts, chairman of the College of St. Benedict/St. John's University biology department, said more valuable may be the glimpse of government policy and exposure to human impact.

"We don't really have humans as part of the equation," Lamberts said of the ecology lab, where students learn techniques and gain understanding of how lakes work. "The internship is giving him practical experience in taking part in the management of natural resources."

the St. Cloud area, including those located in Friedrich Park, near the St. Cloud Reformatory and a new quarry park located in Waite Park near Parkway Drive and Seventeenth Avenue South, may offer some relief to the heavily used swimming holes in Quarry Park and Nature Preserve.

As this book is going to press, the City of Waite Park is considering the construction of an amphitheater at the Seventeenth Avenue South quarry property donated to the city by Martin Marietta Aggregates. The proposed facility could seat up to 5,000 for outdoor concerts and community events.

It has been said Central Minnesotans tend to "love our parks to death." It is critical in the years ahead to not only maintain these parks but possibly to limit the number of individuals using the park on any given day. Managing this valuable resource will ensure that future generations of park enthusiasts will share in the unique beauty that is Stearns County Quarry Park and Nature Preserve.

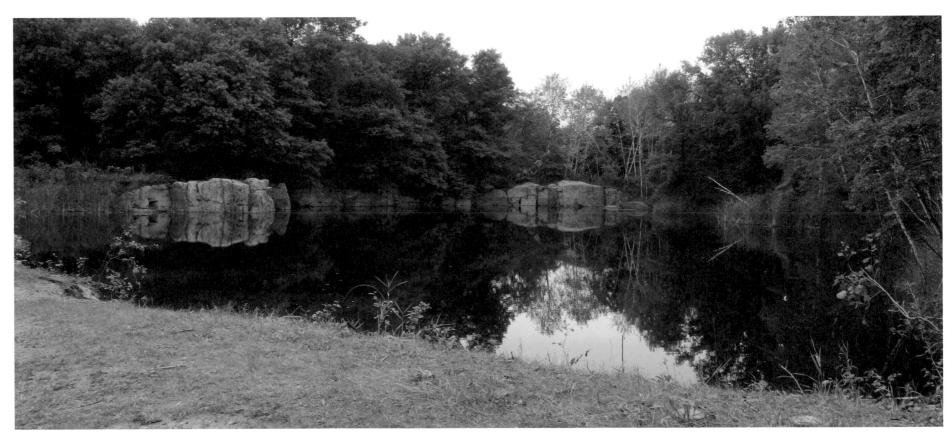

Opening Quarry 11 as the second swimming quarry in the park took several years of planning and water testing. Students from St. John's University asssisted in gathering water samples to establish a base line, enabling staff to determine what effect, if any, recreational swimming would have on water clarity, oxygen levels, water temperature, and other factors. (Author's Collection)

St. Cloud Times
Monday, June 22, 2015

Quarry Park's newest
swimming hole
opens Tuesday

Stearns County Parks Director Peter Theismann talks with recent Lakeville North High School graduates Peter Sherman, from left, Allison Aadland and Janette Romero at the new Quarry No. 11 swimming area Thursday in Quarry Park & Nature Preserve.

Quarry No. 2 is more for the adventure seekers; No. 11 is more for families, picnickers and laid-back swimmers

ANN WESSEL
AWESSEL@STCLOUDTIMES.COM

The trio of recent high school grads found Stearns County Park Director Peter Theismann on the 100-foot strip of sand at Quarry 11, the new swimming spot in Quarry Park & Nature Preserve officially opening Tuesday.

Theismann was being interviewed for this story. The three were holding a paper map of the park, looking for the cliffs. They meant Quarry No. 2, aka Melrose Deep 7, the 116-foot-deep magnet that draws college kids carrying inflated tubes and coolers.

Allison Aadland said she'd heard from friends that Quarry Park was the place to go cliff-jumping. With her were fellow Lakeville North High School grads Janette Romero and Peter Sherman.

They paid no attention to the sand under their feet, to the smooth-as-glass 0.6-acre quarry flanked by a swimming platform to the right, steps leading to the water on the left.

See QUARRY, Page 4A

Jeremy Monn and Hannah Wulf of Apple Valley check out the new Quarry 11 swimming area Thursday in Quarry Park & Nature Preserve from the water level.

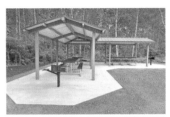

A picnic shelter is one of the amenities at the new Quarry 11 swimming area Thursday in Quarry Park & Nature Preserve.

Quarry

Continued from Page 3A

The encounter seemed to confirm planners' intentions for the two swimming spots within the 684-acre park off Stearns County Road 137 in Waite Park. Quarry No. 2, a half-mile from the parking lot, is more for the adventure seekers. No. 11, a third of a mile from the lot, is more for families, picnickers and laid-back swimmers.

"The second swim quarry was designed to be more family-friendly. You definitely need to know how to swim before you go in the water. But the ledges aren't so high, the water isn't so deep," Theismann said.

"We thought we'd try to create a bit of a quieter atmosphere. We built a sand beach so people can walk in the water — again, if they already know how to swim. The cliffs are only 8 feet high so maybe you wouldn't even call them a cliff," he said.

While the 20 dump truck loads of sand help to smooth the approach, ledges result in drop-offs. Maximum depth is about 45 feet. At the swimming platform ladders, it's about 12 feet deep.

County parks staff built the 20-foot-wide wooden swimming platform, which has two bench seats and two ladders, on the ice in February so it would be in place when the water opened up. Theismann said staff at first tried drilling through the ice and the granite on the quarry floor to install the anchoring metal posts. But the granite was too hard. Posts are

Details

Quarry No. 11 officially opens for swimming at 1:30 p.m. Tuesday. The park is open from 8 a.m. until 30 minutes after sunset. It's regularly patrolled by sheriff's deputies, partly to keep people from climbing on dangerous rock piles, which are clearly marked. Parking costs $5 for a daily pass, $16 for the year.

anchored within rock-filled, fence-wrapped baskets.

Improvements to the spot include two grills on either end of an L-shaped shelter shading three tables plus three more picnic tables along the quarry's oak-and-aspen shaded rim. A two-room concrete outhouse is nearby. Smaller slabs of granite, which staff found within the park, are incorporated in the retaining ledges at the beach, the landscaping that leads to the swimming platform and the submerged steps on the opposite side of the quarry.

Theismann said the project stayed within its $151,000 budget, which included $136,000 in Legacy Amendment funding. Bernick's covered the balance.

The project also expanded the parking lot capacity from 130 to 180 vehicles.

Monitoring for E. coli will continue at all Stearns County swimming beaches, which include spots in Quarry, Warner Lake and Kraemer Lake-Wildwood county parks. This year, water-temperature readings will be tracked in the swim quarries.

Follow Ann Wessel on Twitter @AnnWessel.

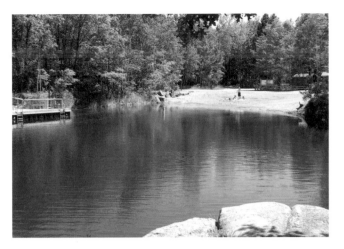

Top: Quarry 11. It's maximum depth is approximately forty-five feet and it has a water surface area of six-tenths of an acre. (Courtesy of the Stearns County Park Department) Bottom: It took twenty dump-truck loads of sand to create the beautiful beach. The unofficial opening of Quarry 11, the second swim quarry, took place on Friday, June 12, 2015. The official ribbon-cutting and grand opening for the second swim quarry was Tuesday, June 23, 2015. Crowds of excited swimmers all summer long have convinced park staff that public demand for additional swimming quarries might have only just begun. (Author's Collection)

Chuck Wocken, retired Stearns County Parks director, and his wife, Barb, visited Quarry Park for the grand opening of the second swim quarry. The Wockens' daughter, Sarah Mariette, was also in attendance, along with six of the Wocken grandkids. Left to right: front row: Christian, Rose, Gianna, Joseph, Celine, and Elizabeth; back row: Sarah (Wocken) Marriette, Chuck Wocken, and Barb Wocken. (Courtesy of Scott Zlotnik, City of St. Cloud Park director)

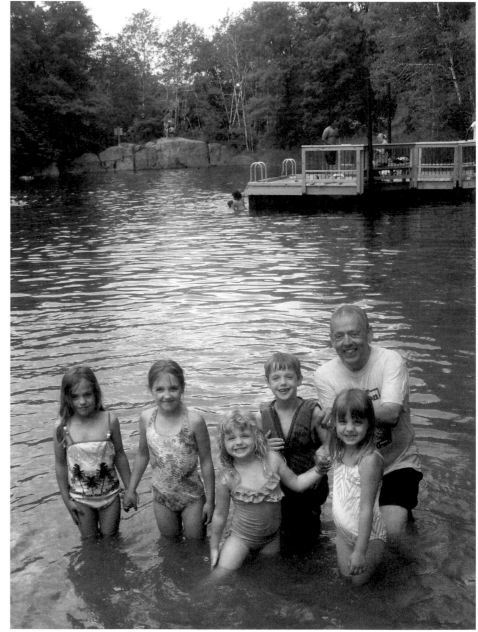

Chuck Wocken said, "I never thought I would see the day that my grandchildren went swimming in the quarries with me. What a blessing! They will always remember that as one of the highlights of visiting us last summer." (Author's Collection)

Peter Theismann, who has been appointed the new Stearns parks director, checks the trails Tuesday at Quarry Park & Nature Reserve in Waite Park. JASON WACHTER, JWACHTER@STCLOUDTIMES.COM

FAMILIAR TERRITORY

STEARNS COUNTY NAMES THEISMANN AS PARKS DIRECTOR

By Kirsti Marohn
kmarohn@stcloudtimes.com

Stearns County's newest parks director won't need time to get acquainted with the county's natural places.

Peter Theismann has spent many hours in its parks and on its trails during his 15 years working for the county, the last year as acting parks director. In his free time, he enjoys cross-country skiing, riding his bike and kayaking on the Sauk River.

Building on the success of Stearns County's expansive park system will now be Theismann's challenge as he takes over as permanent director. He was appointed by the county board on Tuesday to replace Chuck Wocken, who retired last February after 38 years with the county.

"I look forward to working with you and taking on some of the challenges we have," Theismann told the board.

Theismann, 63, is a Wabasha native who has a bachelor's degree in

See DIRECTOR, Page 2B

Director

From Page 1B

social science from St. John's University and a master's degree in recreation from the University of Wisconsin-La Crosse. He worked for the Stearns County social services department from 1979-82.

Theismann joined the Stearns County parks department as an intern in 1998, then became a full-time park technician the following year. He was named operations coordinator in 2006.

Looking to future

He inherits a county park system that encompasses 19 parks and trails that span more than 2,600 acres, as well as some daunting goals for the next few years.

At the top of that list is extending the Lake Wobegon Regional Trail from its current end point in St. Joseph to Waite Park, providing residents of the St. Cloud metro area easier access to the trail. The county is seeking state bonding and Legacy funds for the project.

Theismann also wants to make repairs to the 15-year-old trail, which is beginning to show its age with some serious cracks.

"They're not life threatening, but we want to upgrade the asphalt," he said. Theismann acknowledges that the repairs aren't very exciting, but added, "It's an important part of taking care of ... the money we've spent to build the trail, to keep it up so it's in good shape for bicycle riding and roller-blading and snowmobiling."

Another goal for this year is to add a second swimming quarry at Quarry Park & Nature Preserve in Waite Park.

Theismann said he learned a lot from his predecessor, whom he said worked hard and took advantage of opportunities to purchase land when it was offered or became available.

Theismann said money is tighter, and he probably won't have the same opportunities as Wocken to acquire land, but he hopes to develop existing parks like Wildwood County Park on Kraemer Lake near St. Joseph.

"There are some funds out there, and you've got to chase them and compete for them," he said.

Theismann was one of four finalists interviewed for the director job, along with Marc Mattice, parks administrator for Wright County; Scott Zlotnik, park and recreation director for St. Cloud; and Jon Henke, park director for Crosslake.

He will earn a salary of $73,535.

Follow Kirsti Marohn on Twitter @kirstimarohn.

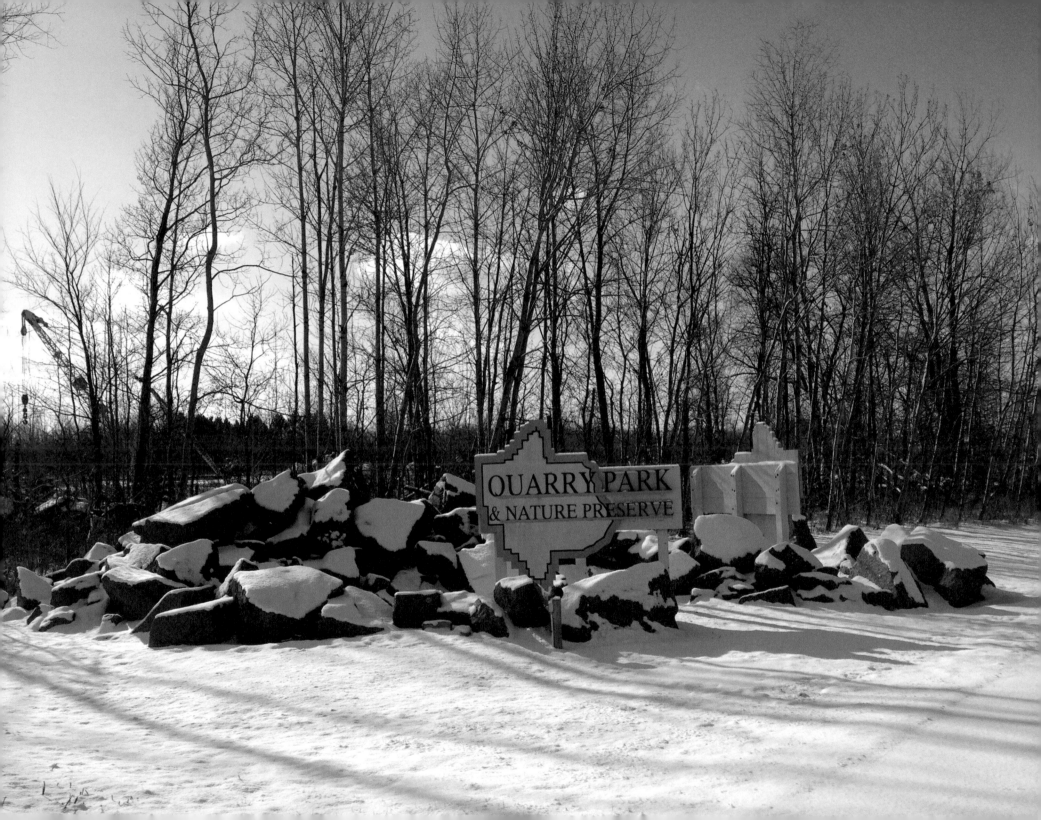

BEATING THE HEAT

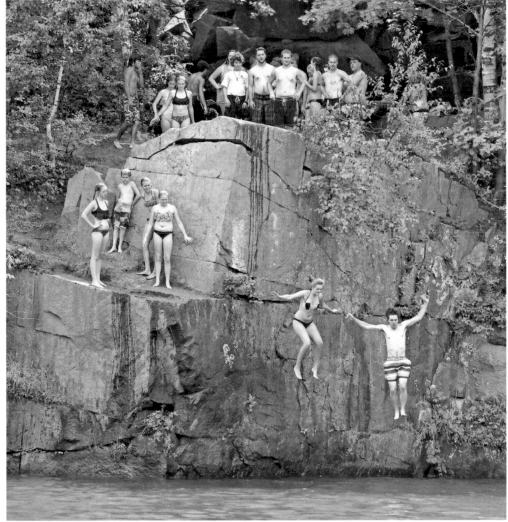

DAVE SCHWARZ, DSCHWARZ@STCLOUDTIMES.COM

People jump from ledges into the cool waters of the Melrose Deep 7 Quarry on Wednesday at Quarry Park & Nature Preserve in St. Cloud. Rain later in the day canceled several area activities including Summertime by George!

Used with permission of the *St. Cloud Times*.

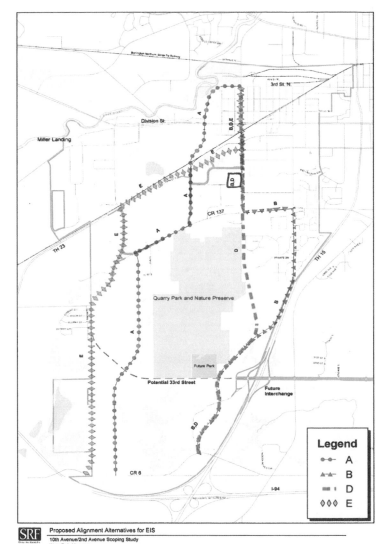

SRF Proposed Alignment Alternatives for EIS
10th Avenue/2nd Avenue Scoping Study
Waite Park, Minnesota

Planning parks involves planning roads. These were considered in a study commissioned by Waite Park, Stearns County, and the Area Planning Organization (APO). Alternative D (in pink) considers a future parkway along the east side of the park, intersecting with a future east/west route along the southern border. What will the future bring? Traffic counts and available dollars will tell. (Courtesy of SRF Consulting)

Times photos by Dave Schwarz, dschwarz@stcloudtimes.com

St. Cloud State University assistant professor Juan Fedele explains a research project under way in Quarry Park & Nature Preserve to try to determine why the water in a particular quarry is green.

QUARRY GENERATES MINT-COLOR TINT

SCSU group investigating

By Kirsti Marohn
kmarohn@stcloudtimes.com

WAITE PARK — Amid the dozens of quarries filled with clear water in Quarry Park & Nature Preserve, No. 21 is a mystery.

The small hole surrounded by jagged granite turns bright green every summer, and no one is sure why.

Juan Fedele, an assistant hydrology professor at St. Cloud State University, is trying to find out.

With help from his students, Fedele is studying the quarry and hopes to discover what's causing the algae growth that annually turns No. 21 into a vat of pea soup.

St. Cloud State student Jason Draper checks a monitoring station near a quarry at Quarry Park.

"There is a reason for sure, a physical reason, and we're going to discover it," he said.

Fedele's research could provide valuable information for experts who manage larger bodies of water such as lakes and watersheds.

It also will provide welcome answers for Stearns County Parks Director Chuck Wocken, who has long wondered why this lone quarry in the county's flagship park is less than pristine.

"It's the least scenic pool because it's green," Wocken said. "The important part is to isolate what's going on, so we can at least ask ... what else is impacting this?"

Some hydrologists focus mainly on the biological or chemical aspects of water. Fedele, who has taught at St. Cloud State since 2006, is interested in the physical side — how water moves through a system.

To solve the mystery, Fedele's team is tracking all of the water entering and leaving the quarry.

That's easier in a man-made pool with no inlets or outlets, he said. It's a fairly shallow quarry with an average depth of 10 feet.

The team set up equipment at the quarry, including a weather station that measures wind, rain, air temperature and pressure, dew point and solar radiation.

There's also a large metal pan that measures the amount of water lost each day through evaporation.

Quarry 21 is ringed by trees and thick foliage, so it's doubtful that it's being affected by water running across the land's surface. But water also flows underground and can carry pollutants with it, Fedele said. As part of the study, the team is looking at land use in the area and possible links with nearby wetlands.

By the end of the summer, Fedele hopes to have an answer to the mystery. He plans to share the results of his research with the county parks department and state Department of Natural Resources.

There's an academic benefit as well. The project is providing students with valuable experience reading instruments and learning how different variables can affect a water system, Fedele said.

He hopes to bring classes to the site to operate the equipment, collect data and do their own calculations.

St. Cloud State is one of the few universities in Minnesota that offers an undergraduate degree in hydrology, and it's gaining popularity, Fedele said. He hopes more people are paying attention to its importance.

"Water is a resource that's limited," he said.

Used with permission of the *St. Cloud Times.*

ANOTHER LOOK MONDAY, JULY 20, 2015 »

FORECAST CALLS FOR FUN

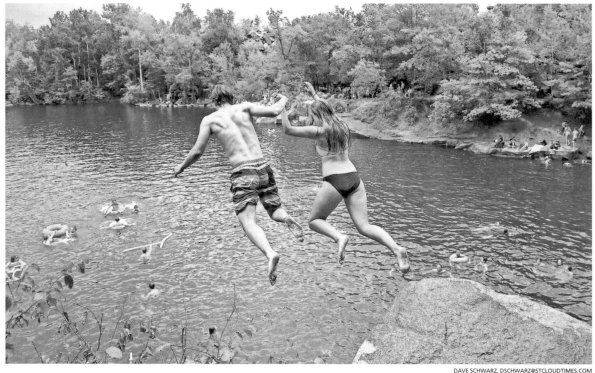

DAVE SCHWARZ, DSCHWARZ@STCLOUDTIMES.COM

Swimmers hold hands while jumping from a granite ledge at the Melrose Deep 7 Quarry Wednesday at Quarry Park & Nature Preserve in St. Cloud. Warm weather has kept both swimming quarries busy at the park this week.

Used with permission of the *St. Cloud Times.*

Quarry 21 has experienced early and thick algae blooms every summer for many years (*see* article to the left). This eutrophic (oxygen depleted) state is not found in other quarries in the park, leading staff to believe this quarry is receiving excessive nitrogen, possibly through the groundwater entering this quarry. Obviously, underground water flow can carry pollutants. It is important to monitor the waters of Quarry Park to determine what's causing the trouble and what can be done to prevent future pollution problems.

Looking to the future . . . imagine the park and recreation opportunities and possibilities when quarrying is completed and Martin Marietta's "Rainbow Quarry" fills with fresh, clean groundwater. Will Quarry Park North be born? Will trails around this extensive man-made lake be included in the reclamation plans? Will *you* attend the public hearings and speak out when the future of this land is being decided? (Author's Collection)

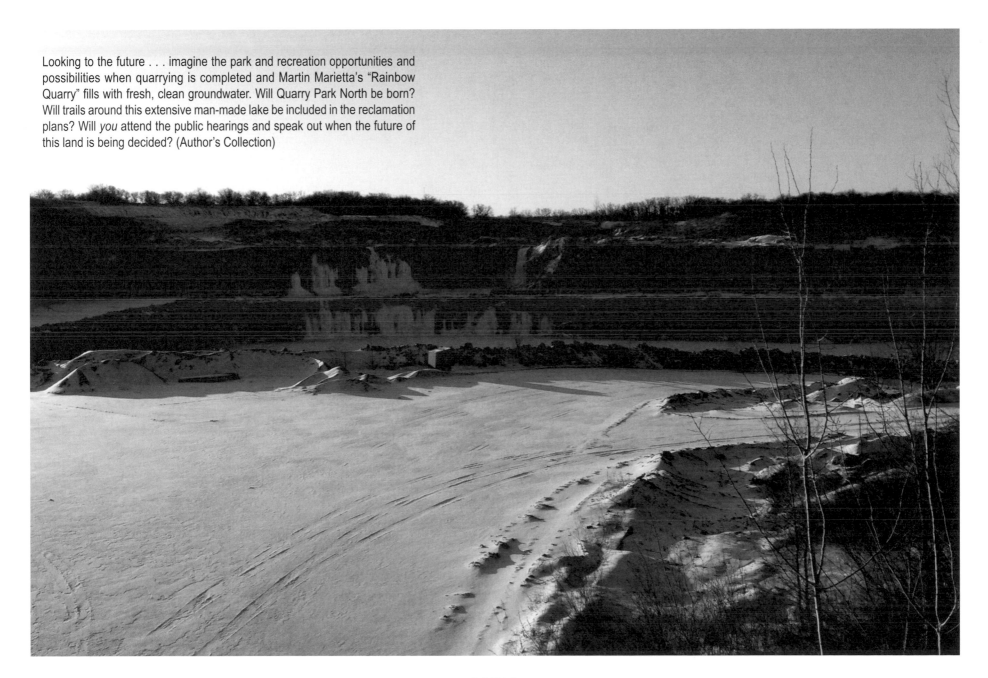

A Tribute to Quarry Park

The clang and commotion of commerce is buffered
and silenced in this magnificent place.
Yellow Lady Slippers peek and sway when touched by nature's breath . . .
Prickly Pear reflects the nurturing of a granite ledge . . .
Indian Paintbrush casts burnt orange over the prairie
as if directed by an intervening artist . . .
Diversity of habitats from wet to dry; plants and animals clinging
to their own private niche because nowhere else will suffice.

Quarry Park offers more than an escape for man;
it is a reflection of his natural treasures.
It blends the spectacle of nature with the culture of our area's pioneers
who faced and conquered this quarry
—driven by pride, fueled with perspiration—
collecting monumental treasures and leaving symbols of the strength
and indomitable spirit of man.

Salutations to those who saved this treasure.
We sing of their wisdom as new visitors
leave the clang and commotion of commerce
and are buffered by this magnificent place.

~Larry Haws,
Stearns County Commissioner

Acknowledgments

On July 1, 2011, in preparing for this book, I interviewed Stearns County Park Director Chuck Wocken for nearly two hours regarding his recollections on a variety of topics related to Quarry Park and Nature Preserve. The transcript of that interview is available in its entirety at the Stearns County History Museum. I drew upon much of that information throughout the course of this book. Special thanks to Chuck Wocken, not only for helping make Quarry Park and Nature Preserve the treasure it is today, but also for his thoughtful advice and willingness to open the Stearns County Park Department's files to help make this book possible.

Others who helped in many ways to make this book possible include:

Michael D. Lee, DNR Botanist/Plant Ecologist

Welby Smith, DNR State Botanist

Kelly Randall–Outreach Coordinator, MN DNR, Scientific and Natural Areas

Stephen G. Saupe, Ph.D., Professor, joint Biology Department of the College of St. Benedict/St. John's University

Robert Wichman, Ph.D., geologist and professor

Bernie Omann, retired Minnesota state repersentative

John Bodette, *St Cloud Times* executive editor

Melissa King, *St. Cloud Times* newsroom assistant

Gena Hiemenz, former *St. Cloud Times* archivist

John Divall—KARE 11 News

Pat and Gary Webber, *St. Cloud Visitors Guide*

Corinne Dwyer, Curtis Weinrich, and Anne Rasset at North Star Press

Computer-savvy Boys & Girls Club staff:
- Deb Nebosis
- Aimee Minnerath
- Nancy Vossen
- Richard Wright

George Rindelaub, Stearns County Administrator

Randy Schreifels, Stearns County Auditor-Treasurer

Steve Holthaus–Stearns County Division of Land Management, Property Tax/ Land Records Supervisor

Marlys Tanner, Stearns County Administration, Office Services Supervisor

Peter Theismann (and staff), Stearns County Park Director

Ben Anderson, Stearns County Parks Operations Coordinator

Julie Nistler, Stearns County Parks Office Specialist IV

John Decker–Stearns County History Museum Director of Archives

Steven Penick–Stearns County History Museum Archivist

Rudy Frank, photographer

Don Kempf, photographer

Roger Peterson, underwater photographer

George Reisdorf, photographer

George Schnepf, Cold Spring Granite Chief Financial Officer

Mike Reinert, Martin Marietta Aggregates

Special thanks to my wife, Diane, for suggesting "Quest" in the book's title and for lots of encouragement along the way!

For more information on Stearns County Park and Nature Preserve, check out the Quarry Park page on Stearns County's website: www.co.stearns.mn.us

At right, Commissioner Larry Haws (back row, right) served on the County Board from 1999 to 2005 before being elected to the Minnesota State House of Representatives. As a former Parks director for the City of St. Cloud, Haws brought great enthusiasm and insight into discussions concerning Quarry Park. Commissioners are, left to right: Don Otte, Leigh Lenzmeier, Mark Sakry, Rose Arnold, and Larry Haws. (Courtesy of Stearns County)

Above: Special thanks to the many dedicated volunteers and staff who made Quarry Park possible. Here are Stearns County Park Commission members out visiting parks on December 14, 2005. Left to right: Lowell Olson, Peter Theismann, Joan Bredeck, Jim Graeve, Prentiss Foster, John Peck, Ed Bouffard, and Mark Sakry. (Courtesy of Stearns County)

At right: When Commissioner Rose Arnold retired in 2003, she was replaced by Vince Schaefer. DeWayne Mareck was elected commissioner that same year, replacing Larry Haws. This group of commissioners served from 2005 to 2010. Left to right: Vince Schaefer, Leigh Lenzmeier, DeWayne Mareck, Don Otte, and Mark Sakry. (Courtesy of Stearns County)

Special Thanks

We would like to express our gratitude to the following sponsors for their generosity and belief in Quarry Park and this book. Without their support, the story of Quarry Park might have gone untold.

GIVE SHARE CARE | **The Bernick Family Foundation**

Sand Companies, Inc.

McDowall Company

A Five Generation Company